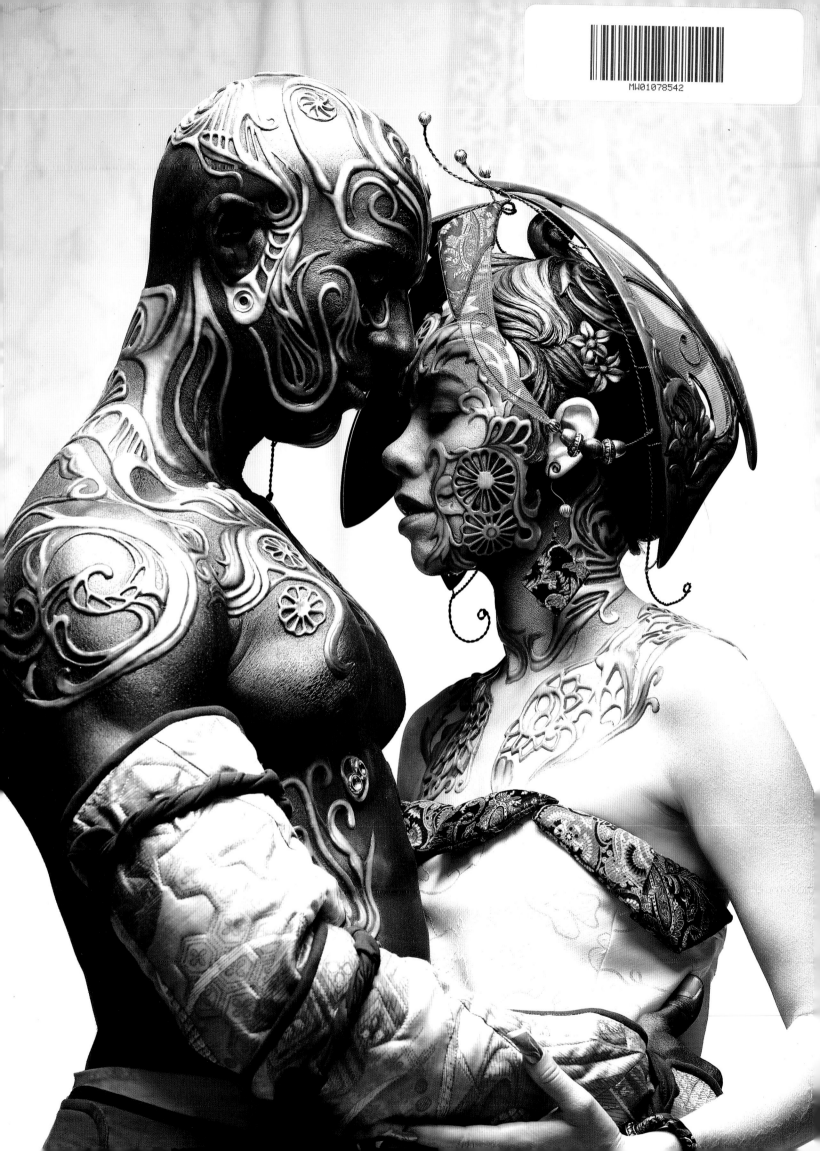

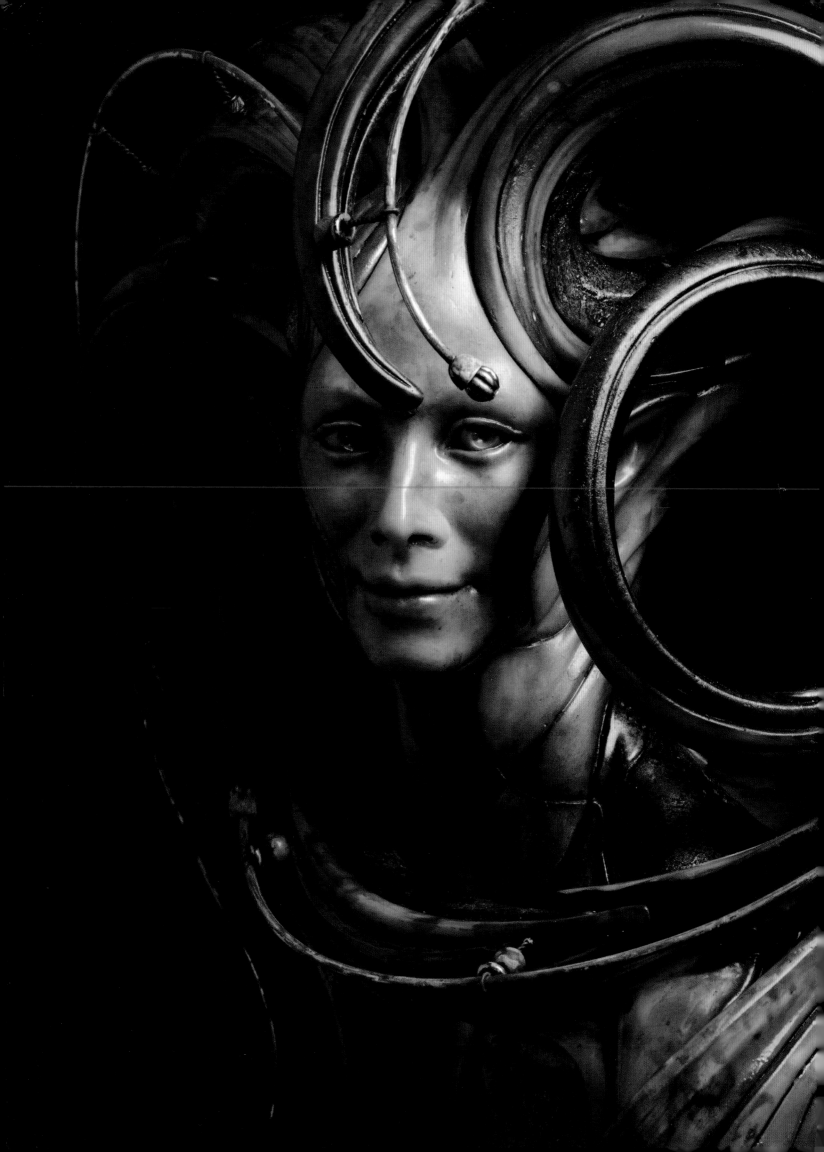

HEART OF ART

WELCOME TO A SMALL GLIMPSE INTO THE GRAND
WORLD OF SPECIAL EFFECTS MAKEUP AND FINE ART OF

AKIHITO

FOREWORD BY RICHARD TAYLOR

designstudio|PRESS

Heart of Art

Graphic Design: Cecilia Zo
Art Direction: AKIHITO
Copy Editing: Jessica Hoffmann

10 9 8 7 6 5 4 3 2 1
Printed in China
First edition, April 2014

Published by
Design Studio Press
8577 Higuera Street
Culver City, CA 90232

Paperback ISBN
978-162465004-8

www.designstudiopress.com
info@designstudiopress.com
www.shiniceya.co.jp

Library of Congress Control Number 2014931104
Book typeset in Alte Haas Grotesk and Copperplate

CONTENTS

6 FOREWORD by Richard Taylor

7 INTRODUCTION by Akihito

8-35 SCULPTURE CHAPTER

 8 Heart of Art
 12 Bathing on Rodeo Drive
 14 Bee Fimily
 18 Reliefs
 22 Killer Clowns
 28 Raijin
 30 Medusa
 32 The Regenerated Man
 34 Wind Messenger

36-75 SFX CHAPTER

 36 Bio-Veronica
 40 Taiko
 48 Fu-Bi
 52 Runway Show
 68 Cherry Blossom
 70 Tengu
 72 TV Champion

76-87 DESIGN CHAPTER

88-120 WORKSHOP CHAPTER

 90 The Regenerated Man
 94 Killer Clowns
 98 Fu-Bi
102 Bio-Veronica
110 Taiko

120-122 BIOS

122-123 CREW LIST

Akihito is a leading practitioner of the art of special-effects makeup. There is no doubt that he is an expert at this most exacting of disciplines, but his world-class technical skill is second to his incredible and unique sense of design and aesthetic.

Captured within every piece of his art is a consummate ability to design and then sculpt truly unique shapes and forms I have enjoyed following Akihito's career over the past 10 years since I had the great pleasure of meeting this amazing young artist at an LA workshop. Akihito graciously gifted me one of his incredible sculptures, which now resides at the front of our design studio to inspire the team that works with me here at the Weta Workshop. Akihito has deftly and successfully invested in his work, creating a sense of a new mythology·a new culture, a new people, and a new aesthetic for all to enjoy.

I have long hoped that a book would be published to celebrate the work of this unique and wonderful artist. Whether Akihito is sculpting clay or putting makeup on a human, the body of work that he has assembled firmly establishes him among the best in the contemporary fine-art arena. I am excited to discover what is yet to come from Akihito.

I lend my voice of support to this world-class publication celebrating Akihito's body of work.

Richard Taylor

Richard Taylor
Design and Effects Supervisor
Weta Workshop

The phrase "The Heart of Art" fundamentally encompasses all I hold dear. I chose to use it as the title of this book and as the title of the sculpture shown on pages 8-11, which represents a milestone in my life. The title's English translation has close ties to my son's name, Kaito.

The Japanese language uses Kanji to create first and last names. The literal Japanese translation of Kaito (絵都) is "Capital of picture." Those who have a Japanese background may see where my son's name originated. "E-no-Miyako" (a simplified version of Kaito) impressed me, and the feeling it conveys fit perfectly. I worked with an American friend until we came up with something that embodied everything important about my art, my family, and my life. "The Heart of Art" became the center. It then became the title of this book. E-no-Miyako flowed from "The Heart of Art." It became the vision behind my art pieces. It drives their creation. It is how I would like the world to look at the objects I create.

I've been working in the film industry as a special-effects makeup artist for 19 years. I started in Japan and worked there for 9 years and then moved to Los Angeles and worked in the United States. It wasn't until recently that I decided to complete this book. I have long thought about publishing a book but never understood when the best time would be. In Japan people discouraged me with the financial hurdles of writing a book. Books were not popular at all with my generation. Looking back, the best advice I can give to anyone who wishes to create is to believe in yourself and persevere toward achieving your goals. It sounds simple but it's not. It's the single most important thing to keep in mind when setting and working toward your dreams. This book you are reading is my dream. You cannot imagine the emotions I will be experiencing when this book is published. My pleasure will come from sharing my dream with you. It will come from opening my world to you.

I have to thank many people for their help on my projects. Thank you, everyone! I would like to thank Design Studio Press for giving me this opportunity. I would love to thank my family. I would like to thank my beautiful wife, Atsuko, my son, Kaito, and my daughter, Anna. Their love and support ground and relax me. I would like to thank my parents, Katsunobu and Kazuko. I would like to thank my sister, Chinatsu, as well. They have always encouraged me and pushed me toward my dream. I enjoy my life and the world I've been given. I feel I am only halfway to my goal, though. I am looking forward to my future. I feel there are wonderful things in store.

Akihito Ikeda

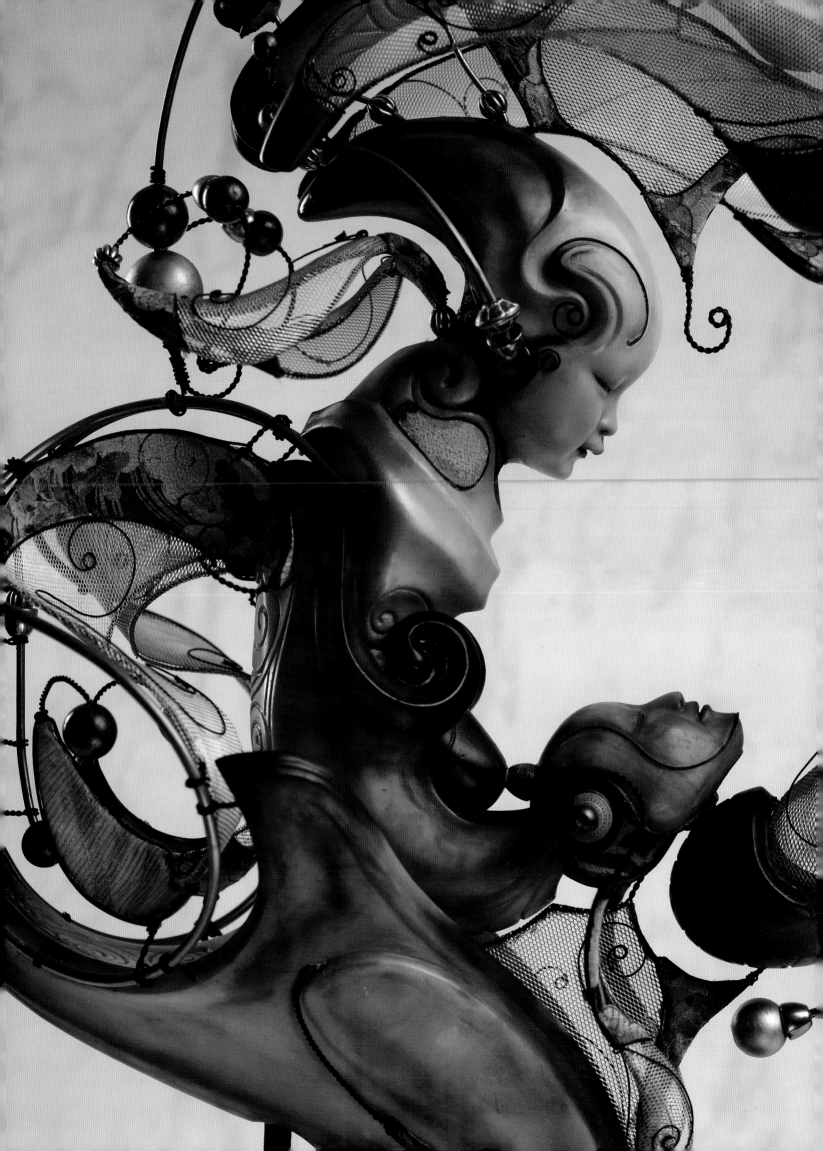

SCULPTURE

HEART OF ART

SIZE: H 33 INCHES (83CM) X W 20 INCHES (51CM) X D 12 INCHES (30CM)
MEDIUM: MIXED

The Best in Contemporary Fantastic Art 15
Dimensional Silver Award

I started creating these art pieces in 2003 after moving to Los Angeles. In Japan I never had the opportunity to produce art that didn't relate to the film industry. My new art gave me the opportunity to communicate and to connect with people in ways I never imagined. In May 2005 my son, Kaito, was born. I was living in the United States with my beautiful wife, Atsuko, and I was working in the profession of my dreams. This piece represents that wonderful time. It came to epitomize my family. In the center of the circle Kaito's face can be found. Atsuko is looking up at him. They are connected in an eternal circle of beauty and art.

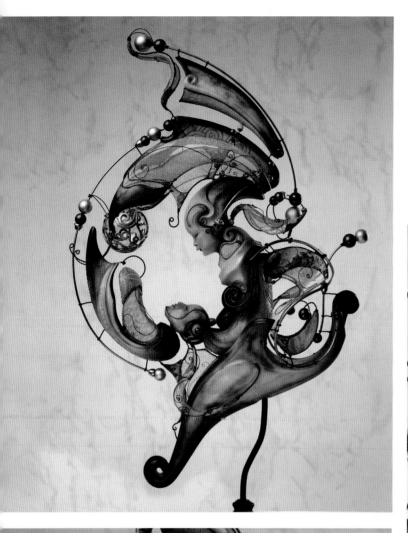

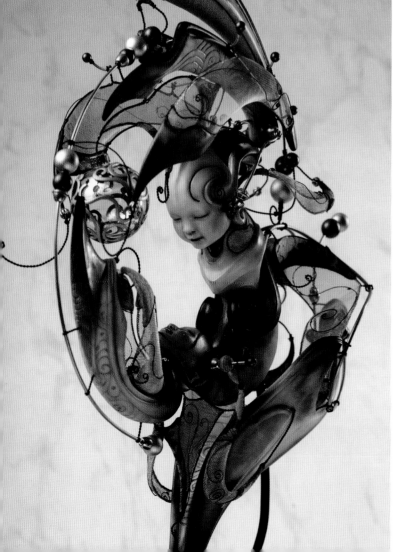

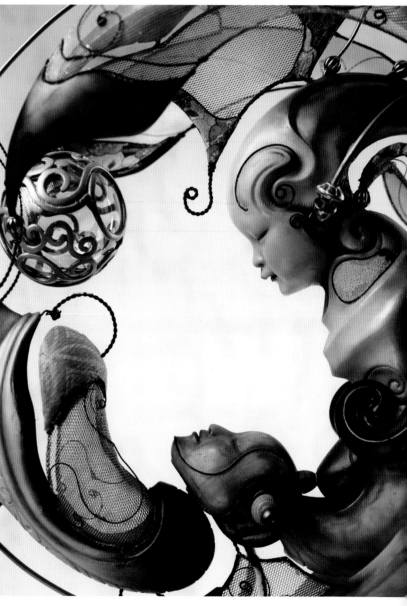

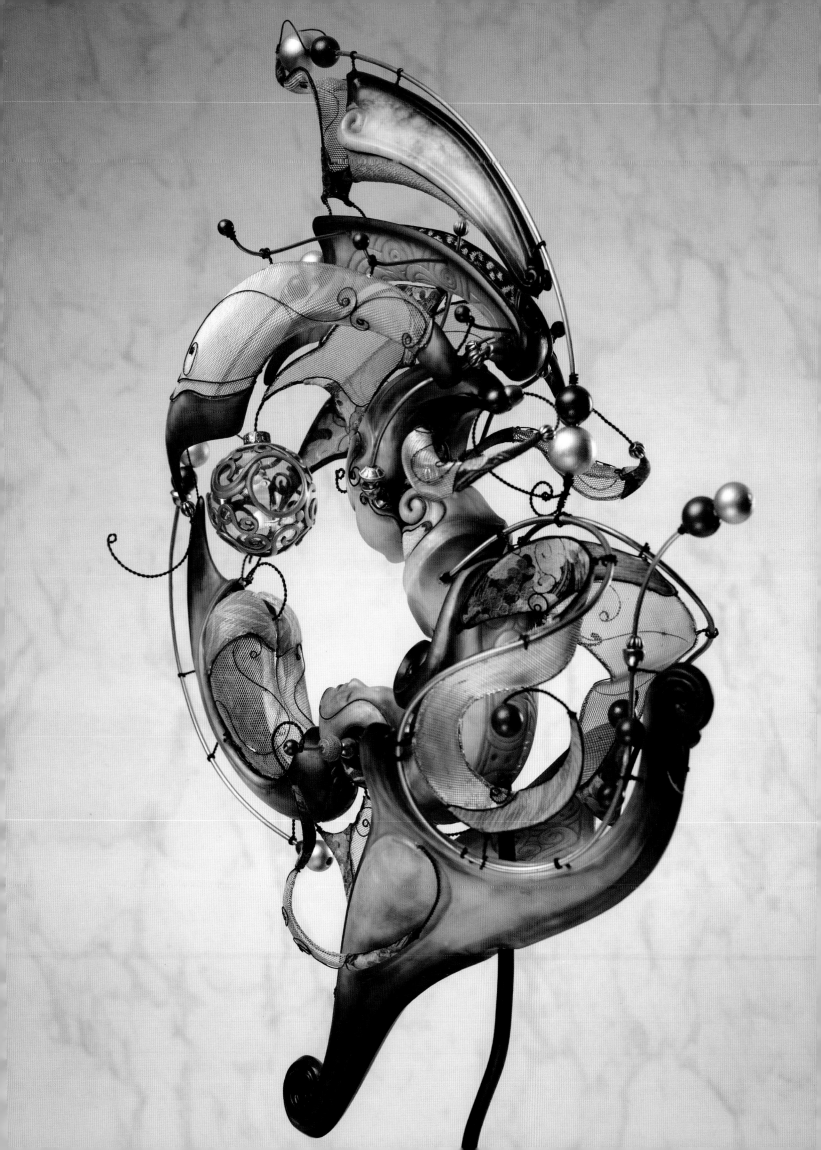

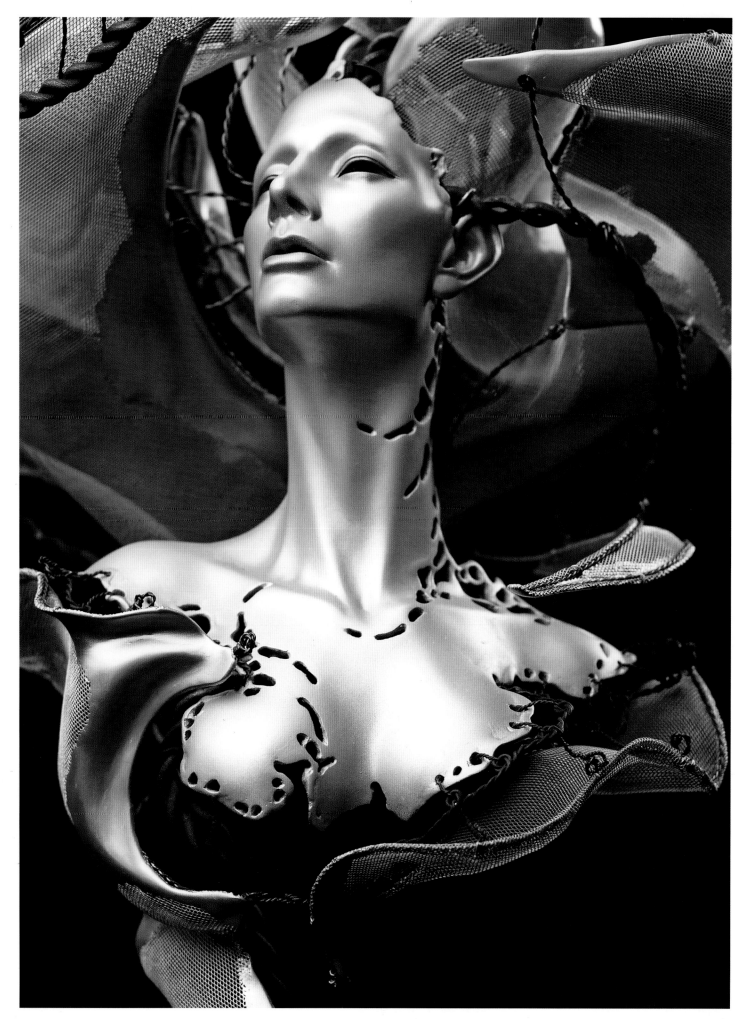

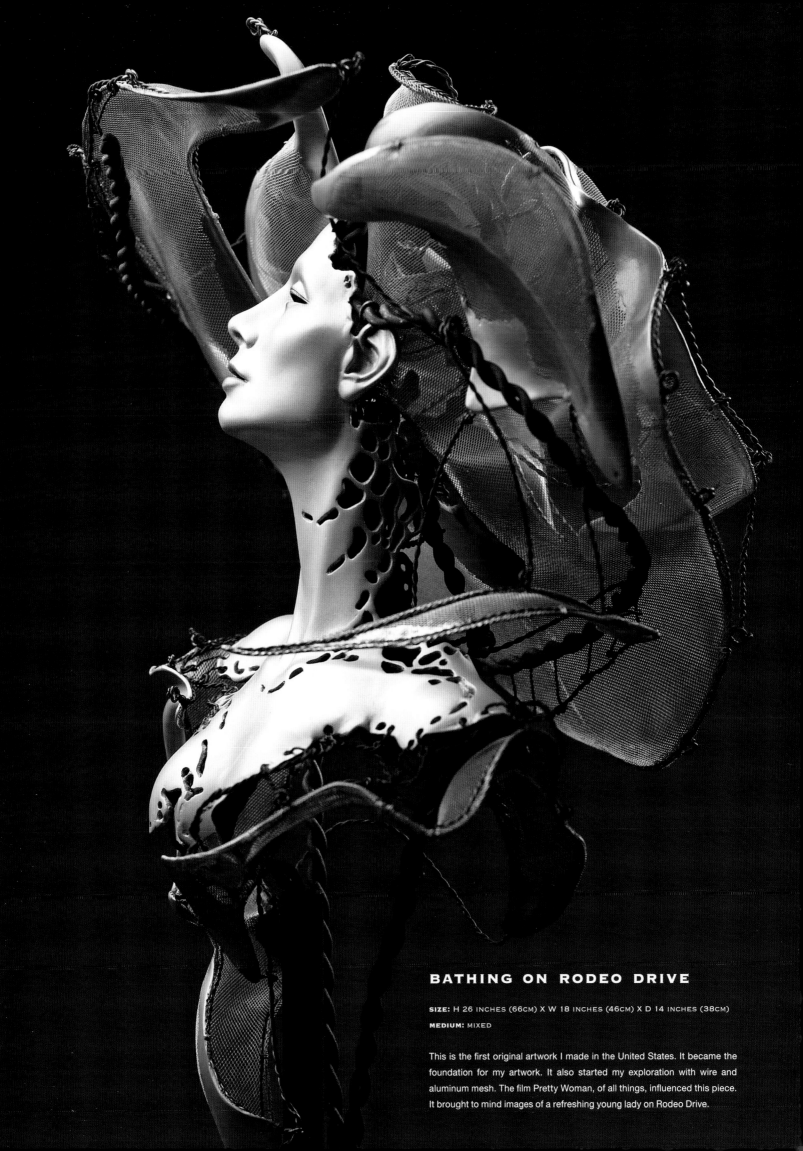

BATHING ON RODEO DRIVE

SIZE: H 26 INCHES (66CM) X W 18 INCHES (46CM) X D 14 INCHES (38CM)
MEDIUM: MIXED

This is the first original artwork I made in the United States. It became the foundation for my artwork. It also started my exploration with wire and aluminum mesh. The film Pretty Woman, of all things, influenced this piece. It brought to mind images of a refreshing young lady on Rodeo Drive.

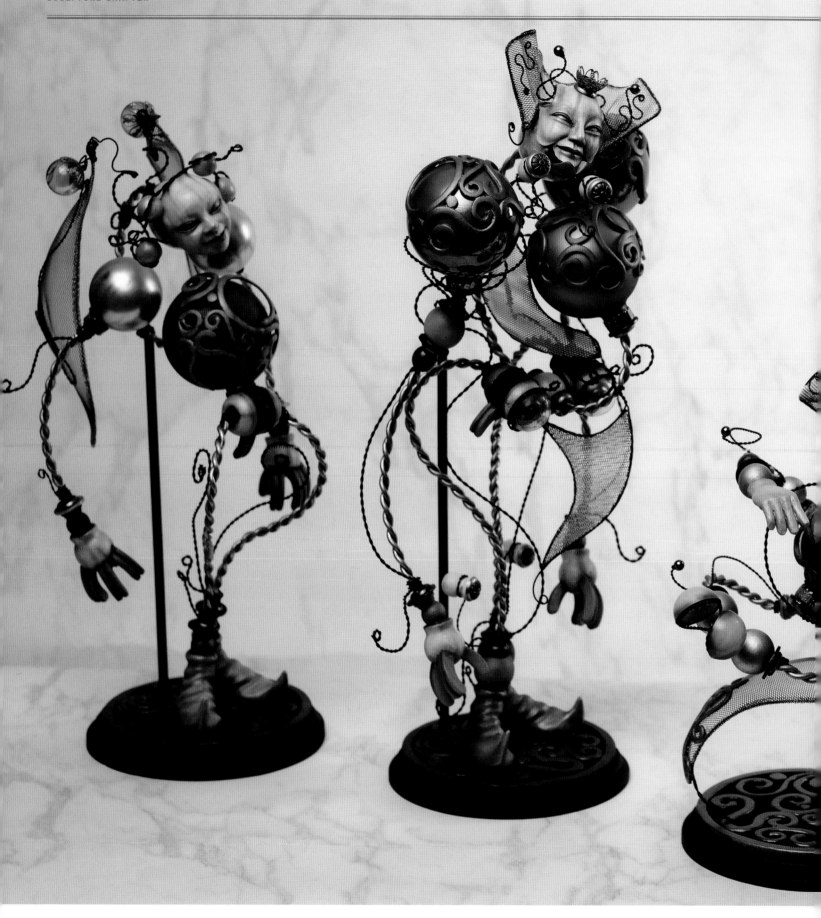

BEE FAMILY

MEDIUM: MIXED

As a child, I did not have many toys. The Japanese economy was poor, and my parents grew up during a time when such things were considered luxuries. That conservatism carried over to my childhood. Frankly, I want to thank my parents for that now. It truly helped me appreciate the things I have, and it shaped my future and my career. Things like the Christmas holiday, Christmas trees, and ornaments were completely novel to me. As children we received 1 gift at Christmas and celebrated with strawberry cake. That alone was enough to make us consider Christmas special. It was so different from the extravaganza I experienced when I came to the United States.

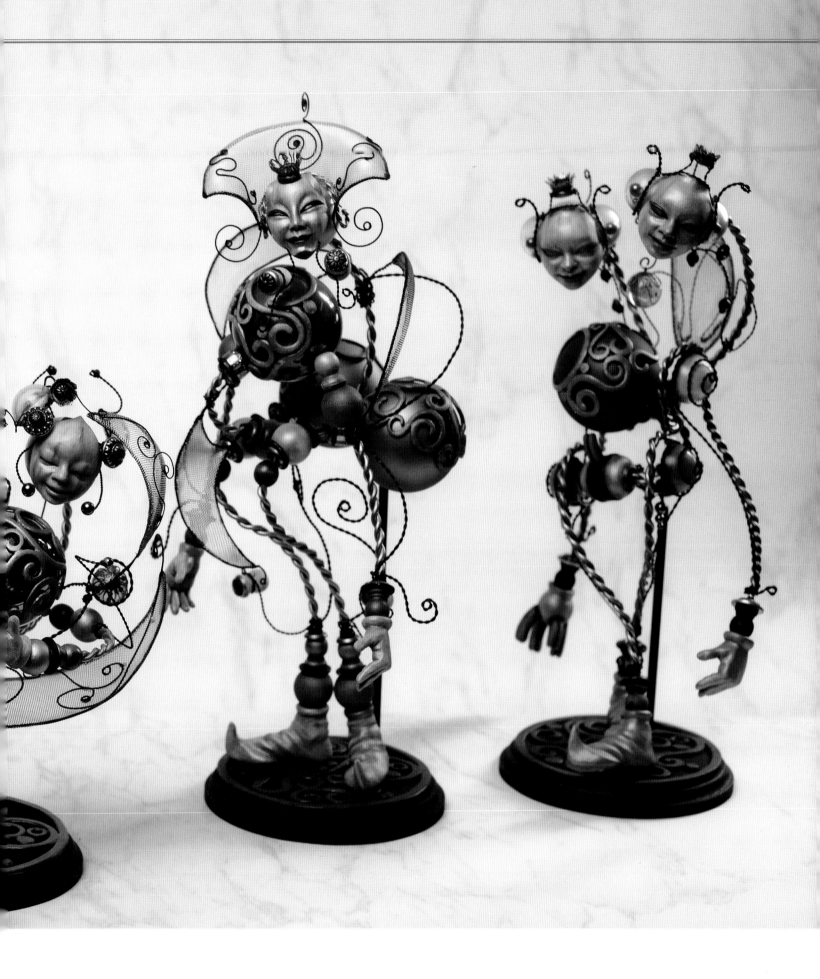

The first time I encountered this was while working at KNB Effects Group Inc. on a film called *The Island* in 2004. The studio placed a bare tree in front with boxes of ordinary Christmas bulbs and encouraged us to customize them. We then placed them on the tree. Some made their ornaments look like hearts and others made their ornaments look like zombies. Each was unique. Each was creative and wonderful. I placed traditional Japanese patterns called arabesques on the ornaments. The imaginative ornaments that others were contributing inspired me. I had an amazing amount of fun doing what I do best. These ornaments encouraged me to make the bee family.

KING BEE

SIZE: H 18 INCHES (46CM) X W 10 INCHES (25CM) X D 8 INCHES (20CM)

QUEEN BEE

SIZE: H 18 INCHES (46CM) X W 10 INCHES (25CM) X D 8 INCHES (20CM)

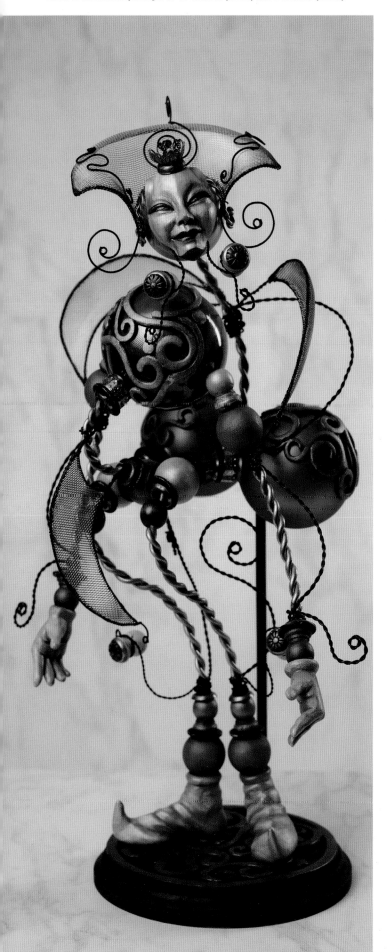

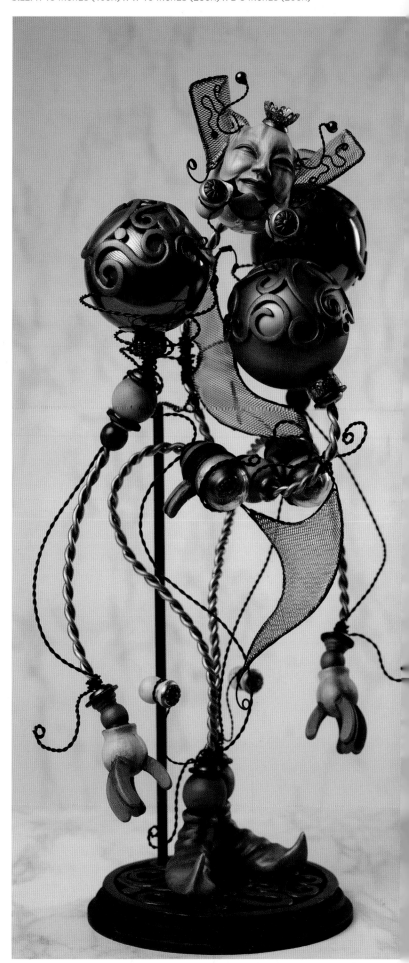

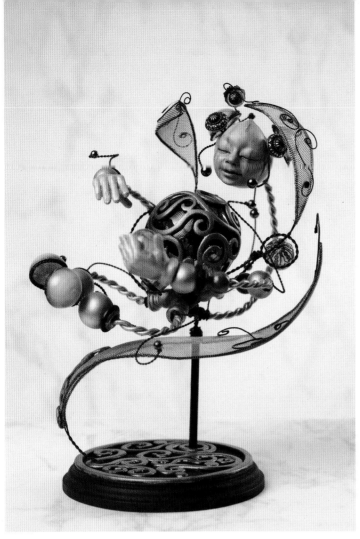

BABY BEE

SIZE: H 12 INCHES (40CM) X W 8 INCHES (20CM) X D 8 INCHES (20 CM)

COMMANDER BEE

SIZE: H 16 INCHES (40CM) X W 8 INCHES (20CM) X D 8 INCHES (20CM)

MISCHIEF BEE

SIZE: H 16 INCHES (40CM) X W 8 INCHES (20CM) X D 8 INCHES (20CM)

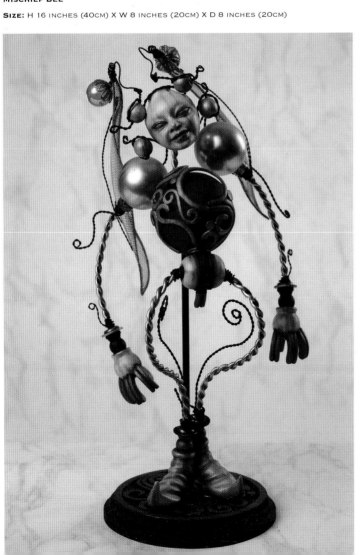

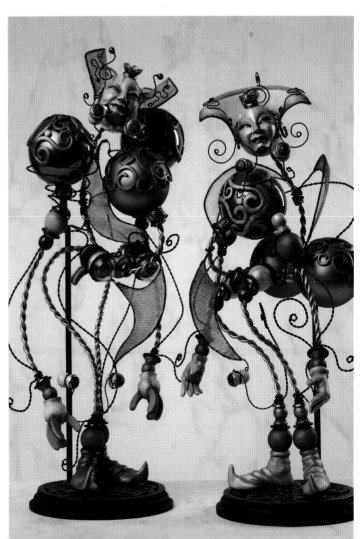

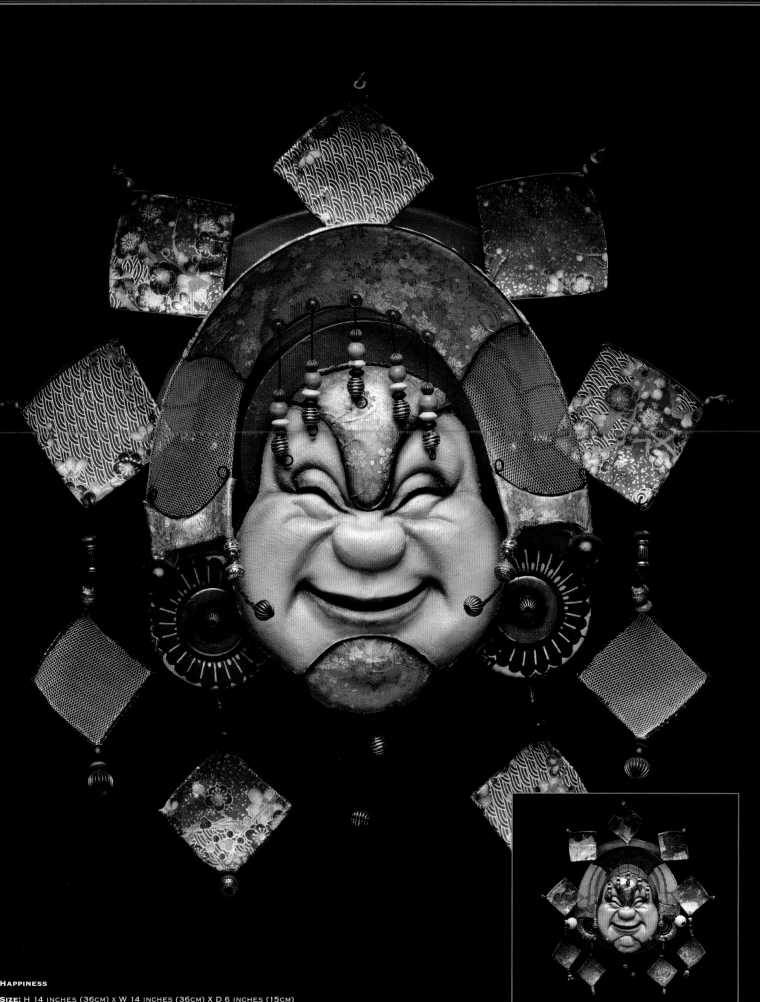

HAPPINESS

SIZE: H 14 INCHES (36CM) X W 14 INCHES (36CM) X D 6 INCHES (15CM)

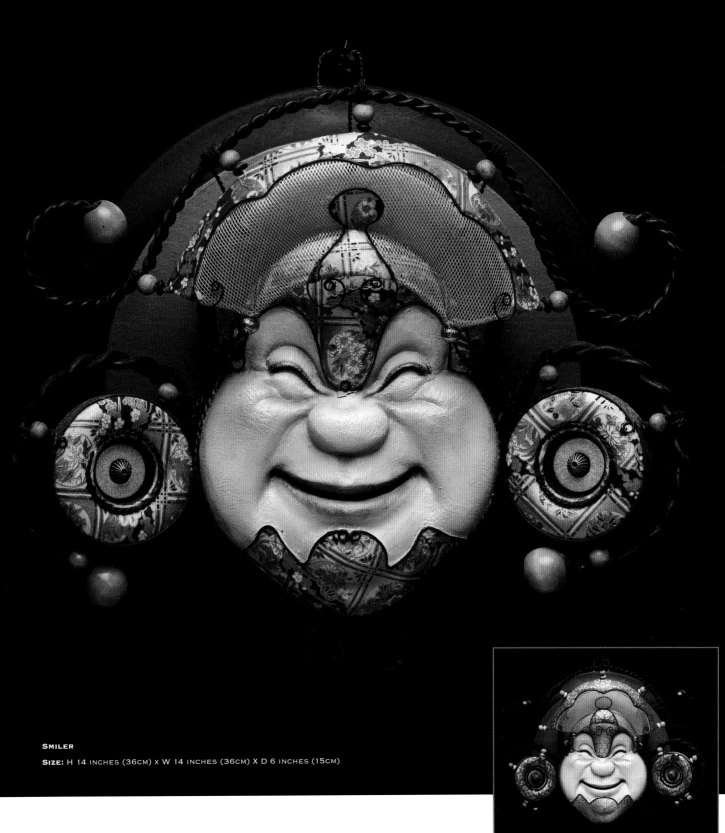

SMILER

Size: H 14 inches (36cm) x W 14 inches (36cm) x D 6 inches (15cm)

RELIEFS

The Smilers are reliefs I made during my lunch breaks while I was working on the films *Dragon Ball: Evolution* and *Cirque du Freak* at Amalgamated Dynamics Incorporated. I enjoy exploring my ancestry and developing artwork that is distinctively Asian. These guardians represent happiness, joy, and anger and serve to protect you, grant you happiness, and instill peace.

I also wanted to incorporate Japanese papers called Washi, which originate in Kyoto. Kyoto is a well-known province for temples and antiques, rich in culture and heritage.

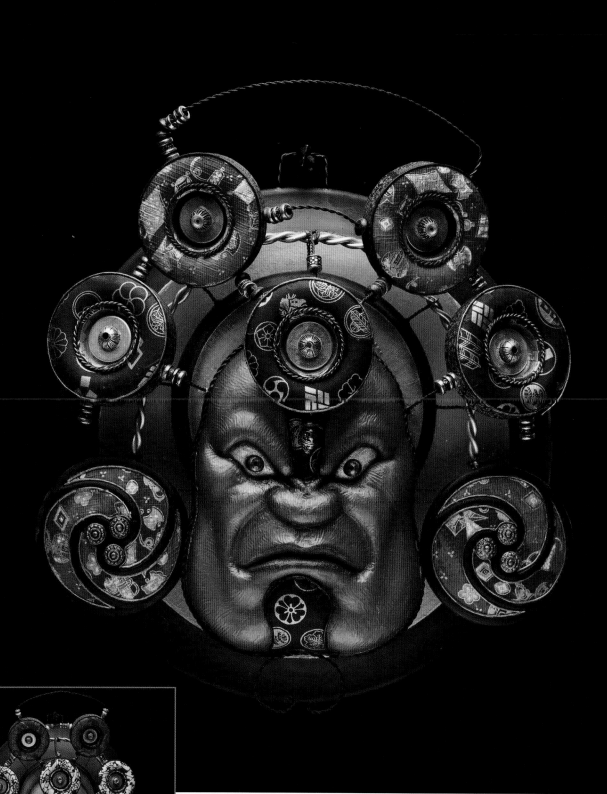

THUNDER

SIZE: H 14 INCHES (36CM) X W 14 INCHES (36CM) X D 6 INCHES (15CM)

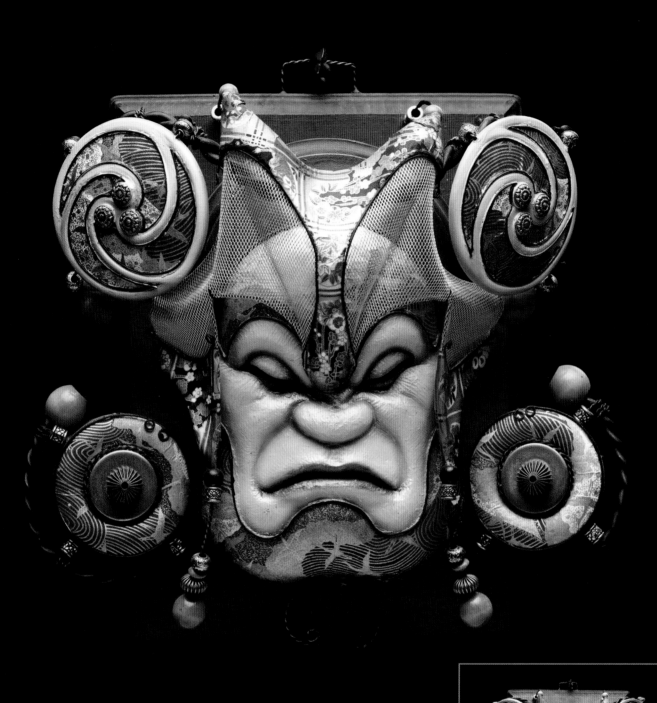

SERMON

SIZE: H 14 INCHES (36CM) X W 14 INCHES (36CM) X D 6 INCHES (15CM)

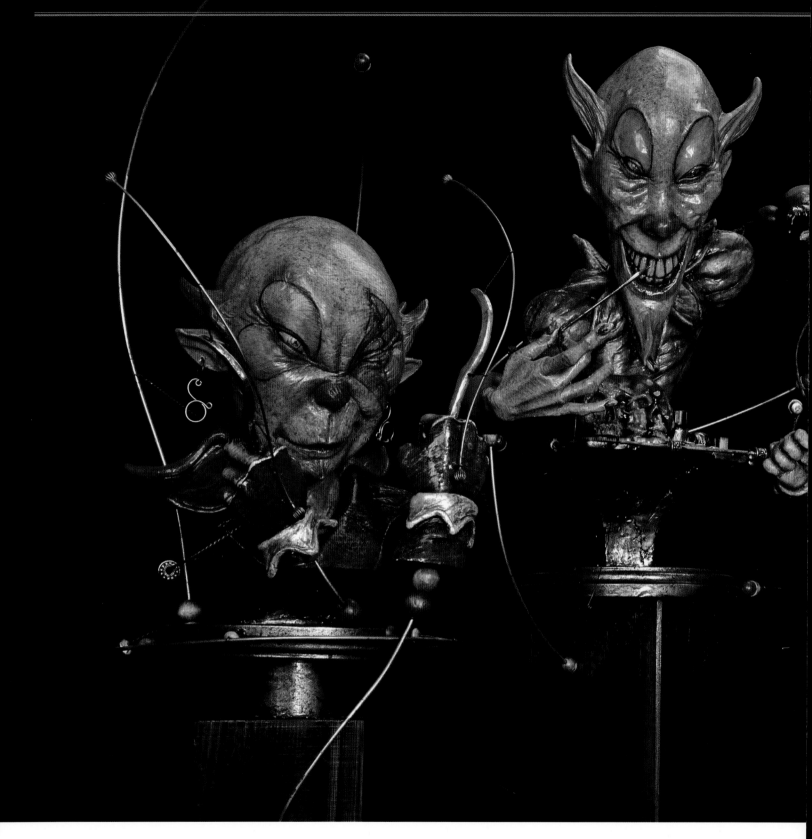

KILLER CLOWNS

MEDIUM: MIXED

It all starts off like a joke. A guy walks into a bar, except this bar is called Clown Boys. It's a forgotten little place in a faded-neon-lit corner of downtown. The bartender there is just as dimly lit, with bloodshot eyes and a senseless smile. However, if you really want to split your sides, mention the words "boon boon" to him. The buffoon of a bartender will then ask you the "who, what, and where." You've just invited the Boon Boon Django Clown Killers to your party.

These clowns are not the kind you invite to your kid's birthday. They're assassins. Each is a sickly twisted incarnation of psychosis and sideshow. Each has his own specialty and his own punch line. Are they sick sociopaths or grease-painted avengers? When it comes to their job, they don't clown around.

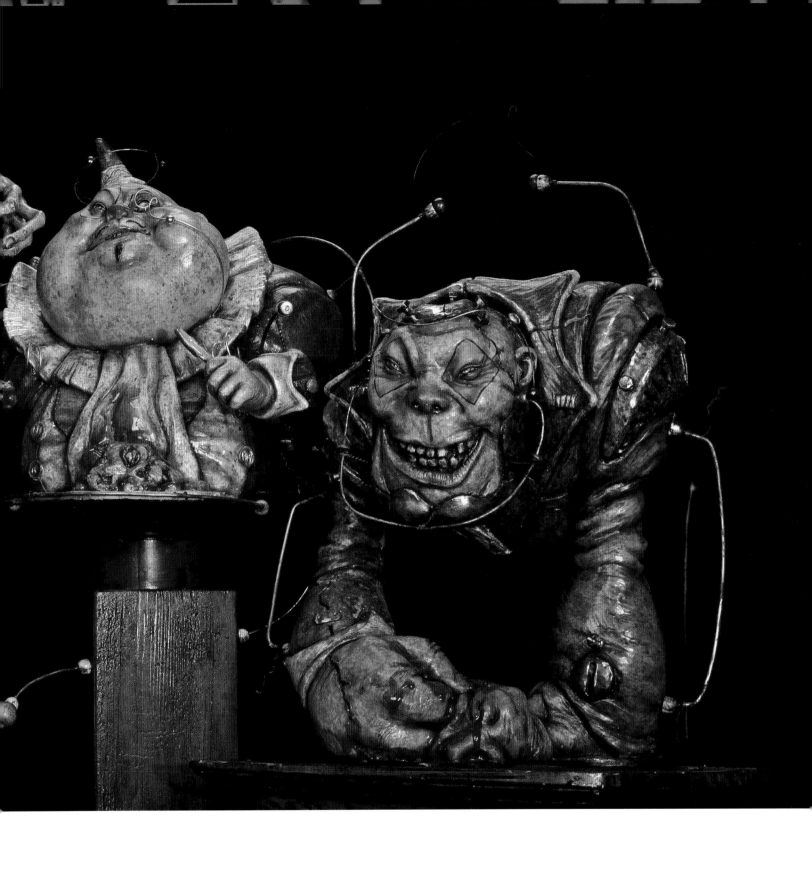

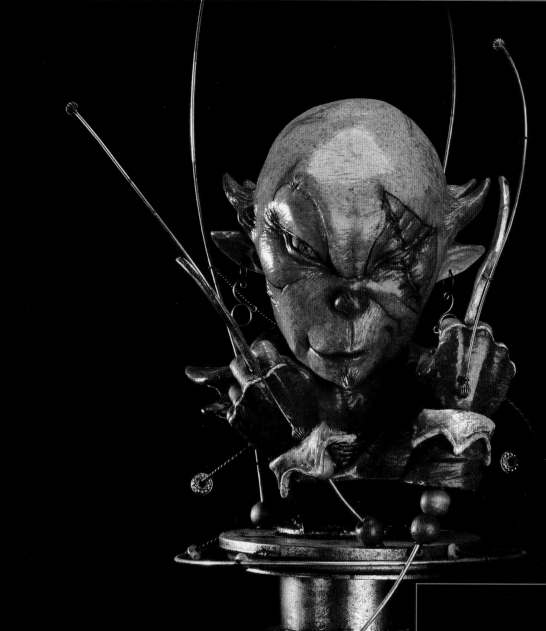

ICHI KILLER

SIZE: H 20 INCHES (51CM) X W 12 INCHES (30CM) X D 9 INCHES (23CM)
MEDIUM: MIXED

Ichi is the Django team leader, a wacky whirlwind of death and intellect. Armed with a cornucopia of cutlery, he gets his kicks by clumsily cutting necks with carving knives. His face is an opus of slits, slashes, and crazy cuts. These are not from his many violent encounters but from hours of training with fumbling fingers. He has 1 particular scar that is both physical and emotional. It sits prominently upon his blood-red nose and supports his most eccentric affinity. It's an old scratch from an old cat that he received when he was very young. Now, he hates cats and won't think twice about making your kitty's intestines into balloon animals.

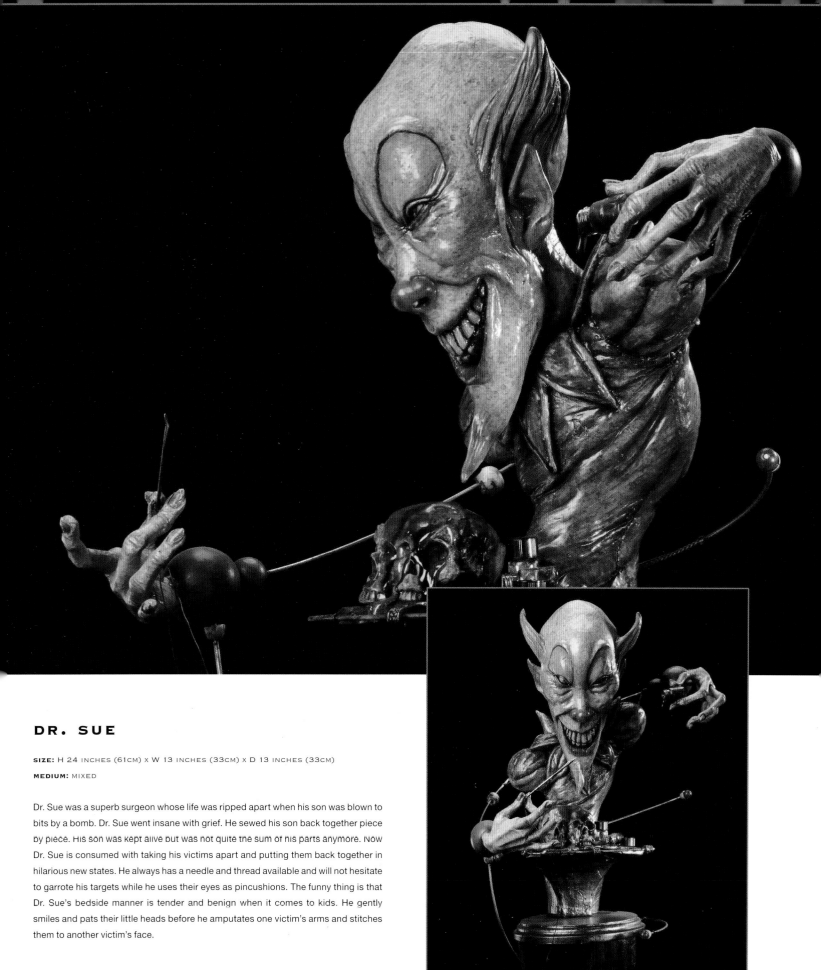

DR. SUE

SIZE: H 24 INCHES (61CM) X W 13 INCHES (33CM) X D 13 INCHES (33CM)
MEDIUM: MIXED

Dr. Sue was a superb surgeon whose life was ripped apart when his son was blown to bits by a bomb. Dr. Sue went insane with grief. He sewed his son back together piece by piece. His son was kept alive but was not quite the sum of his parts anymore. Now Dr. Sue is consumed with taking his victims apart and putting them back together in hilarious new states. He always has a needle and thread available and will not hesitate to garrote his targets while he uses their eyes as pincushions. The funny thing is that Dr. Sue's bedside manner is tender and benign when it comes to kids. He gently smiles and pats their little heads before he amputates one victim's arms and stitches them to another victim's face.

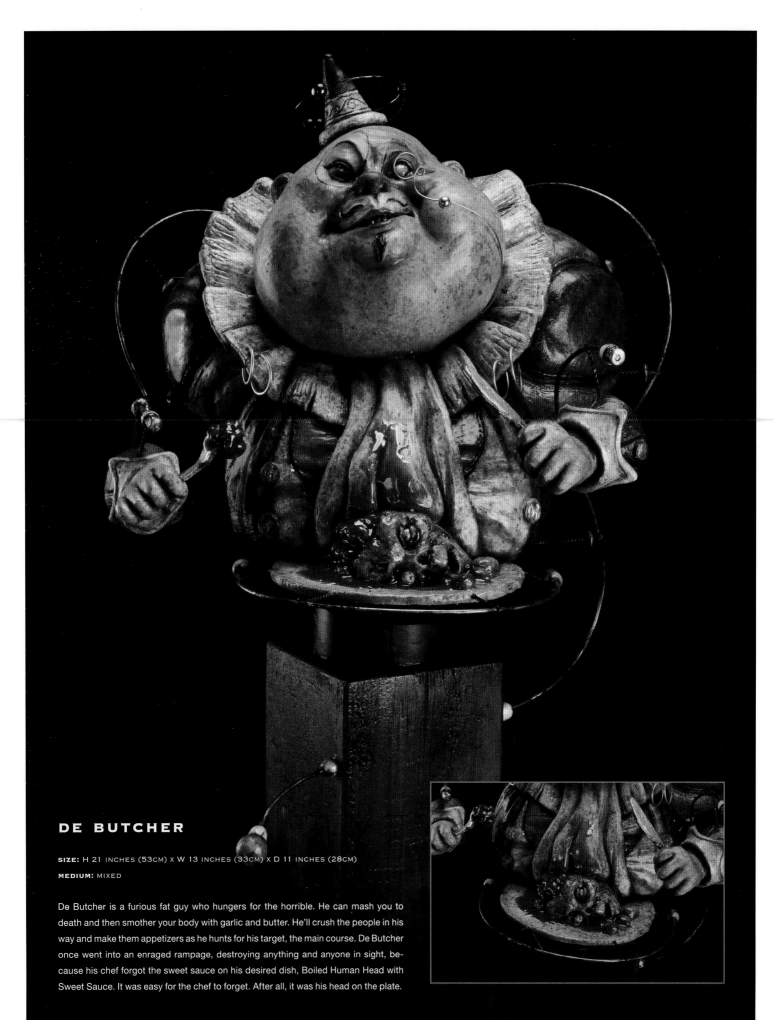

DE BUTCHER

SIZE: H 21 INCHES (53CM) x W 13 INCHES (33CM) x D 11 INCHES (28CM)
MEDIUM: MIXED

De Butcher is a furious fat guy who hungers for the horrible. He can mash you to death and then smother your body with garlic and butter. He'll crush the people in his way and make them appetizers as he hunts for his target, the main course. De Butcher once went into an enraged rampage, destroying anything and anyone in sight, because his chef forgot the sweet sauce on his desired dish, Boiled Human Head with Sweet Sauce. It was easy for the chef to forget. After all, it was his head on the plate.

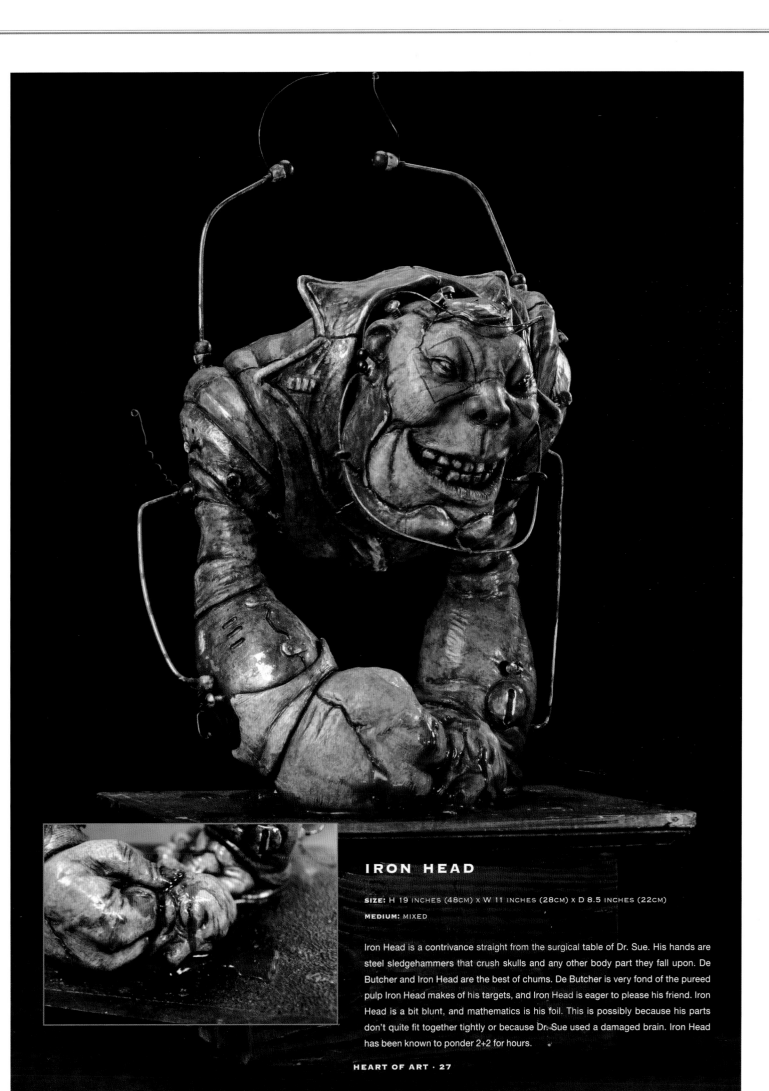

IRON HEAD

SIZE: H 19 INCHES (48CM) X W 11 INCHES (28CM) X D 8.5 INCHES (22CM)
MEDIUM: MIXED

Iron Head is a contrivance straight from the surgical table of Dr. Sue. His hands are steel sledgehammers that crush skulls and any other body part they fall upon. De Butcher and Iron Head are the best of chums. De Butcher is very fond of the pureed pulp Iron Head makes of his targets, and Iron Head is eager to please his friend. Iron Head is a bit blunt, and mathematics is his foil. This is possibly because his parts don't quite fit together tightly or because Dr. Sue used a damaged brain. Iron Head has been known to ponder 2+2 for hours.

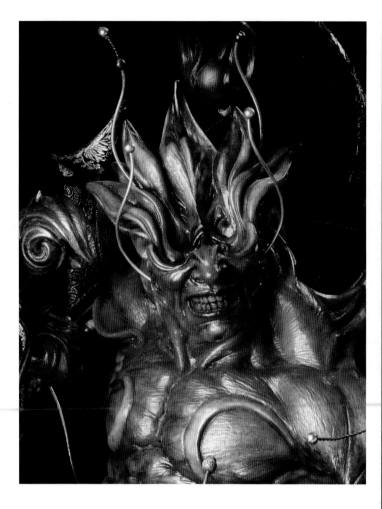

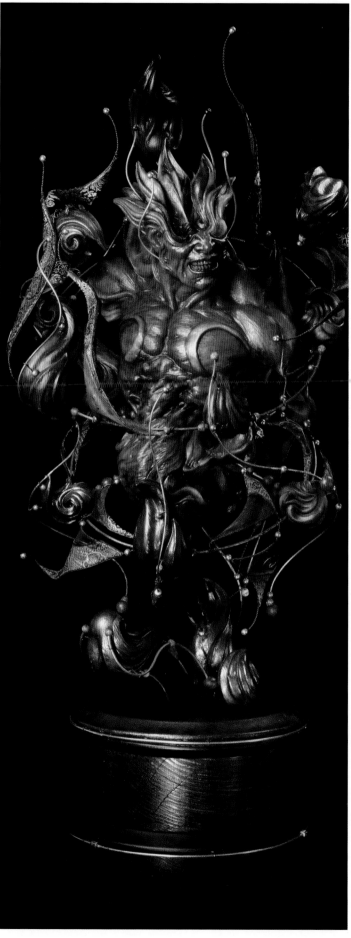

RAIJIN

 SIZE: H 32 INCHES (81CM) X W 17 INCHES (43CM) X D 16 INCHES (41CM)
MEDIUM: MIXED

Raijin is the Japanese God of Thunder. In Japan he usually is depicted wearing a tiger-skin Fundoshi (a traditional Japanese undergarment). In early portrayals Raijin's shoulders were masked with taiko drums to beat out thunderous booms. Traditional depictions of this deity were transformed, and I added elements that came from my conception of him. Fireballs replaced drums. Now ornate fabrics clothe Raijin. These garments are more suitable to the God of Thunder.

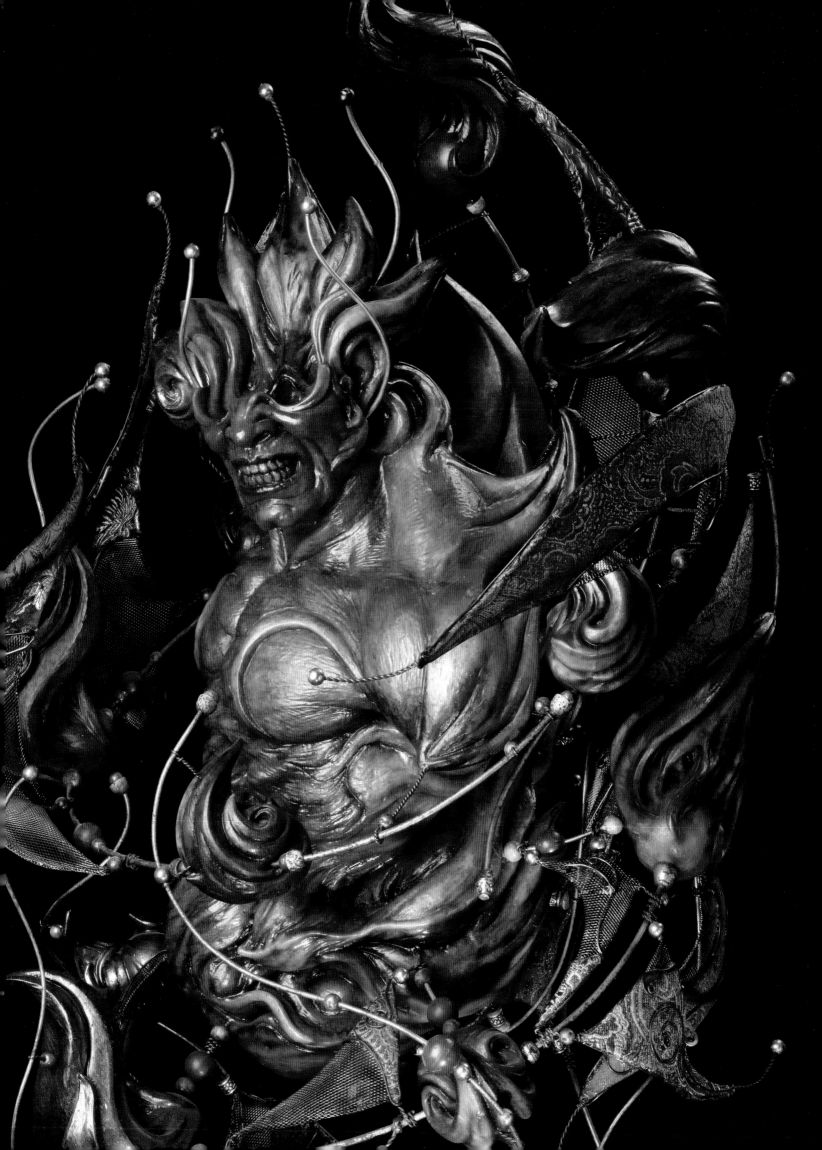

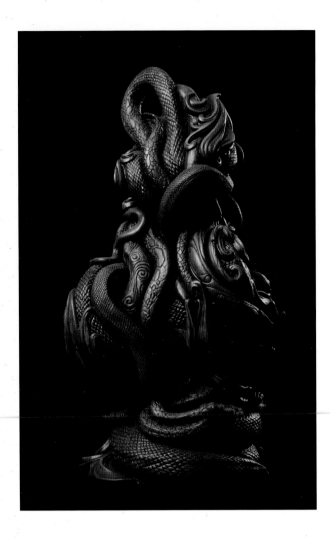

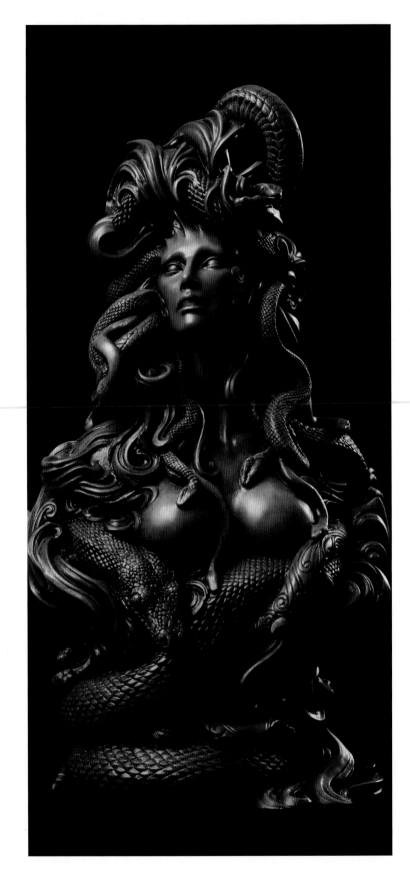

ELEGANT MEDUSA

SIZE: H 18 INCHES (46CM) X W 11 INCHES (28CM) X D 8 INCHES (21CM)

MEDIUM: MIXED

The Best in Contemporary Fantastic Art 16
Dimensional Gold Award

I wanted to see how possible it was to push my skills in WED clay. WED clay is a frequently used and popular water-based clay. It is formulated to have the properties of water clay, with a longer working time. It is easy and fast to make basic shapes and forms with WED clay. I wanted to see how much the film industry had improved my sculpting. I chose Medusa because I had previously won 1st prize with Medusa makeup in a special-effects-makeup championship sponsored by Japan's TV Tokyo; using Medusa here would allow me to gauge my skills with a direct comparison to my earlier makeup.

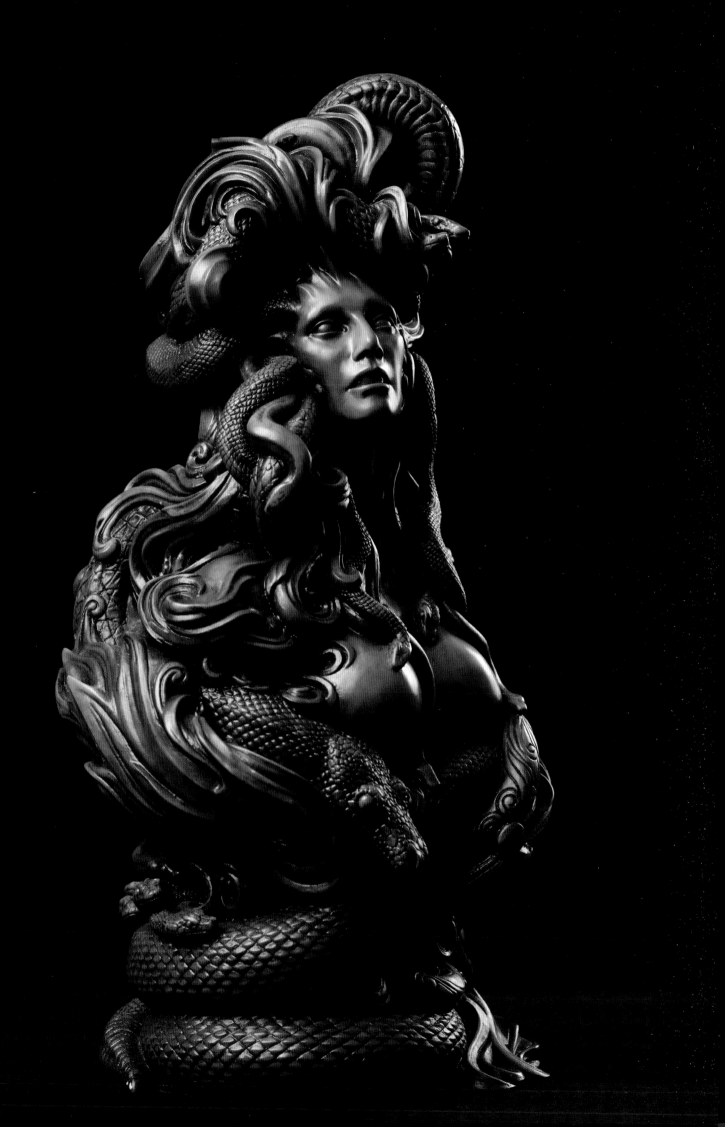

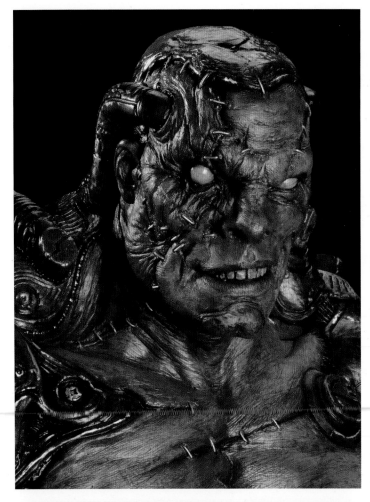

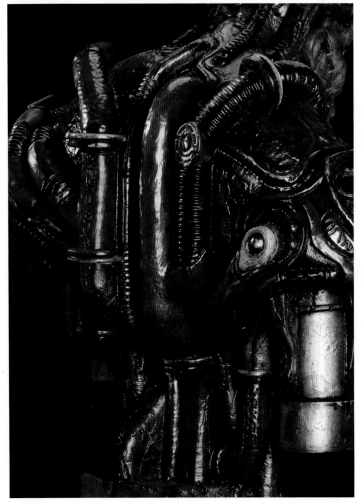

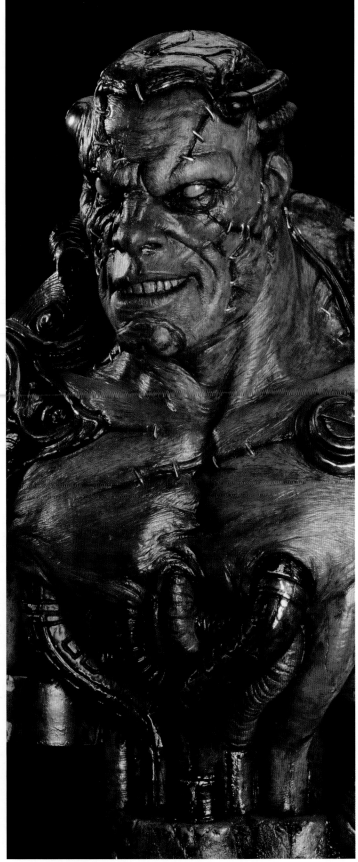

THE REGENERATED MAN

SIZE: H 16 INCHES (40CM) X W 8 INCHES (20CM) X D 8 INCHES (20CM)

This was created for the "Son of the MonsterPalooza" convention that
was held in October 2012.

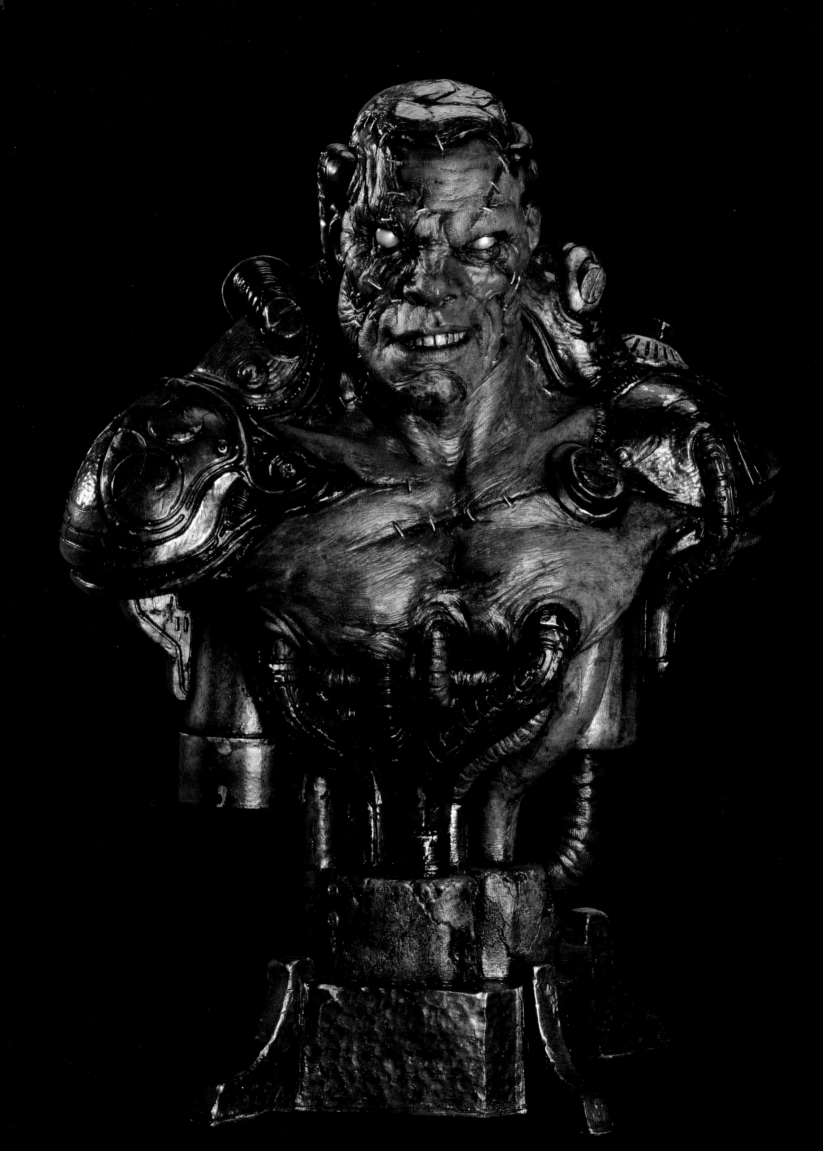

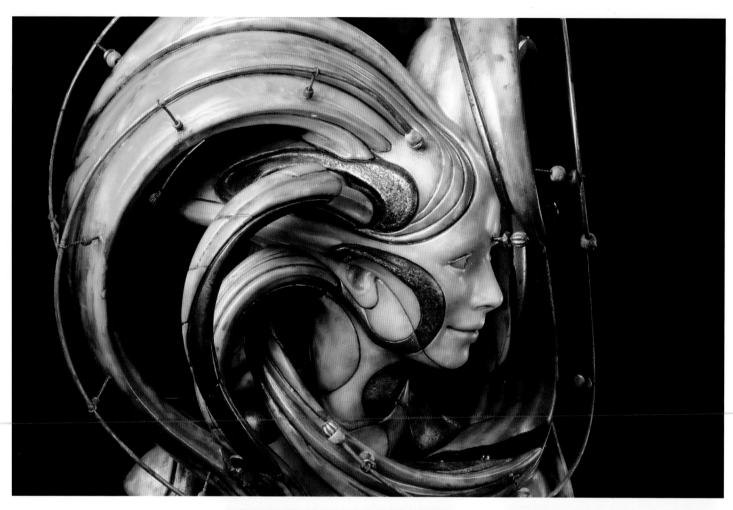

WIND MESSENGER

SIZE: H 26 INCHES (66CM) X W 15 INCHES
(38CM) X D 13 INCHES (33CM)

MEDIUM: MIXED

**The Best in Contemporary Fantastic Art 18
Dimensional Silver Award**

Have you ever had the sensation that the wind was whispering a word in your ear? Imagine if someone you love, who lives far away, dramatically died, and the breeze planted cold news of their passing upon your heart. In ancient times, people spoke of gusts that told them of their army's victories in battle. In Japan, they used to call this "Kaze no Tayori." It literally means "a message carried on the wind." The piece conjures up a beautiful wind spirit, a messenger of both delightful and dreadful knowledge. When the information is good, her pleasant smile punctuates the telling. When the news is sad, her loveliness heals the heart.

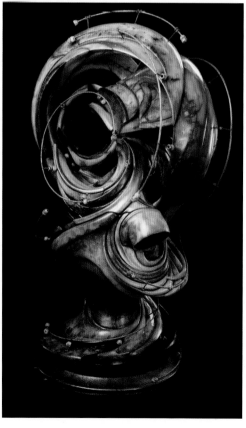

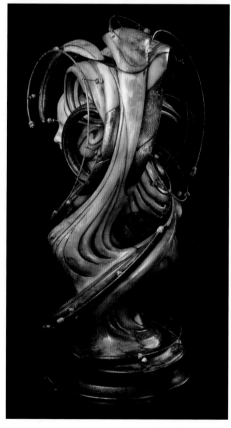

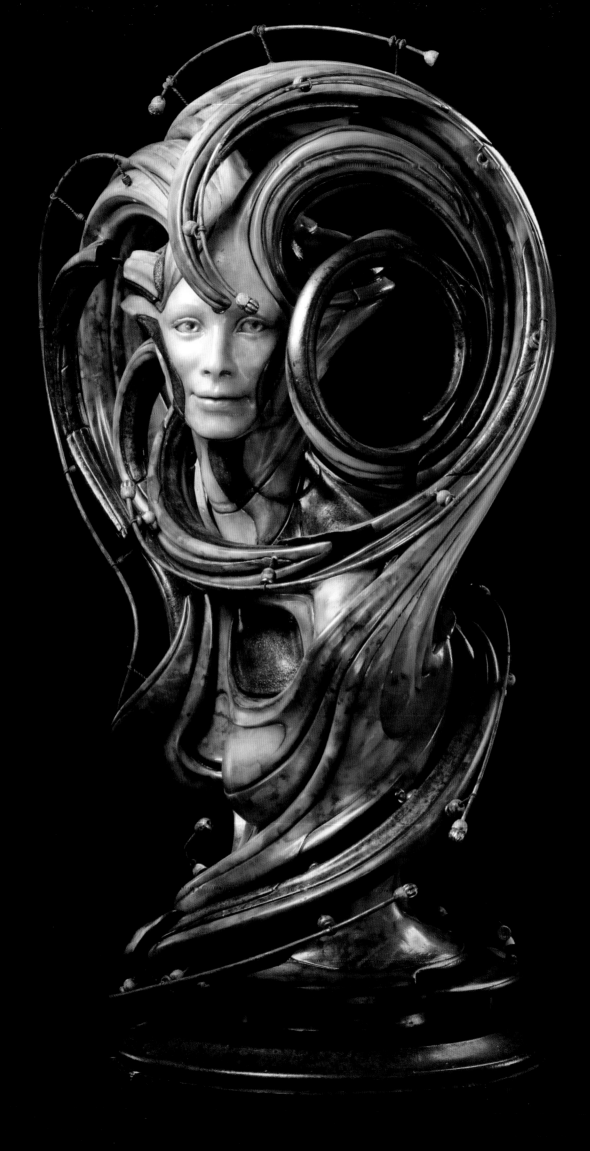

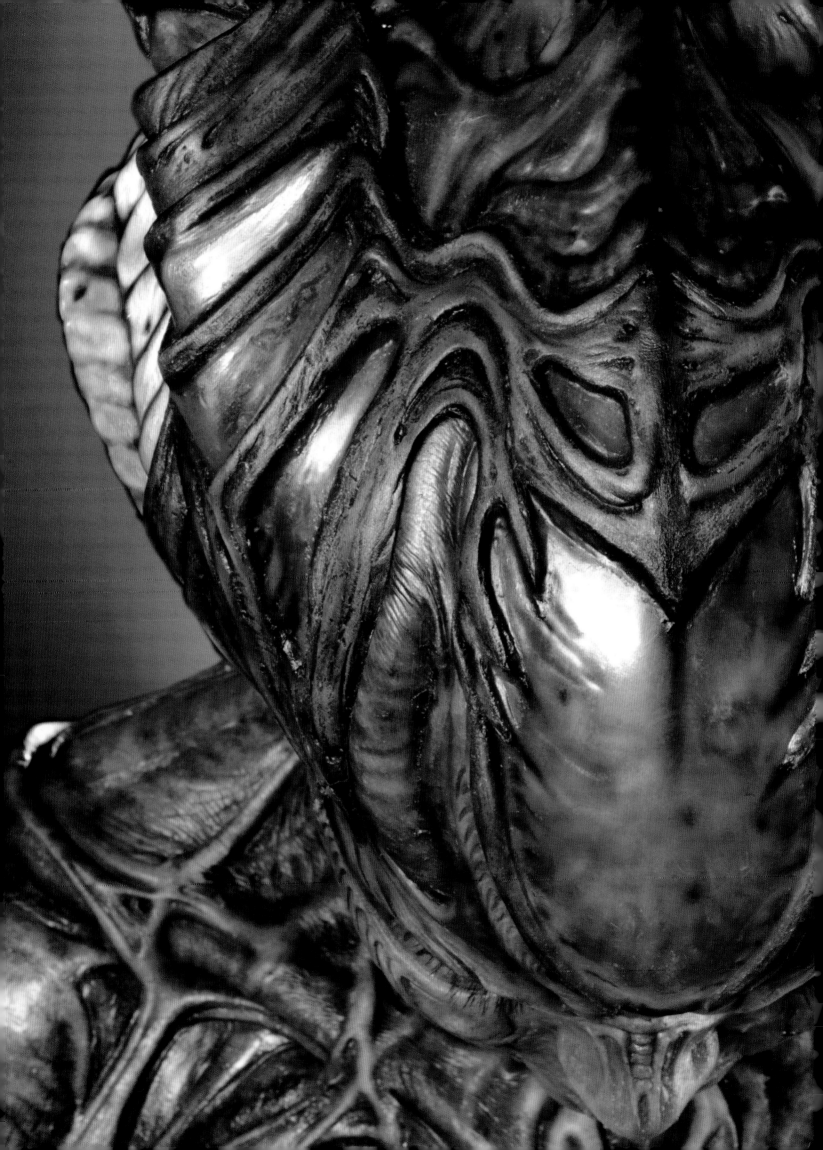

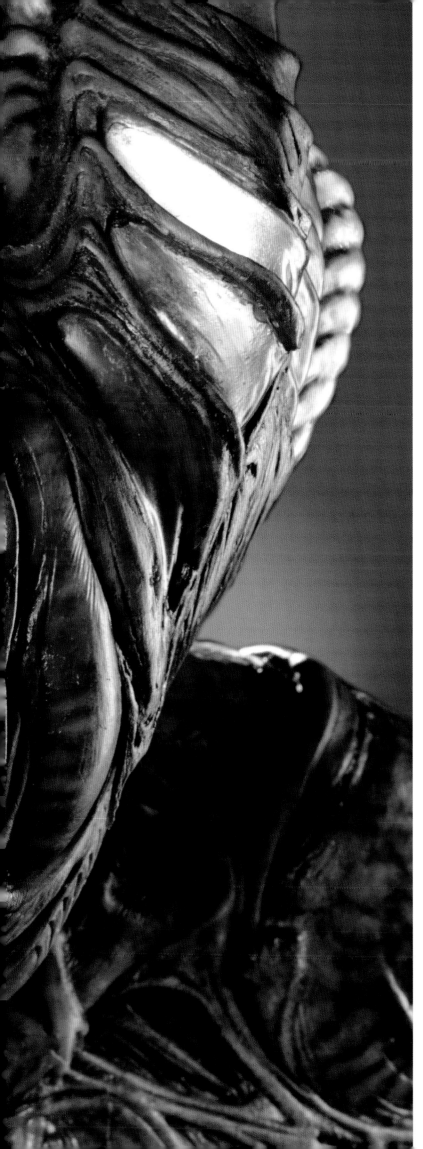

BIO-VERONICA CONCEPT

I created the Bio-Veronica makeup for a 1-week special-effects-makeup program in Hollywood. I also completed 2 other makeups, including a zombie and a Japanese Devil, for the Japanese book *A Complete Guide to Special-Effects Makeup 2: Zombie and Dark Fantasy*. My goal has always been for my work to elicit strong feelings, to inspire, or simply to amaze.

One of my favorite characters is Sil from the film franchise *Species*. I wanted to do a prosthetic makeup based on the concept rather than the mechanical translucent version that was used in the film. Steve Johnson made the original in 1995. My goal was to add my unique style to the character, bringing out more of its back story and approaching the character as I would in a film. This was a departure from my traditional work. It has more of a western flair as opposed to my Asian-influenced pieces. I chose this approach in order to achieve the dark fantasy aspects for the Japanese book this ended up in. Initially, the piece was to have more translucent aspects, reflecting the origins of the concept. However, as a result of constraints of both time and money, that goal could not be realized. In the end only the helmet was semi translucent.

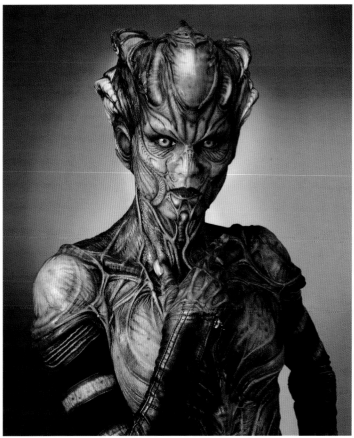

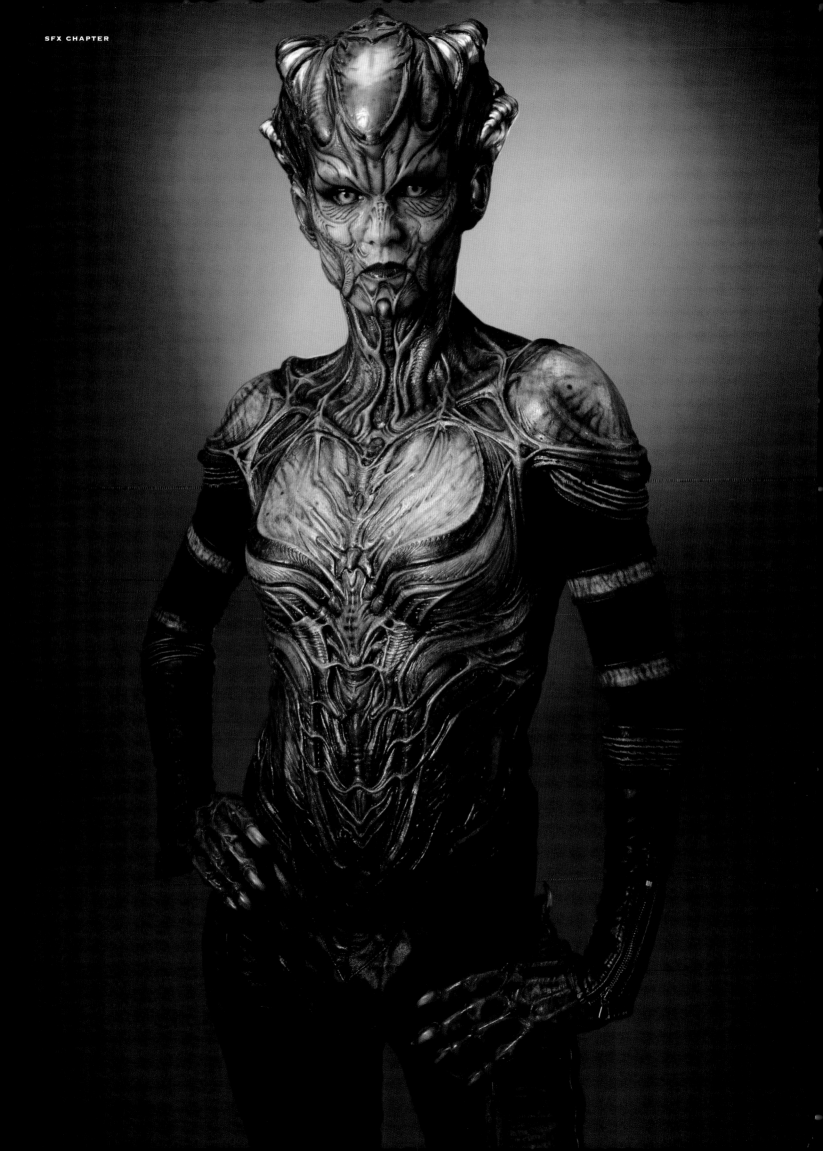

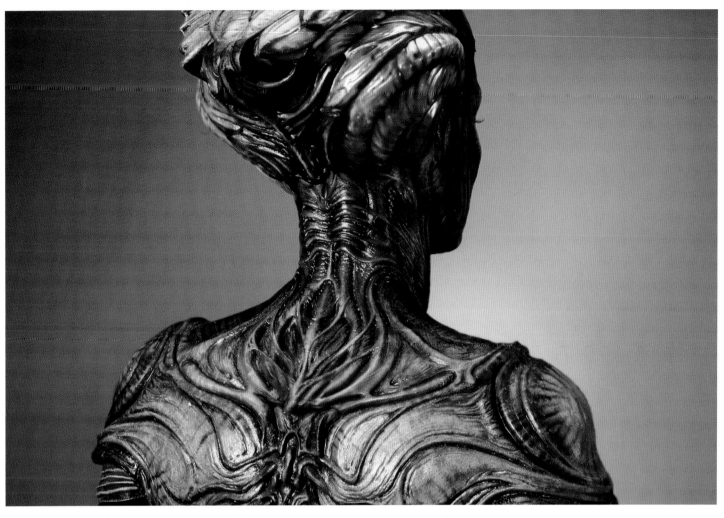

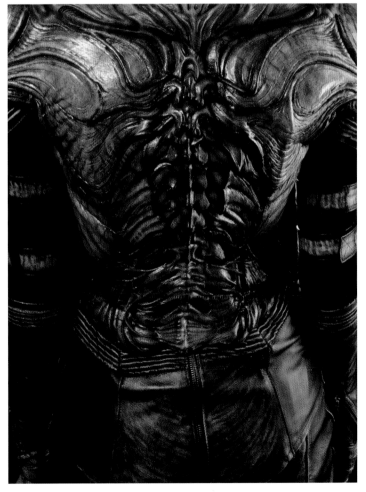

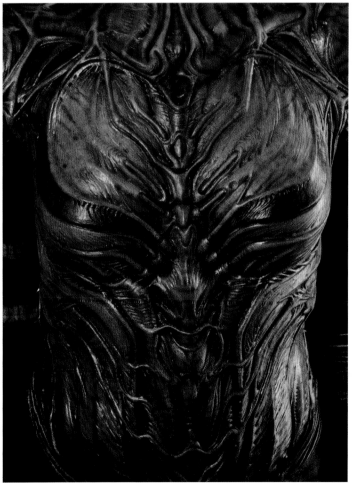

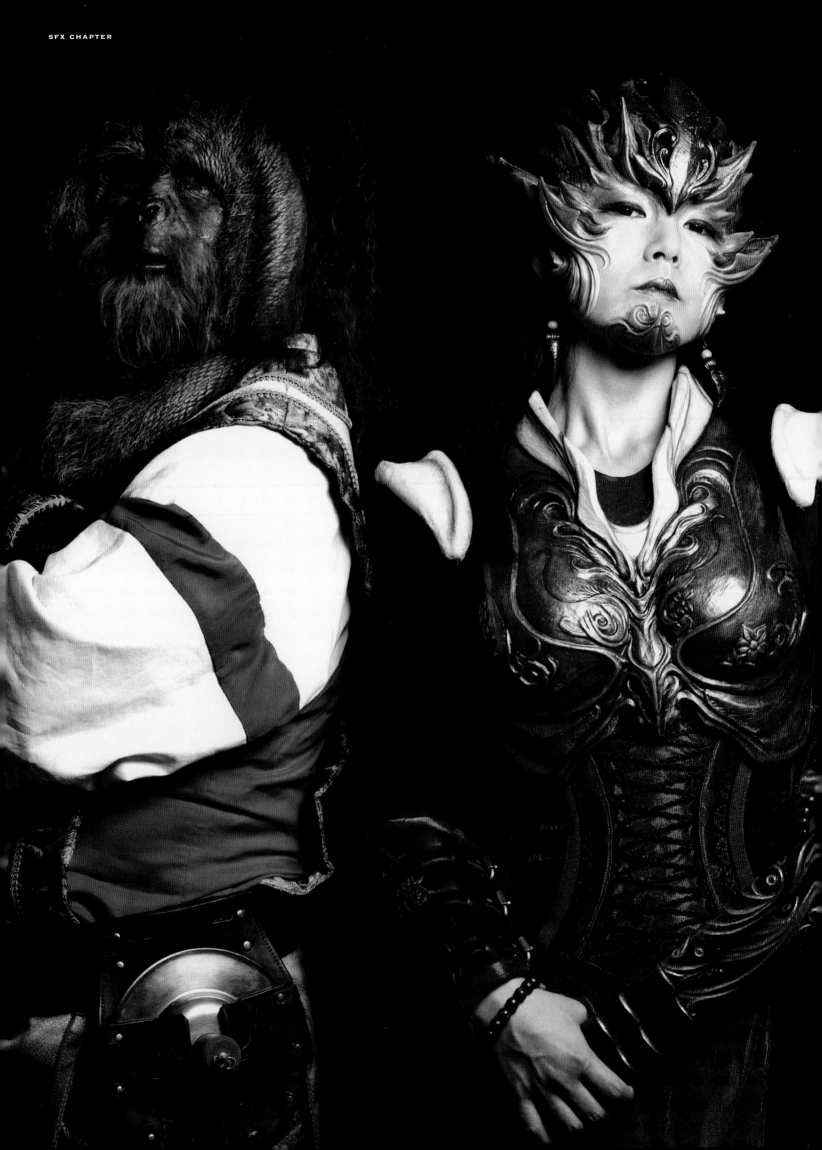

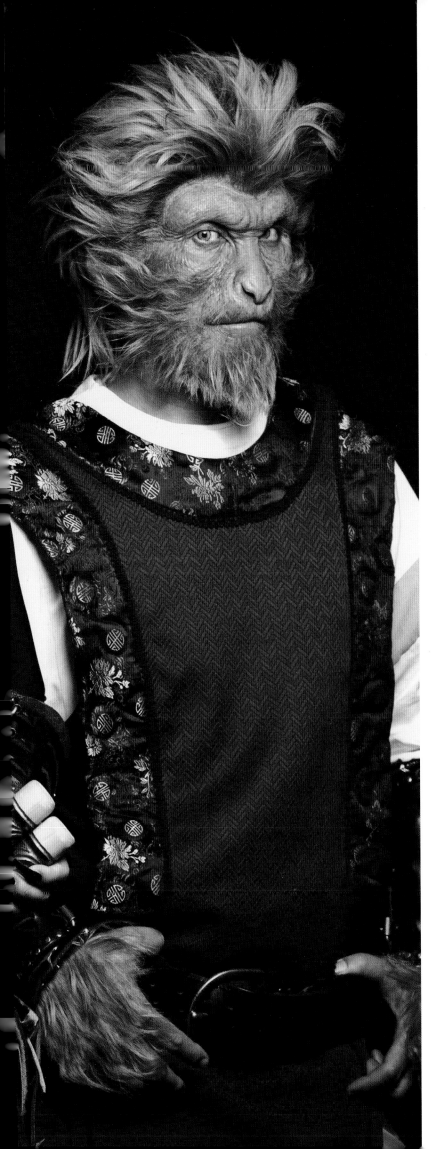

KOKURA GION DAIKO CONCEPT

I believe that special-effects makeup can add to any performance or demonstration. I realize that film is probably the best vehicle to utilize special-effects makeup; however, I do not wish to be limited by that notion. My desire to explore new avenues led me to performance art. This project brings together special-effects makeup and traditional Japanese music.

Taiko means "great drum" and has come to describe an ancient type of traditional performance drumming. Kumi-daiko is a new adaptation of this art form that brings in the notion of an ensemble. The taiko, koto (a Japanese flat harp played on one's lap), and samisen (a 3-stringed instrument similar to a long banjo) epitomize Japan and its customs. Taiko seemed to mesh better than the others with my design style.

Japan has many teams that compete in different styles of taiko, similar to karate competitions. In September 2008 Fukuoka Kenjinkai, an organization that represents people from Japan's Fukuoka prefecture, contacted me to give a lecture on special-effects makeup for their 100th anniversary celebration. The president of the organization introduced me to a gentleman named Mr. Eiji Shisido, who is the leader of the Kogenkai Taiko club. We agreed to collaborate on this project.

The particular taiko that team Kogenkai performs is called Kokura Gion Daiko. It is a very traditional style that has over 400 years of history. Kokura Gion Daiko incorporates small cymbals that make wonderful sounds from both sides of the taiko. The idea was to use special-effects makeup for a large annual taiko festival in Japan. After watching their performance and taking note of their playing methods, I decided to make 2 simian characters for the men and one of my distinct female designs for the woman on the team. Kokura Gion Daiko has been known to send monkeys into a frenzy of wild dancing, and those visions spawned my concepts for the 2 male characters.

Overall, this project took 7 months to finish. I financed the project myself while exhaustively working on it and sleeping an average of 4 to 5 hours a night. I hope one day to perform this show in Las Vegas.

Special Thanks

I would like to thank everyone who helped make this project a success. I worked little by little on this project for 1 to 2 hours every day after work at KNB Effects Group Inc., where I was a sculptor, ZBrush artist, and designer. A glutton for punishment, I got very little sleep during this period as I attempted to juggle my work, my art, my family, and my sanity. Sadly, I fell sick soon after we completed the project. But this assignment had many memorable moments. I was pleased with the results and I felt a great sense of achievement when it was complete. I would never have been able to finish this project without the numerous contributions of KNB Effects Group Inc., including the use of their space for the photo shoot. Kathy Sully once again made herself indispensible, as did my assistant, Yusuke. Finally, I would like to thank all of my volunteers.

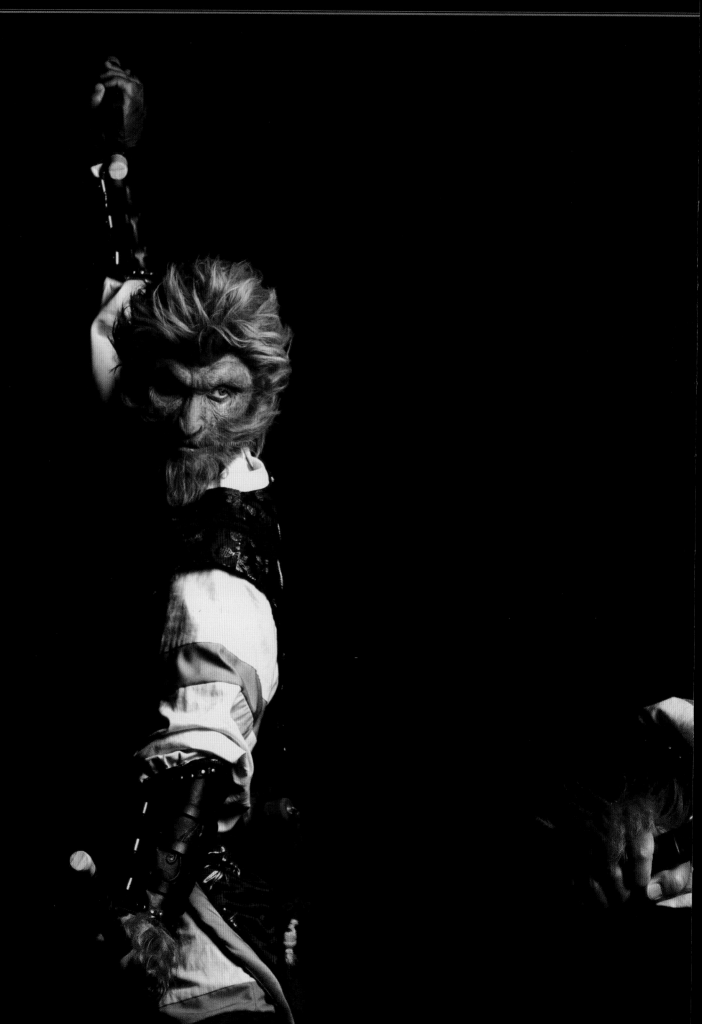

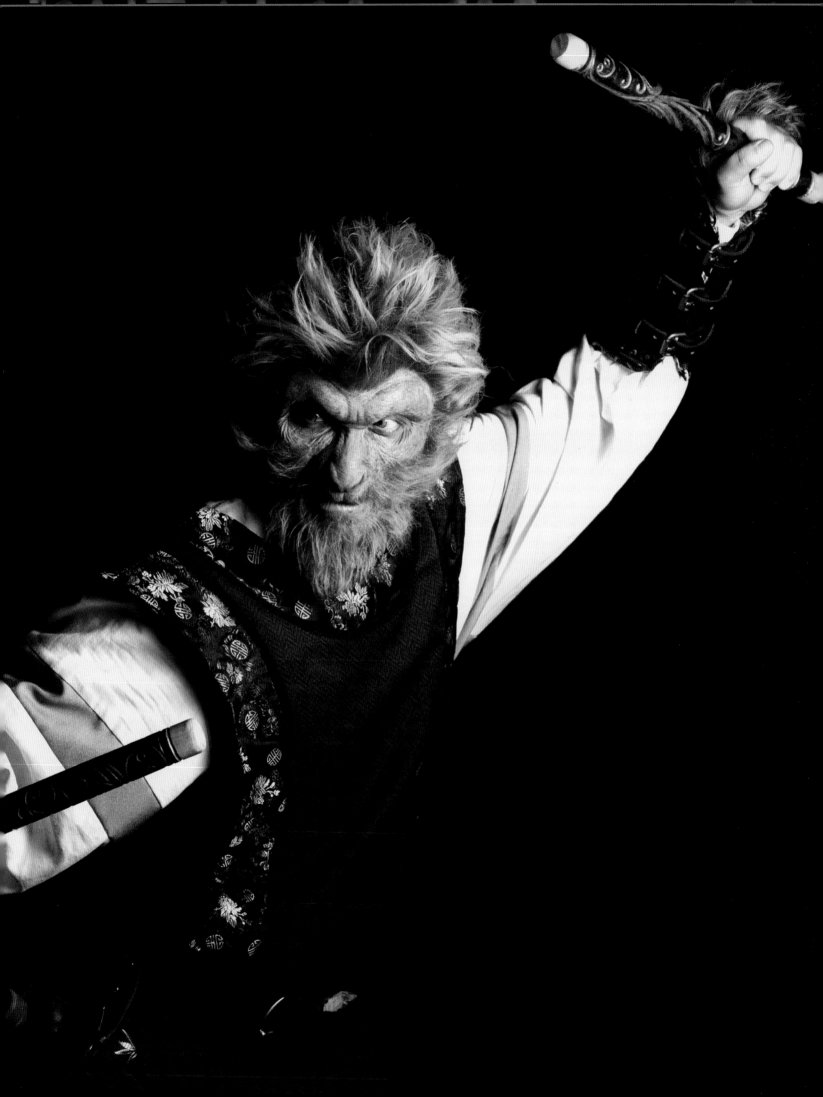

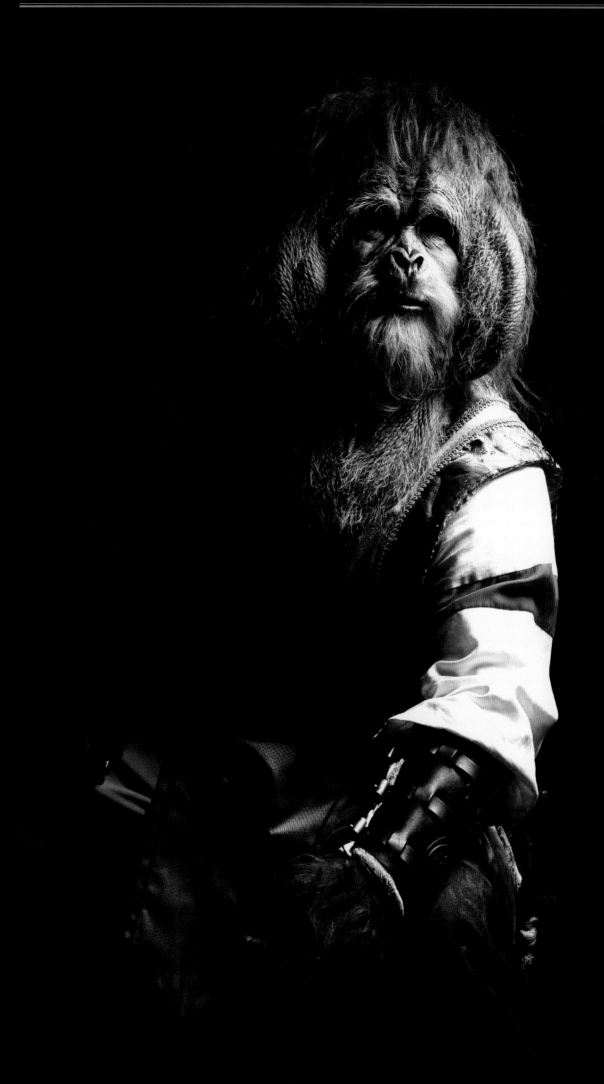

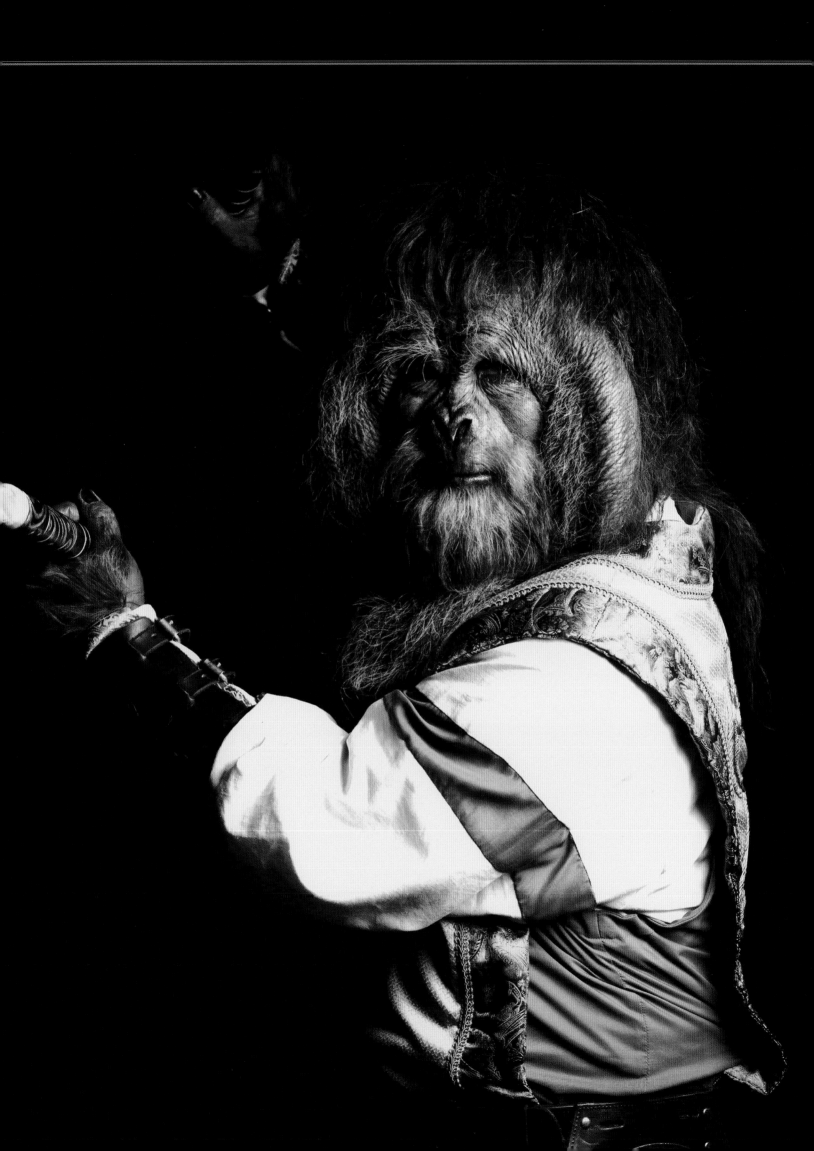

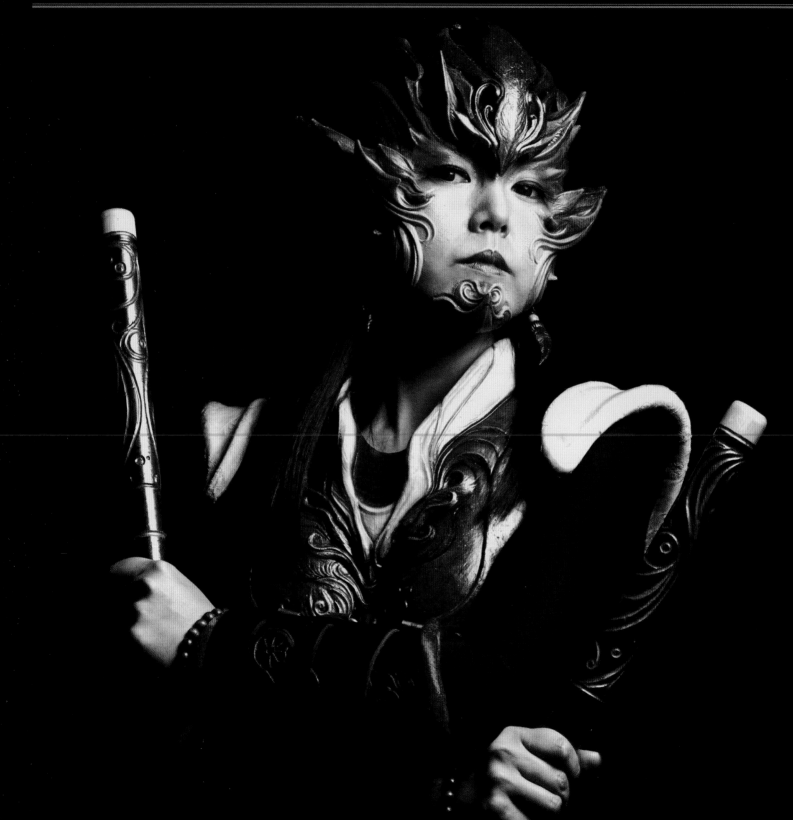

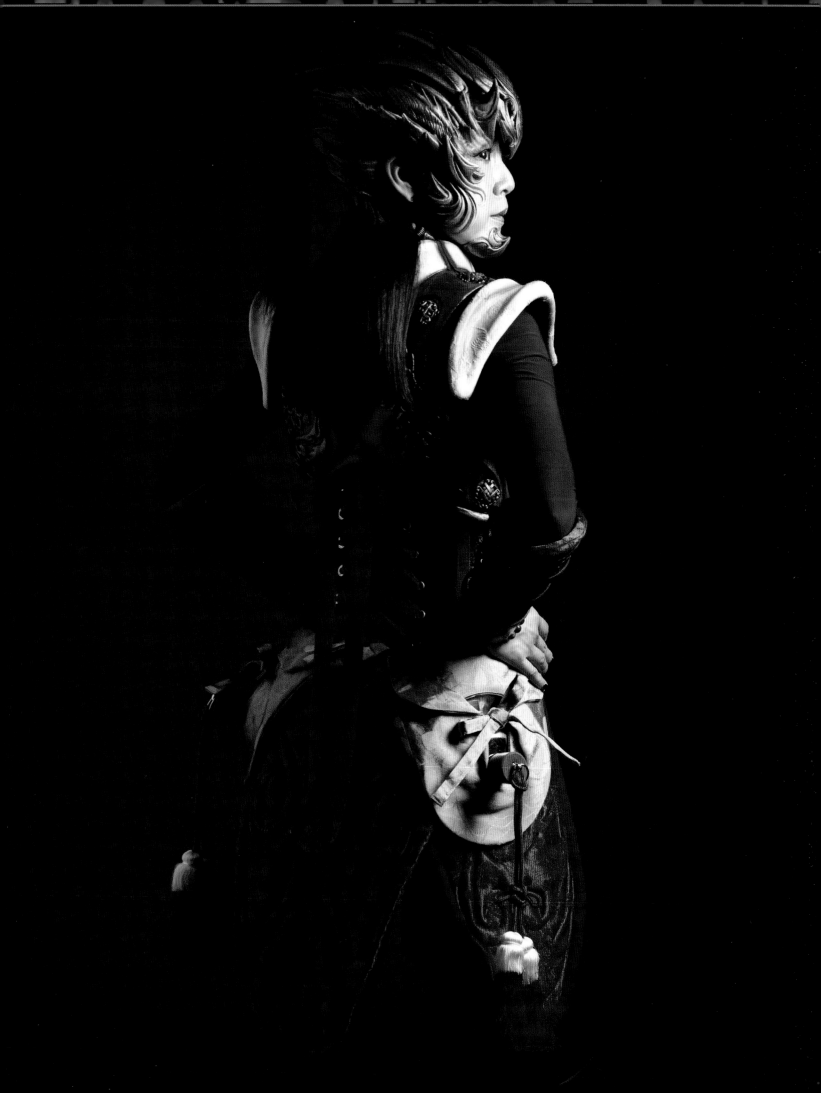

FU-BI CONCEPT

These makeup concepts were created for the book *A Complete Guide to Special-Effects Makeup* which was published in November 2006. The editor assigned a theme to the contributing artists. We were to all incorporate something we felt was iconically Japanese. My idea incorporated the use of Pros-Aide transfers, which, at one time, few people used. When I was introduced to Pros-Aide transfers, they blew my mind. They were extremely easy to use; they cut application time down; and they were translucent. These appliances gave me the idea to create 3-dimensional appliances like temporary tattoos. The concept lent itself especially well because it emulated traditional Japanese lacquered-tray artistry. Together, the concept accomplished my goal: to demonstrate a unity of the two spirits and their love story.

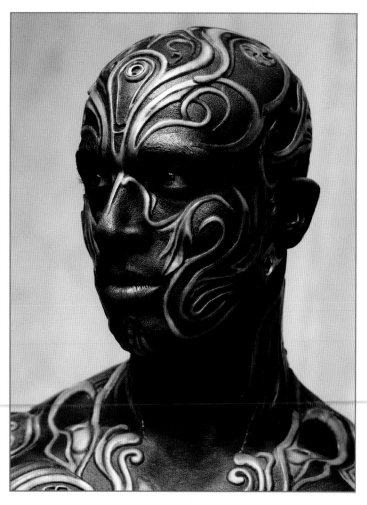

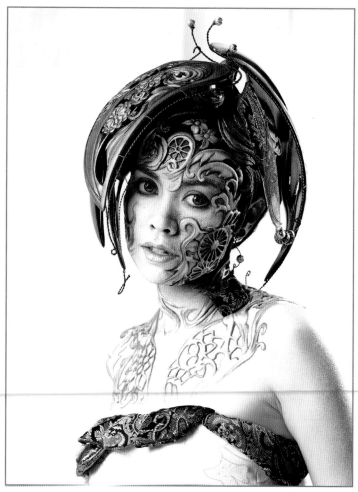

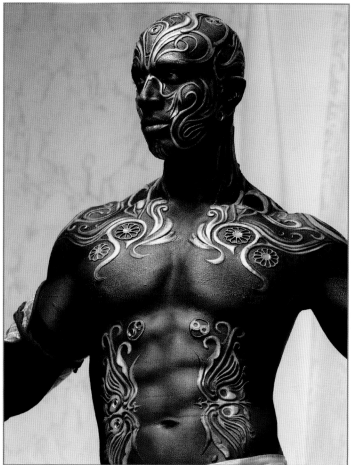

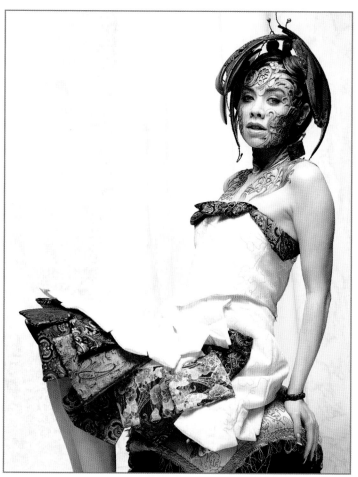

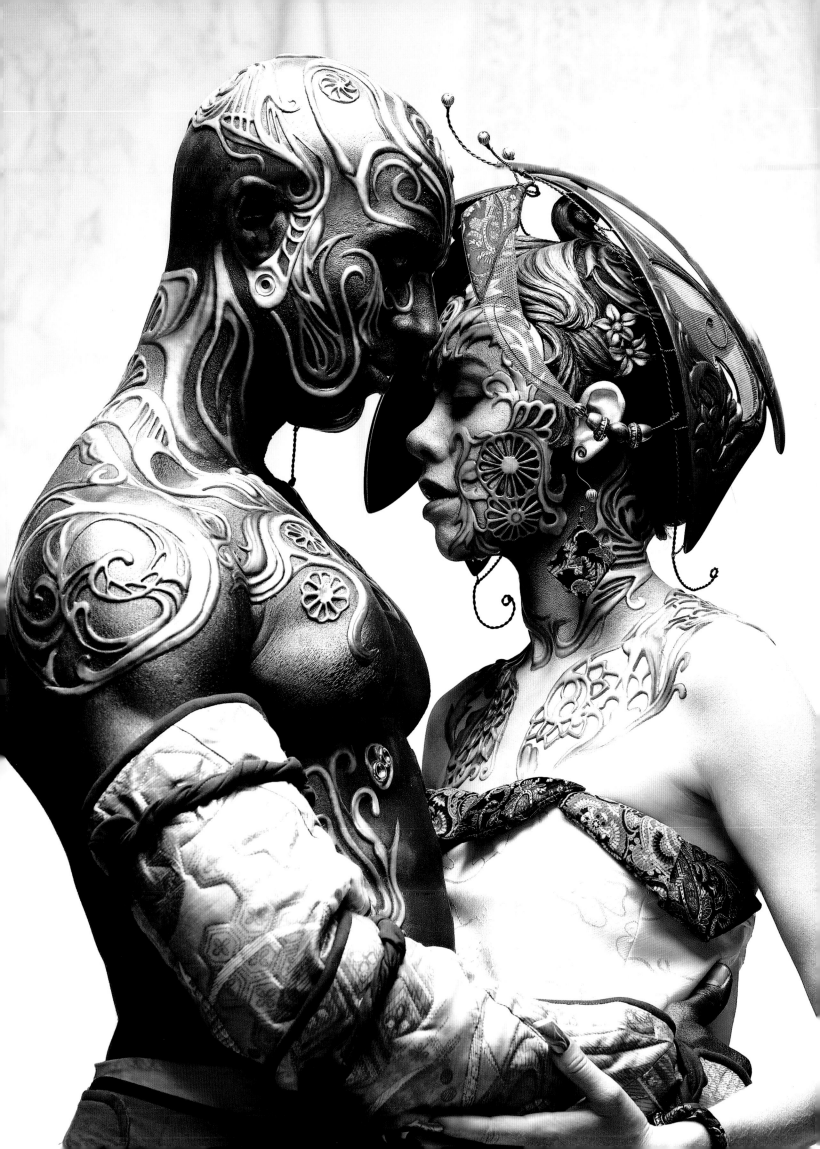

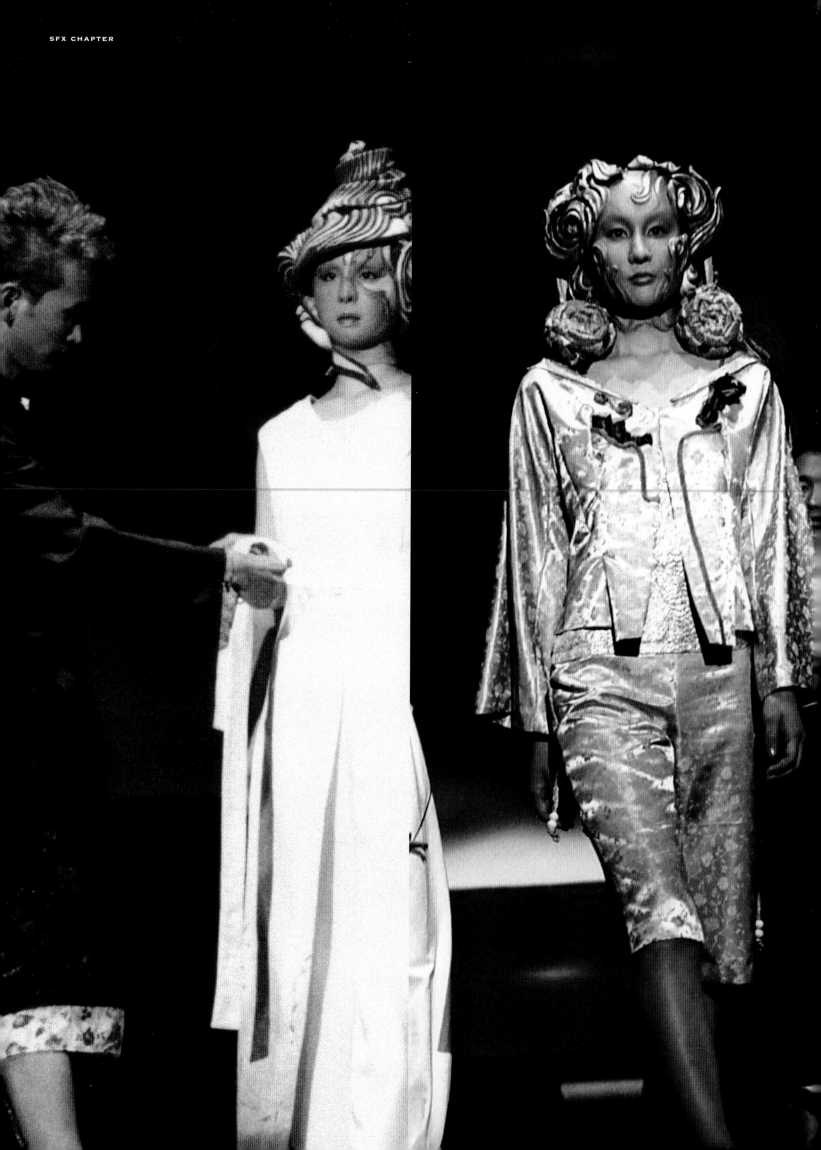

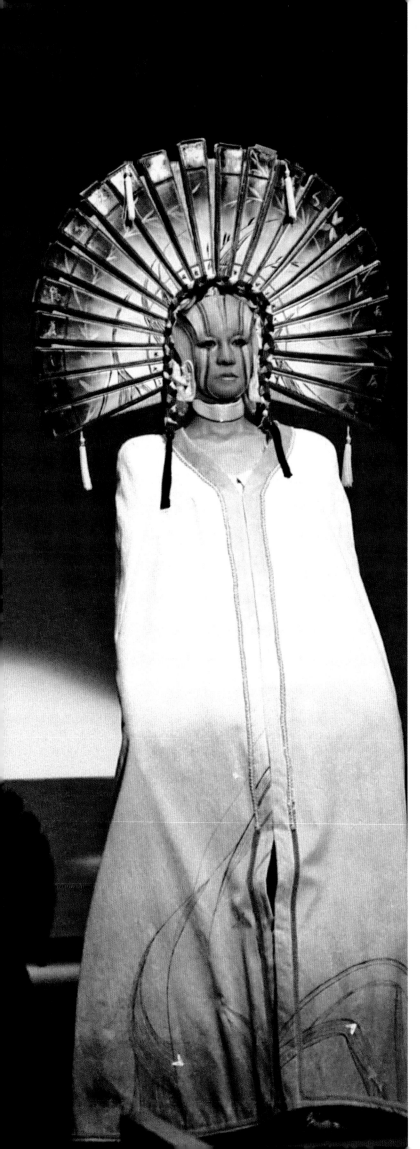

RUNWAY SHOW CONCEPT

I produced the very first special-effects runway show in the world—a difficult task. Held at the Garden Hall in Yebisu Garden Place in Tokyo in 2001, it was orchestrated like a fashion show. The concept of the show was "Color Expression," and the theme was "4 Seasons." Prosthetics were applied to the models to represent each season. The designs focused on Asian culture and style.

I changed their makeup and costumes, and did all touch-ups on stage. It was a fantastic and fascinating night full of sounds, illumination, and imagery.

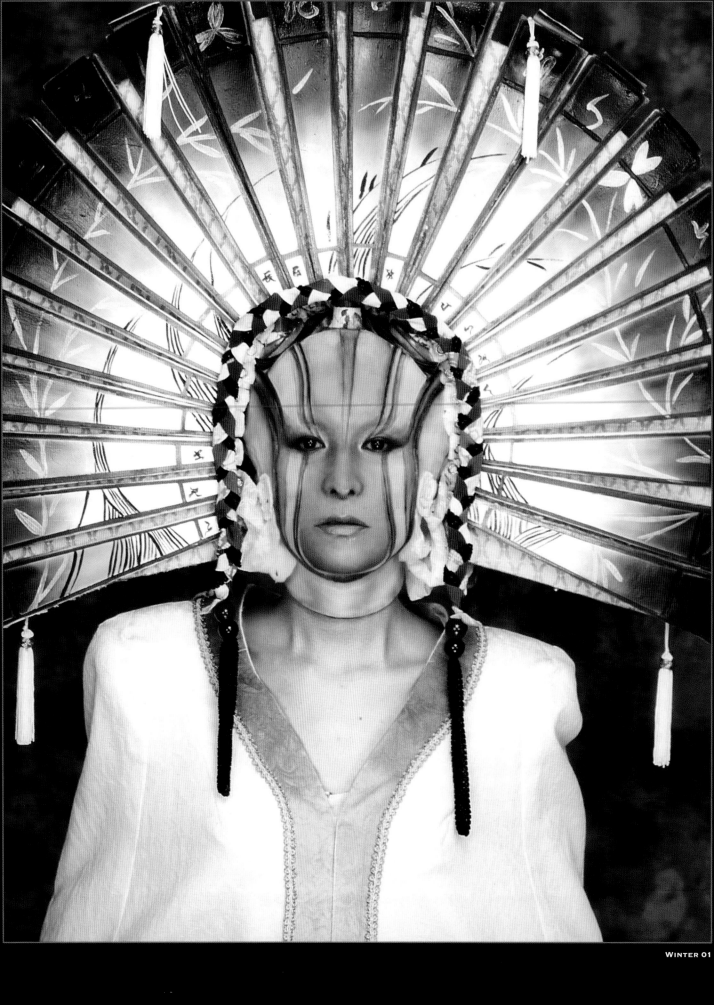

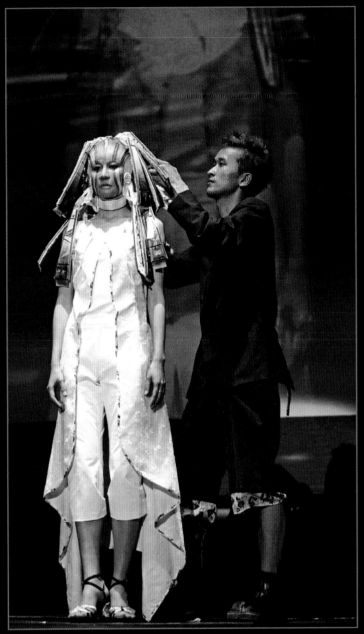

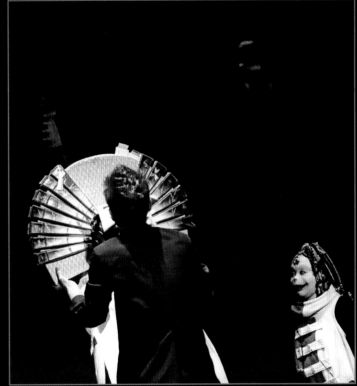

WINTER

This character is like a snow crystal. I used blue and white to make it feel cold. I changed Winter's makeup and costume quickly on stage.

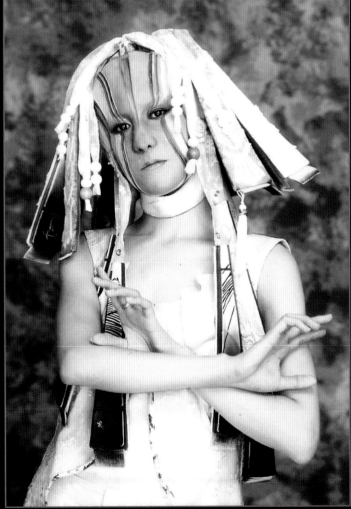

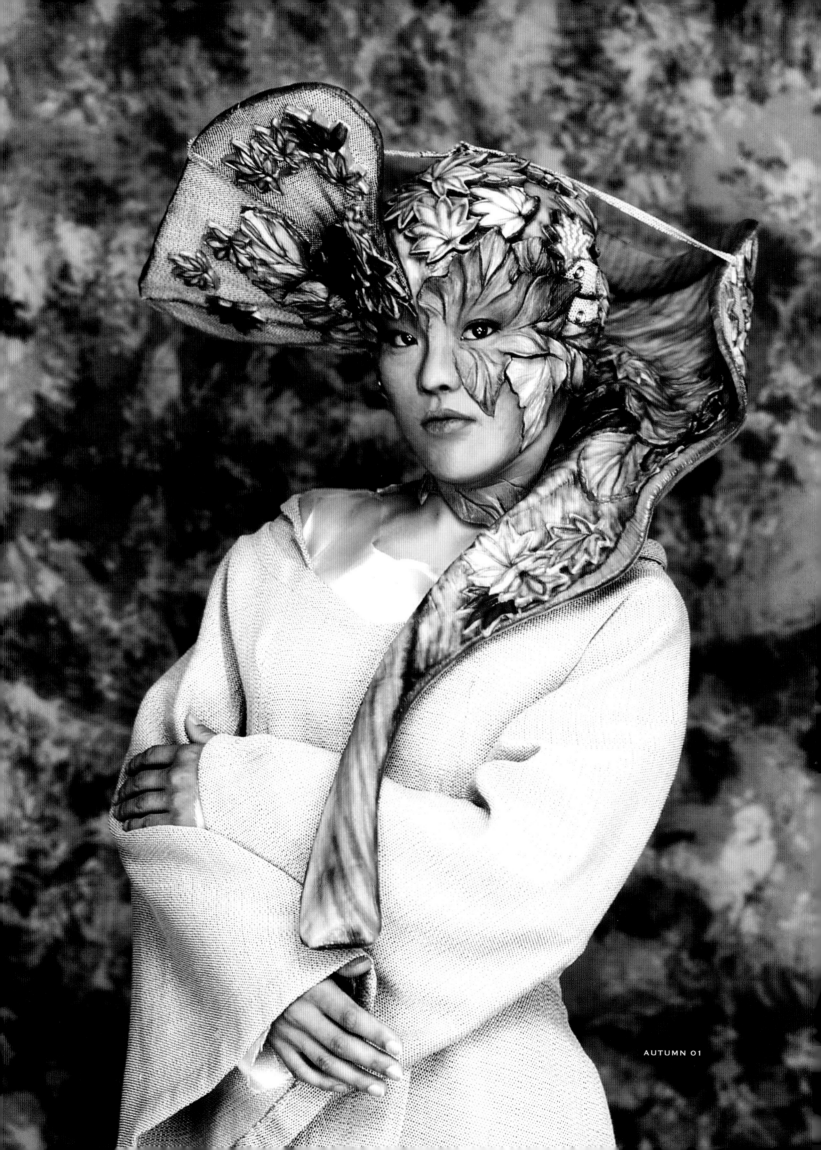

AUTUMN 01

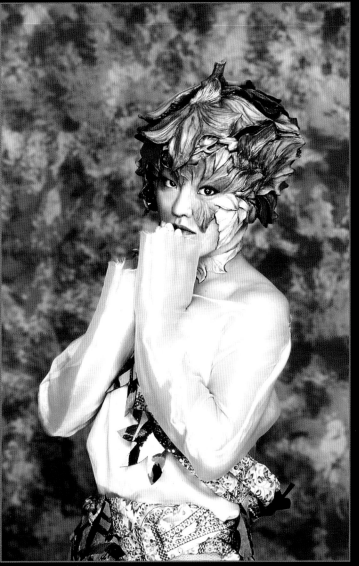

AUTUMN 03

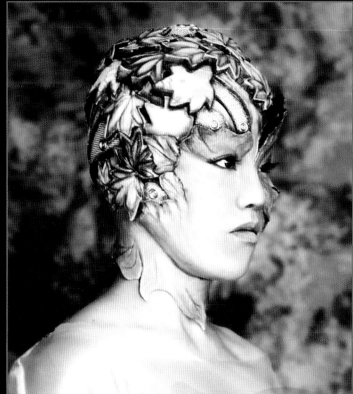

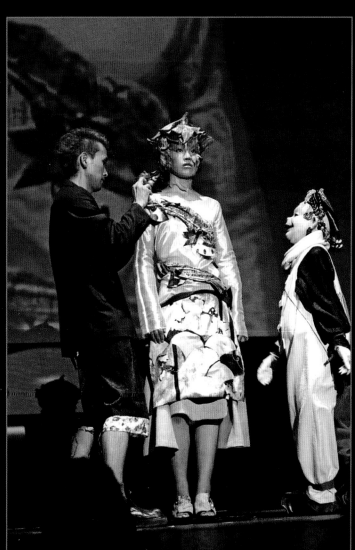

AUTUMN

AUTUMN 01 & 02: These characters represent the season's changing leaves turning red and yellow. I used warm colors—orange and yellow, yellow-green, brown, and white—to make them look and feel like autumn.

AUTUMN 03: This character represents the season's changing leaves falling down.

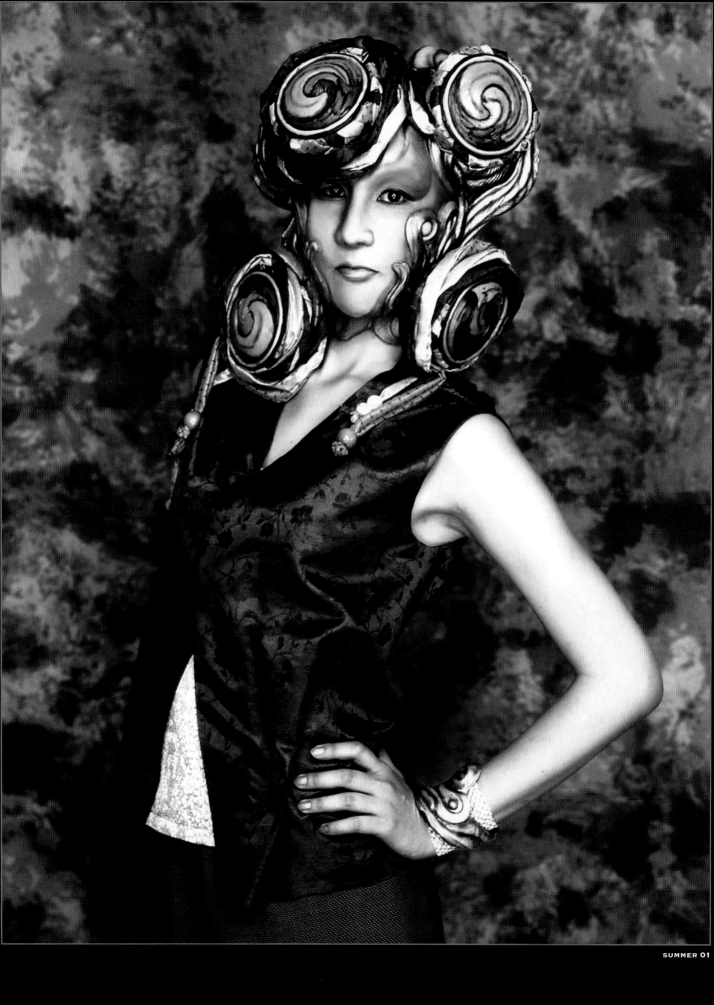

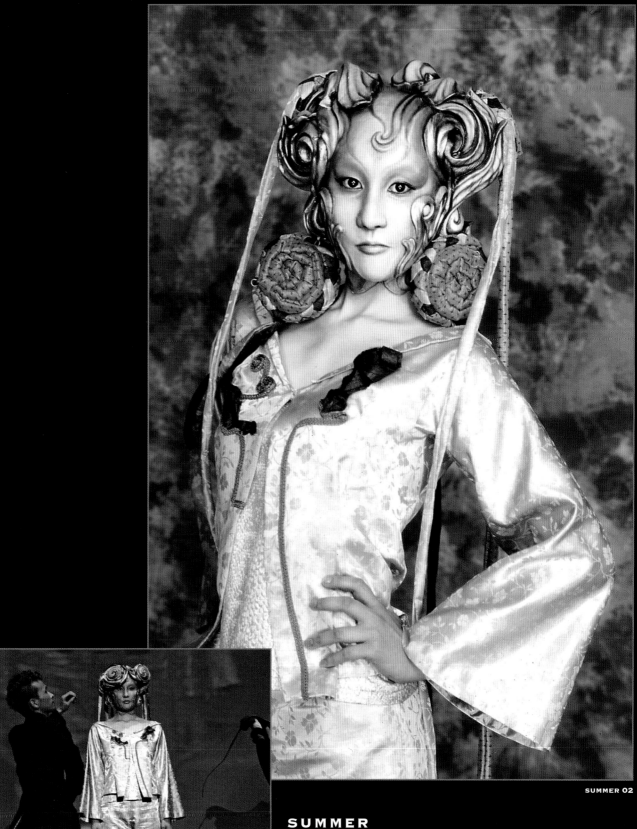

SUMMER 02

SUMMER

This character is like a deep green in the shade of a tree. I used base colors of dark green and gold to give it a warm summer feel. I changed Summer's makeup and costume quickly on stage. Look at the differences between Summer 01 and Summer 02.

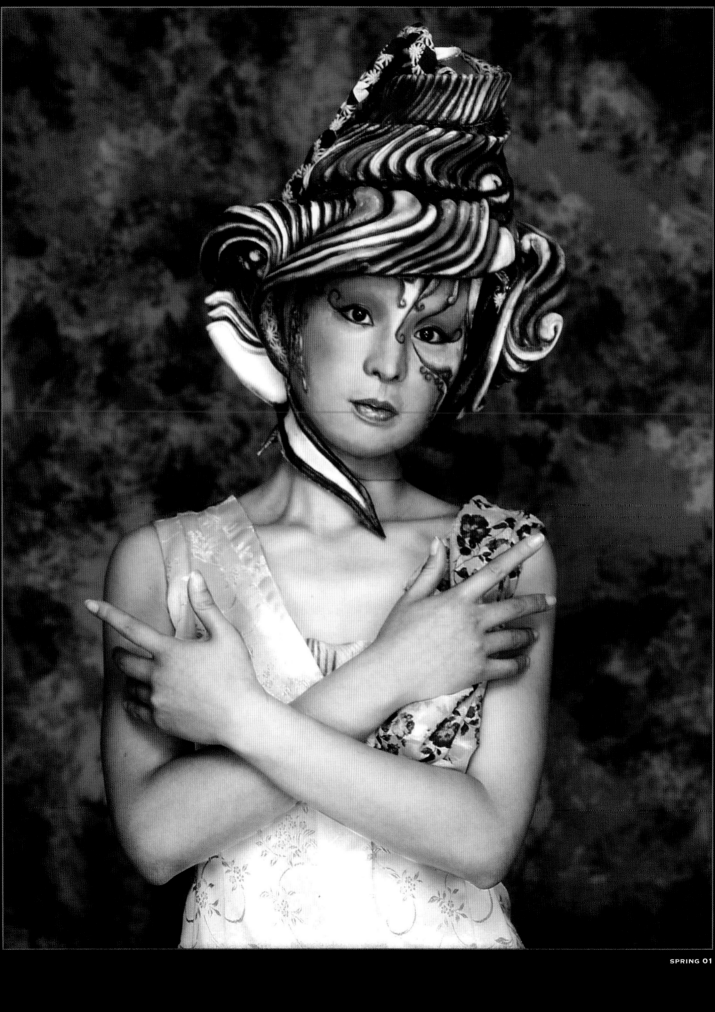

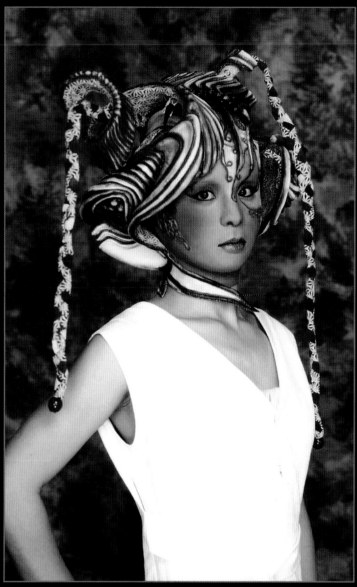

SPRING 02

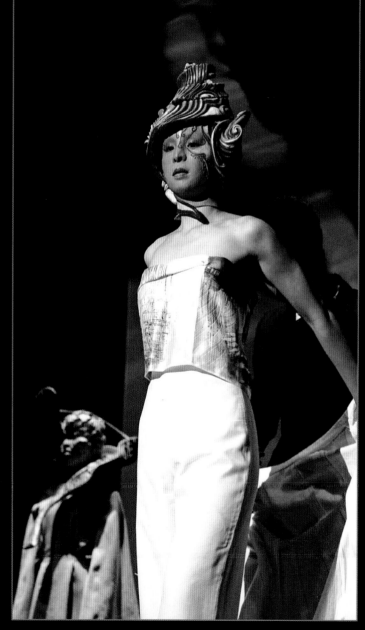

SPRING

SPRING 01: This character is like cherry blossoms; the head shape resembles the Asian-style Buddha. I used base colors of pink and purple to give it a spring feeling.

SPRING 02: I changed Spring's makeup and costume quickly on stage. Take a look at the differences before and after the transformation.

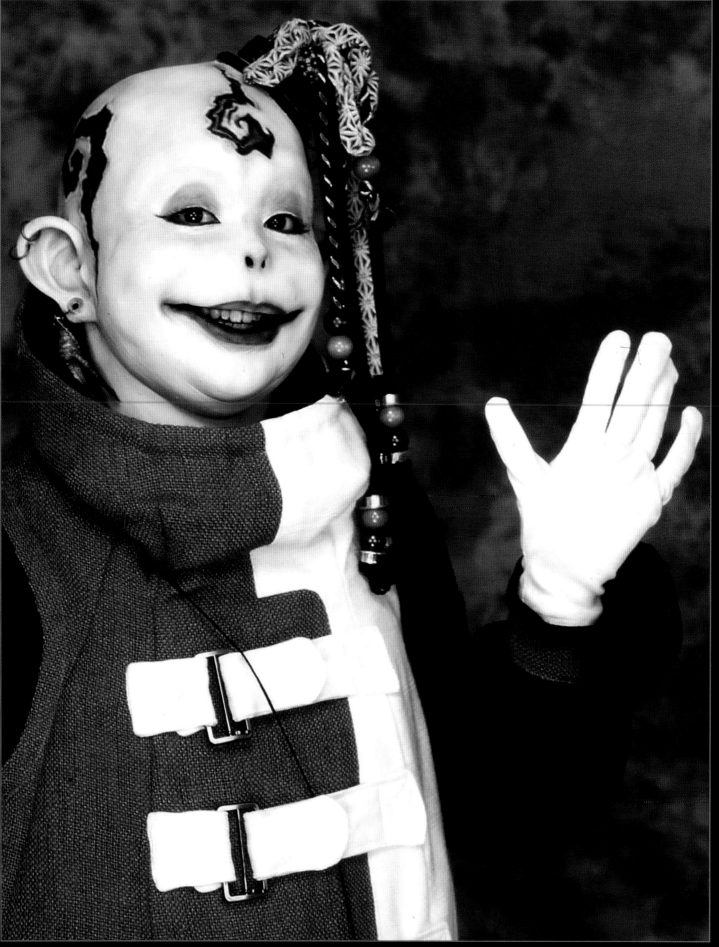

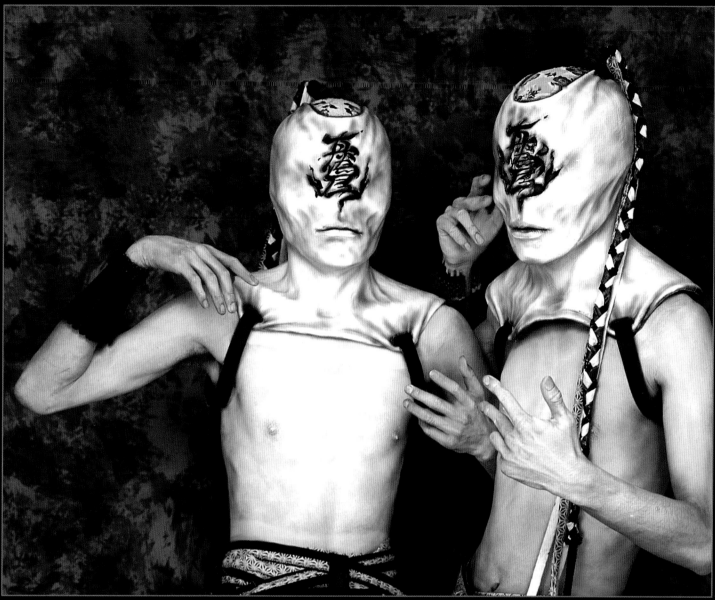

SOLDIERS

CLOWN AND SOLDIERS

CLOWN: This character is like a weird clown in a straitjacket, with Asian influences. This is a very strange image for American people, but a very cute one for Japanese people. In Japanese culture clowns are childlike, innocent, and fantastic. Contrasting greatly, American clowns have evolved into characters that play upon peoples' fears. Light colors make it a charming image.

SOLDIERS: These characters would likely frighten people away because they look like a bizarre entourage of some Asian nature. They look like they could be friendly bodyguards of the small clown.

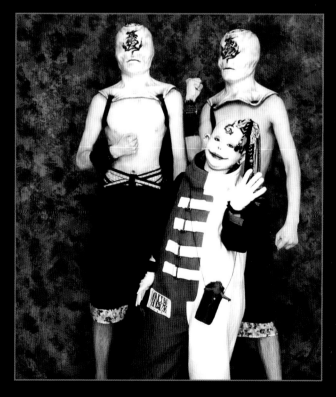

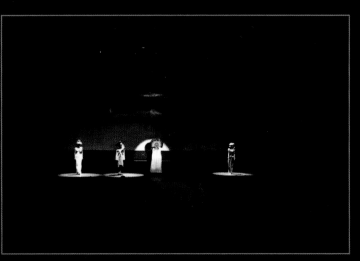
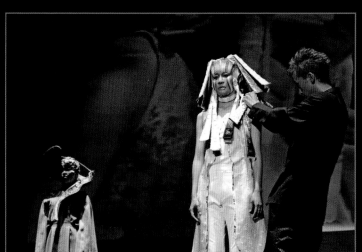
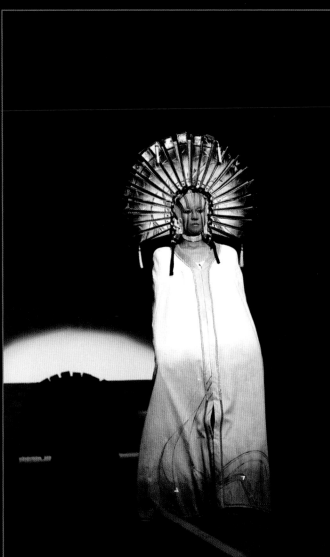
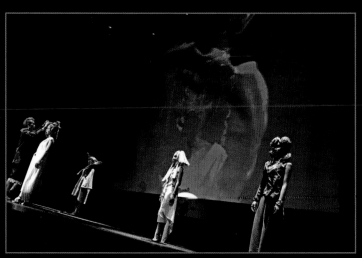
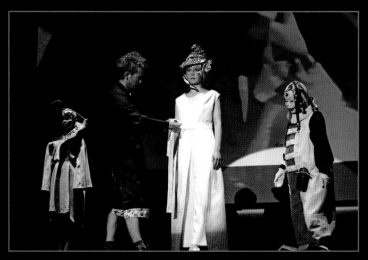

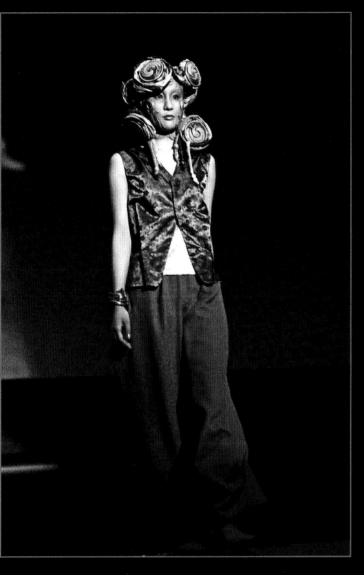
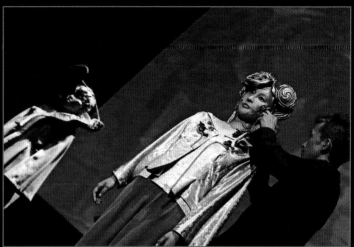
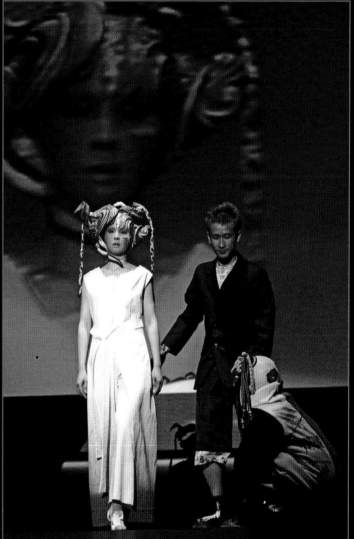

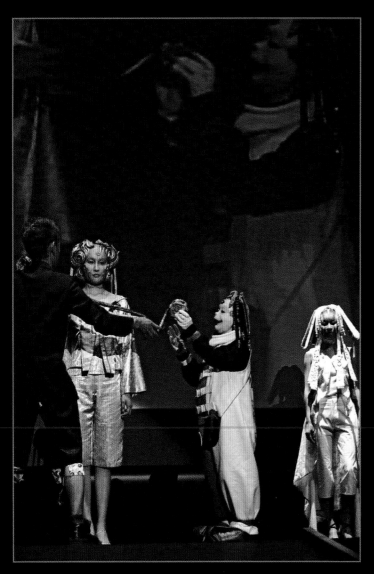
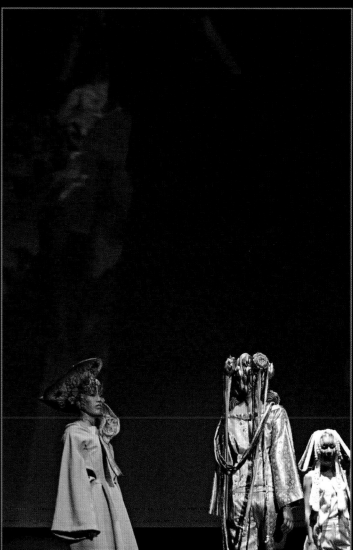

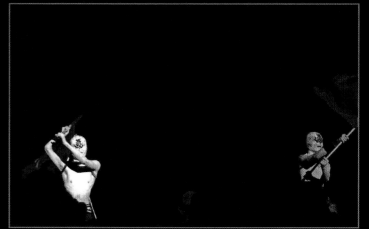

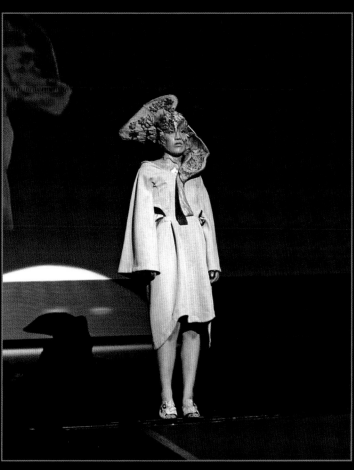
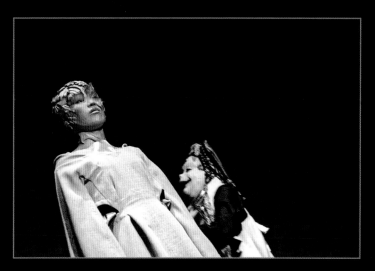

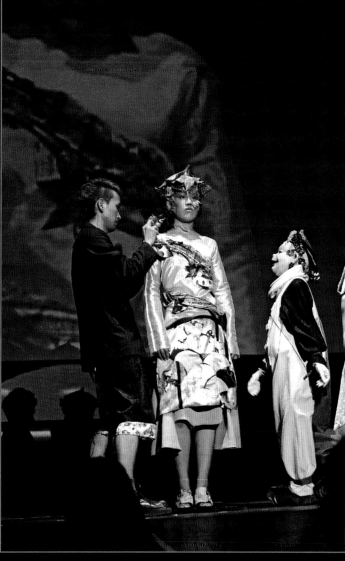

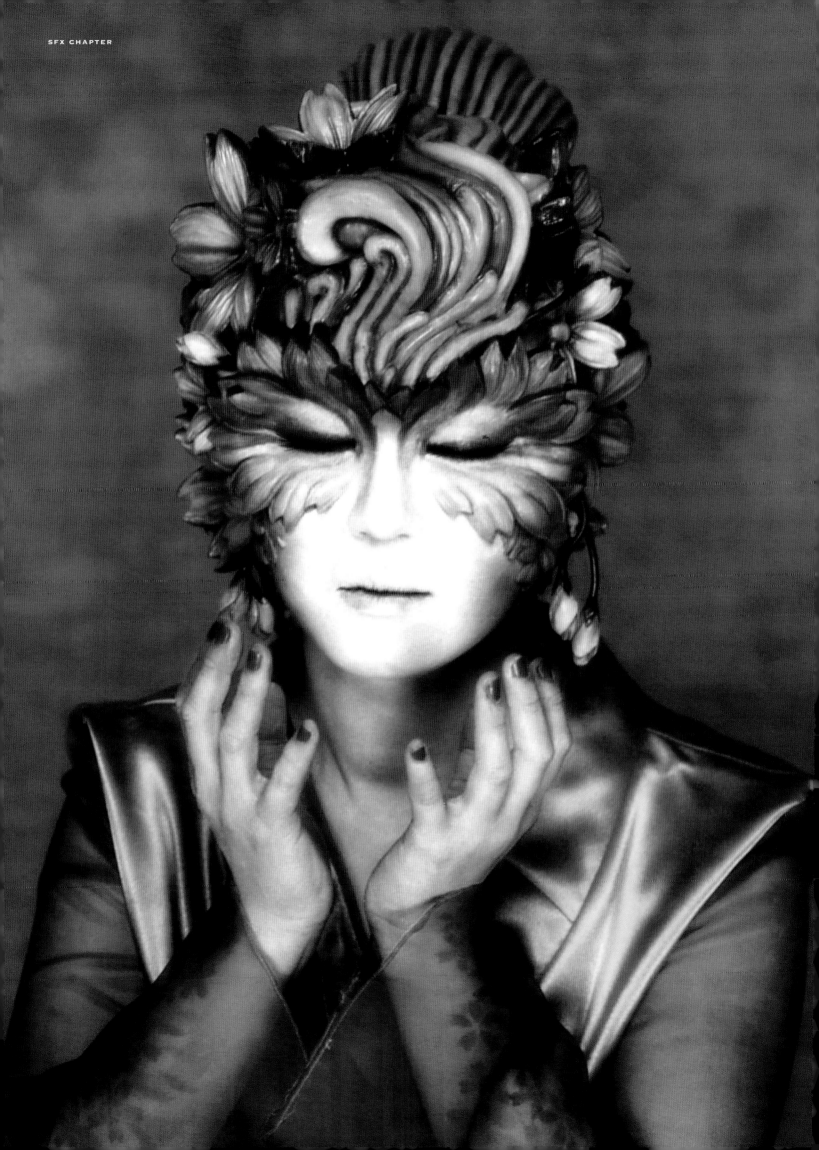

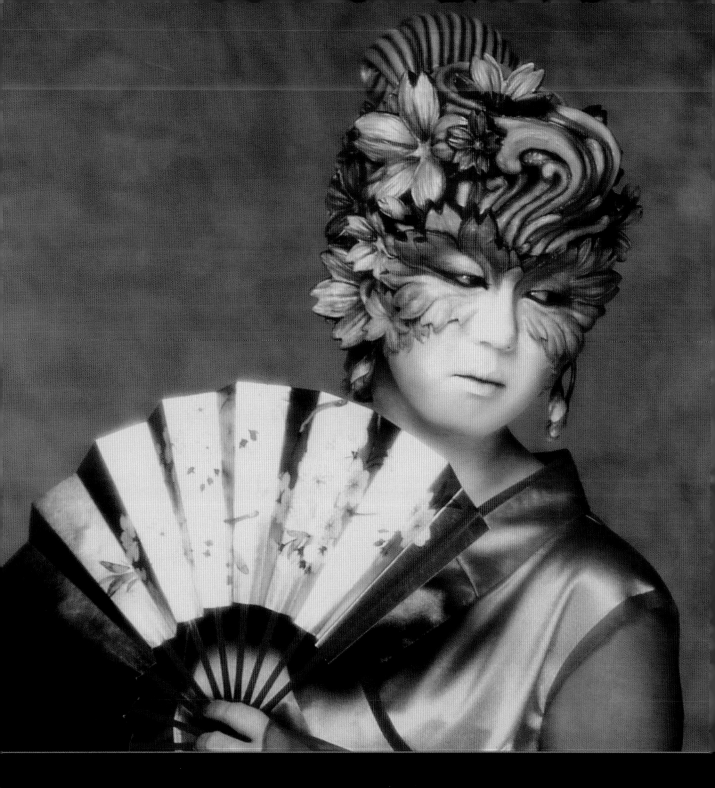

CHERRY BLOSSOMS

won 1st prize in the avant-garde-makeup category at the International Makeup Artist Trade Show (IMATS) in California in 1999. The competition was sponsored by Max Factor and, along with a trade show, is an annual event. Both the makeup (Cherry Blossom Geisha Girl) and the kimono were my original designs.

Known simply as "The Show" to the makeup world, IMATS is the largest trade show o its kind. It is most certainly the highlight of the makeup industry. It is held every yea in Los Angeles, New York, London, Sydney, and Toronto. Several thousand makeup artists from across the globe convene at the Pasadena Convention Center to ex-

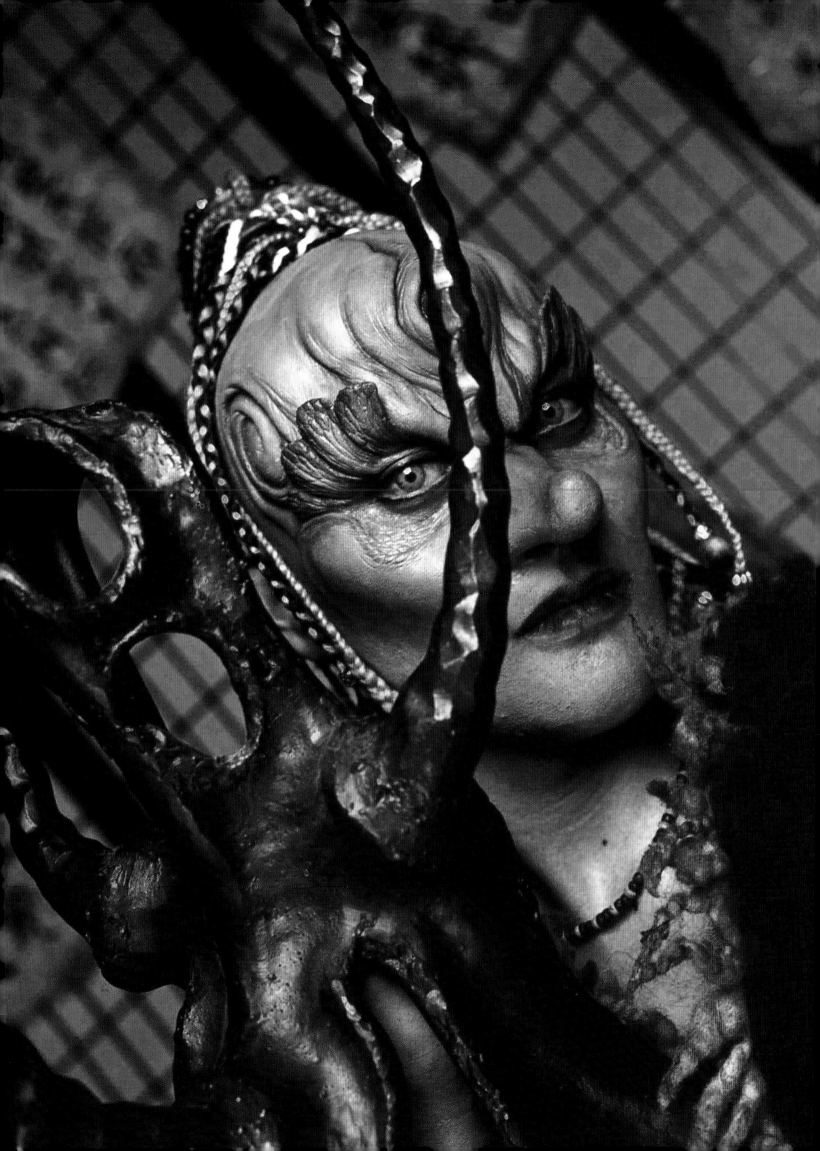

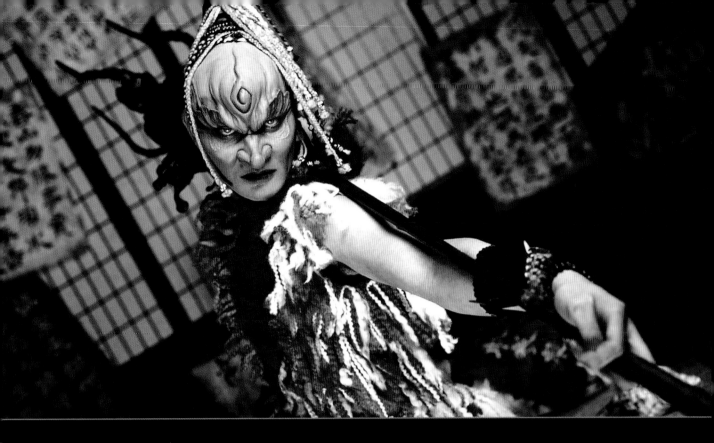

TENGU

designed and created the makeup and costumes for the largest annual art festival in Japan, Design Festa 2000. This makeup was on the flyer that promoted the event. Over 7,000 artists from all over the world attend the festival to express their creativity and talent. It quickly turns into a wonderful artistic chaos. There are individual booths, miniature and impromptu theaters, and huge food areas. Anyone can exhibit regardless of age, nationality, gender, or genre. The only criterion is that the artist displays original work.

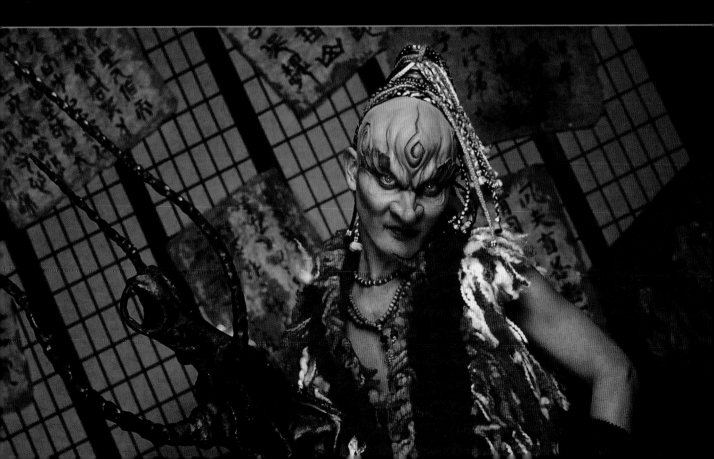

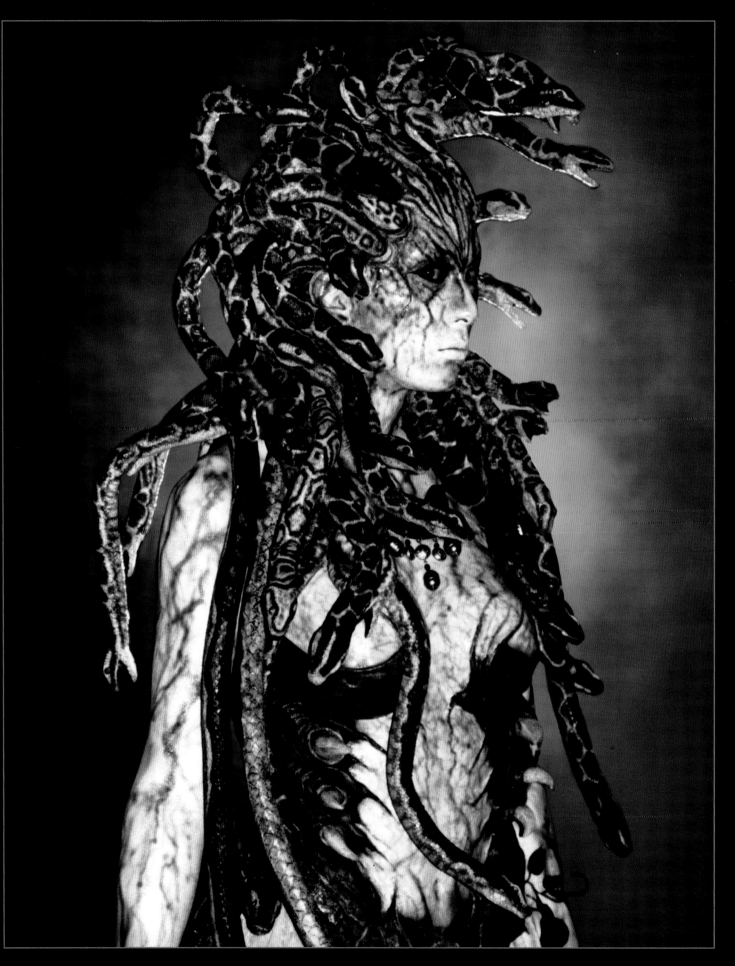

SUPER MODEL MEDUSA

Special-Effects Makeup King Competition 2nd 1st-Place Winner

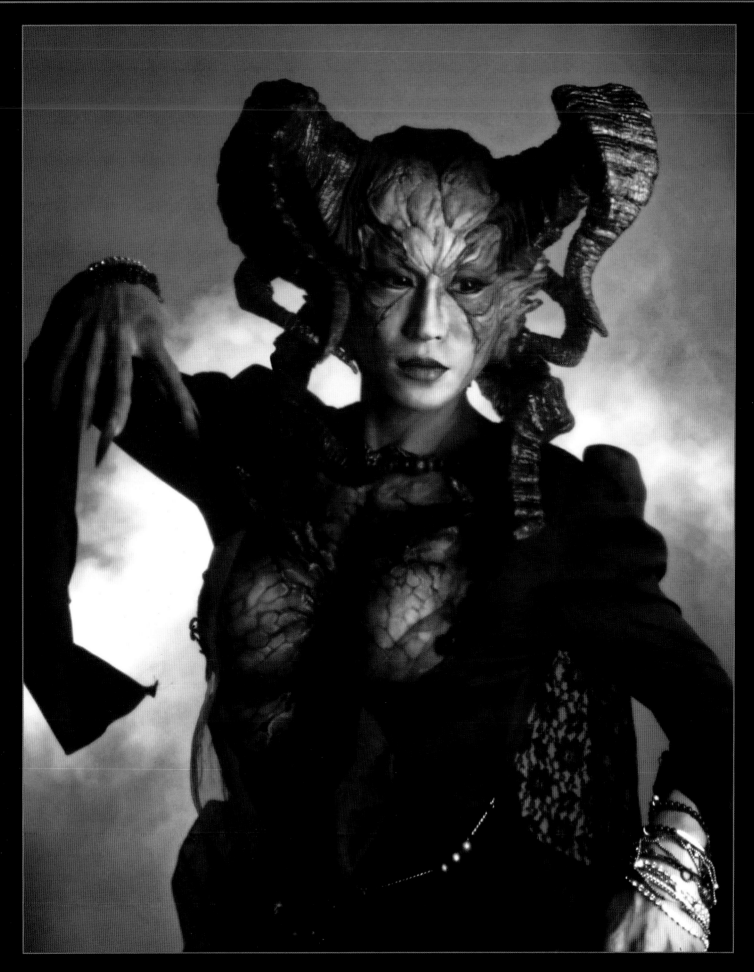

A BRIDE OF THE DEVIL

Special-Effects Makeup King Competition 3rd 1st-Place Winner

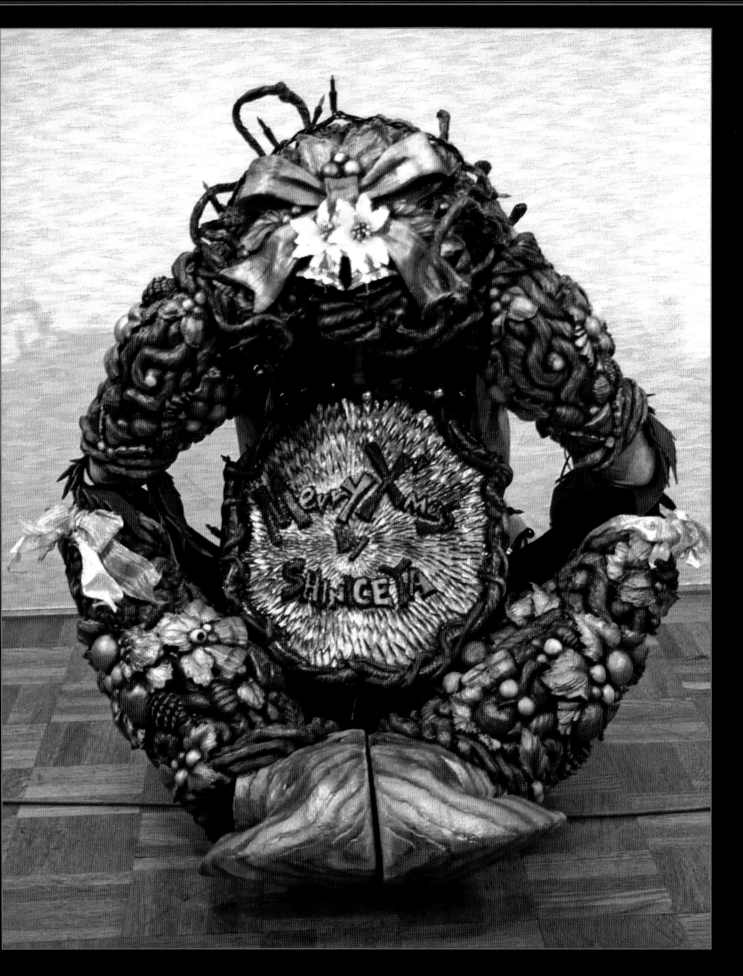

BREATHING WREATH

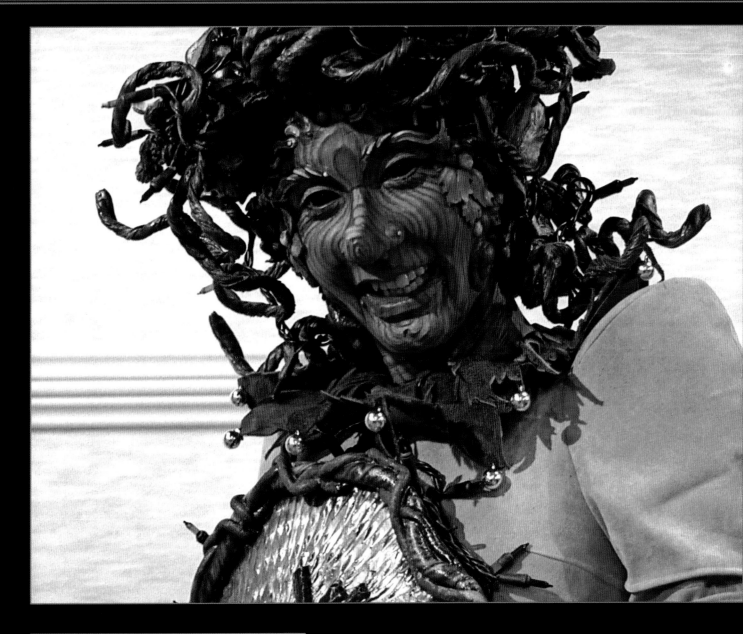

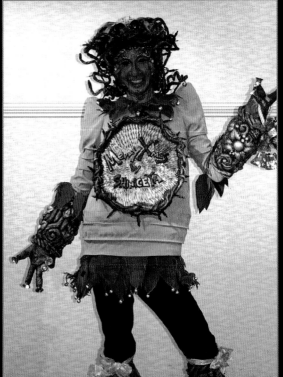

BREATHING WREATH

Special-Effects Makeup King Competition 4th 1st-Place Winner
This character can transform himself from large Christmas wreath to human.

ABOUT TV CHAMPION

In 1997, 1998, and 2000, I won 1st place in TV Champion's Special-Effects Makeup King Competition in Japan. This championship is a very famous TV series supported by one of the biggest Japanese broadcasting stations, TV Tokyo. The show challenges competitors with various talents in an array of tasks in order to crown one "king" of their ability. Episodes have focused on talents like origami, eating, and decorating cakes. TV Champion premiered on April 16, 1992, from 7:30 to 9:00 p.m. It became very popular and ran for 16 years.

I really enjoyed being on the show and creating anything I wanted within the theme of each round. This TV program didn't change my life, but it helped my parents respect me and the way I want to be.

MEVIUS

MEDIUM: ZBRUSH AND PHOTOSHOP

This is a design I quickly made for the last boss character of a short story I wrote. I envisioned this character living in a deep cave for thousands of years, hidden away. Her name is Mevius. Her body is a grotesque tangle of bulbous, sleek organs. Yet, her face is beautiful, serene, and alluring. Well, it is beautiful compared to her body. People are entranced by her face, and they talk to her. She can hear people's inner beings and see into their souls. She sees whether they are good or bad. She leads people to hell.

DESIGN

I wondered how I drew the designs I did in my early 20s. I don't recall my references or the kind of abstract things I was thinking. I feel there was a sense of originality that has been replaced with a new aesthetic that is not necessarily bad but most certainly different. I always drew in pencil because as a special-effects artist, it is good to get designs out quickly in order to be faster than your competitor. Today, we have computers that allow us to produce designs faster using software. However, I will always love the calming nature of drawing with pencil. It is important in today's culture to retain that.

PIPOT ALIEN

BLUE MERMAID

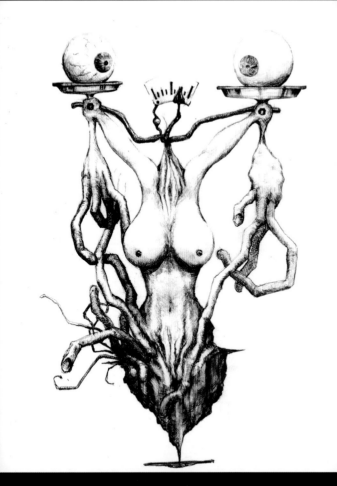

H-GENOMUE-BALANCE

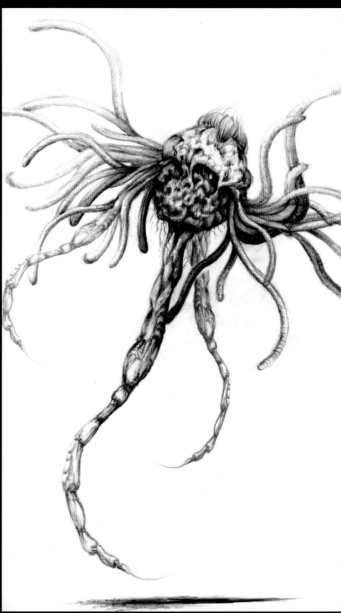

PG. 78-81

SIZE: ALL IMAGES H 11 INCHES (28CM) X W 8.5 INCHES (21.5CM)

MEDIUM: PENCIL

(1995-1998)

SEA-FLOWER

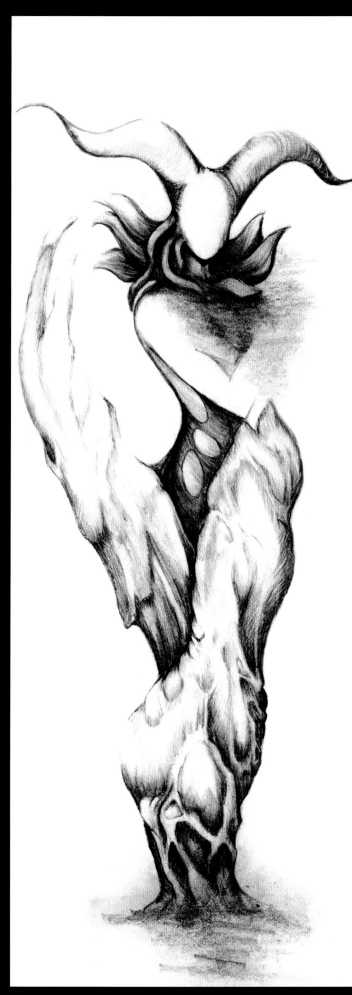

SHELL DEVIL

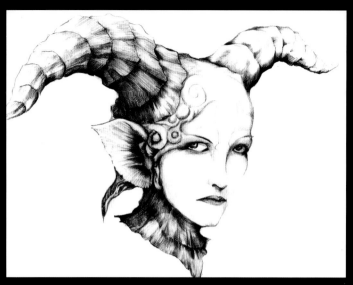

SHELL DEVIL FACE

QUESTION

SKULL SHIP

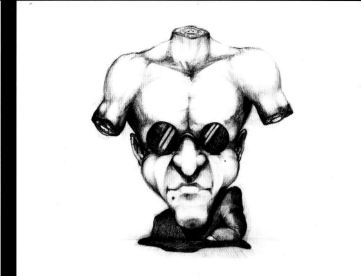

BODY FACE

QUEEN OF LILIACEOUS

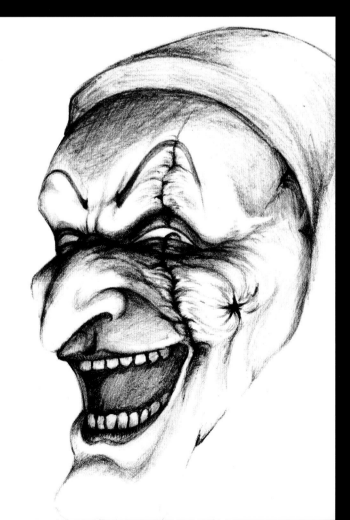

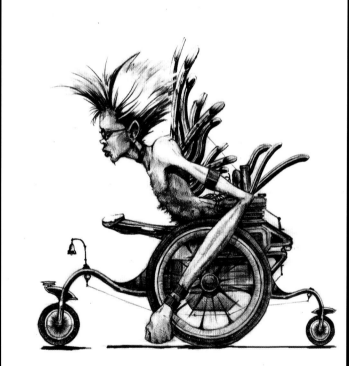

TRICYCLE ROCK MAN

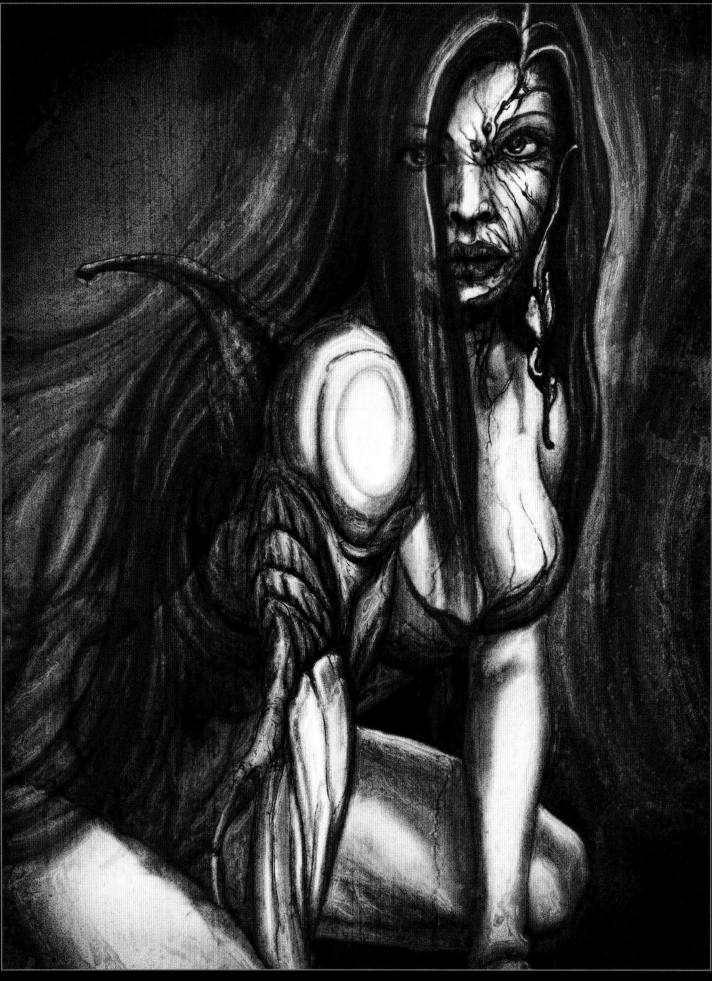

Medium: pencil with Photoshop (2003)

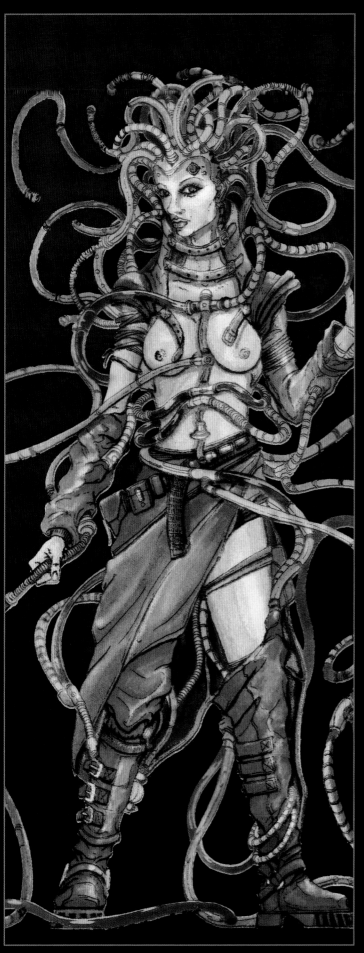

PIPE GIRL **MEDIUM:** PENCIL WITH PHOTOSHOP (2003) ALIEN **MEDIUM:** Z-BRUSH WITH PHOTOSHOP (2009)

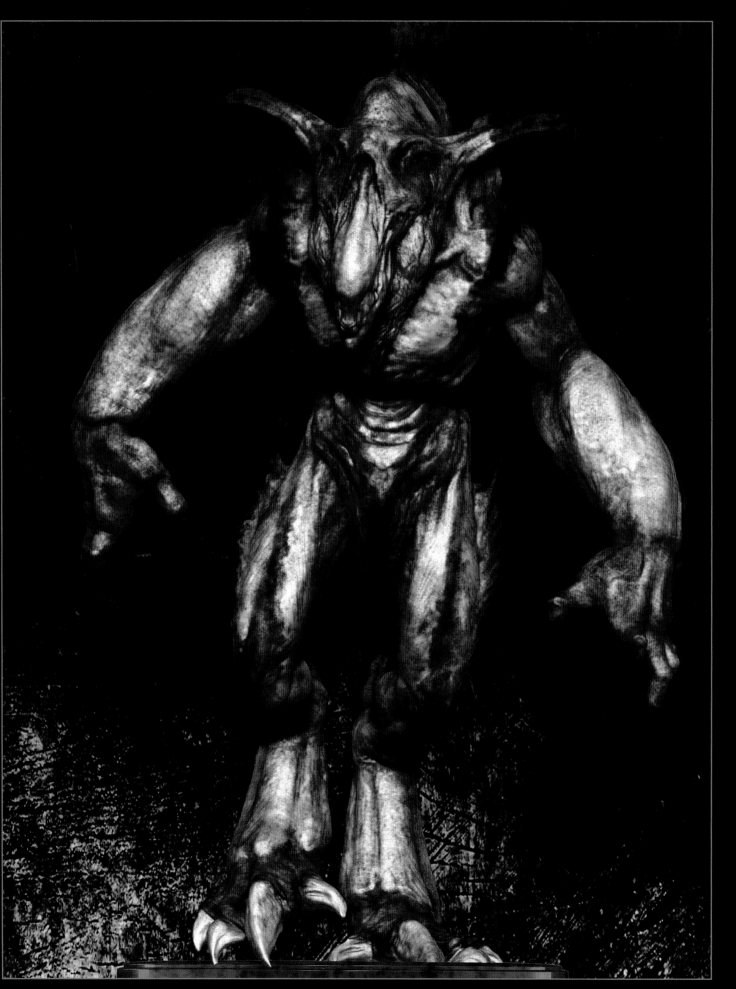

BULL CREATURE MEDIUM: Z-BRUSH WITH PHOTOSHOP (2013)

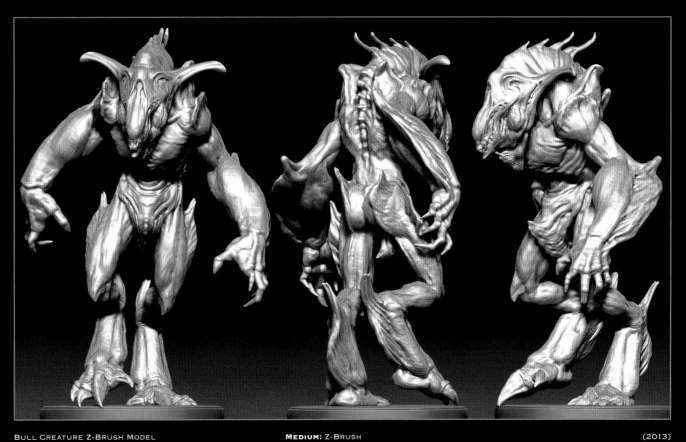

BULL CREATURE Z-BRUSH MODEL **MEDIUM:** Z-BRUSH (2013)

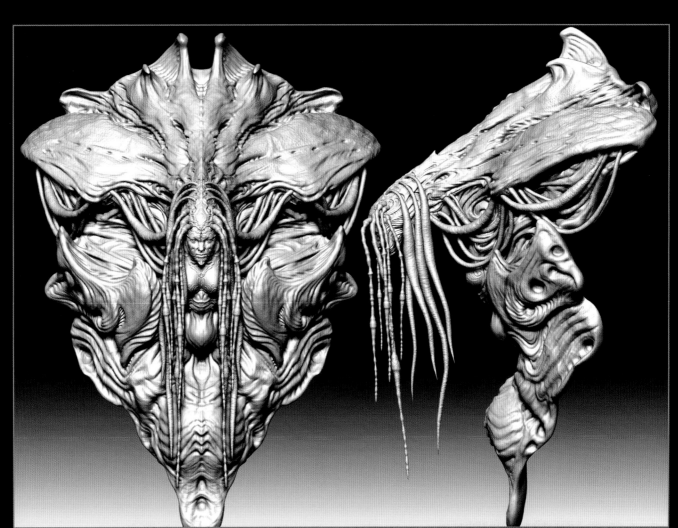

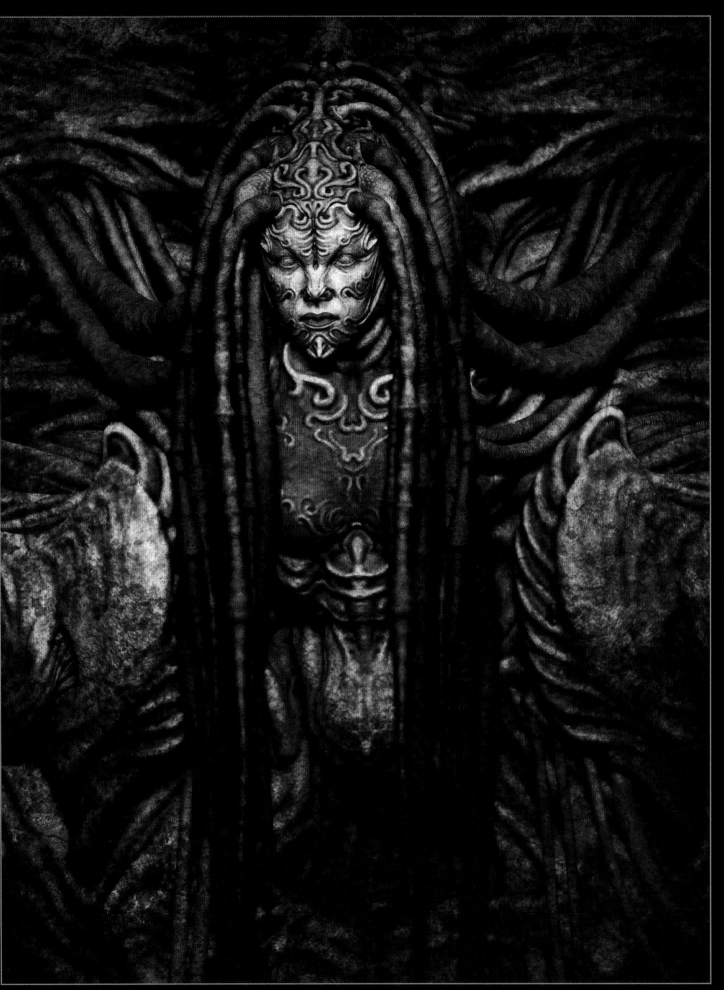

MEDIUM: Z-BRUSH WITH PHOTOSHOP

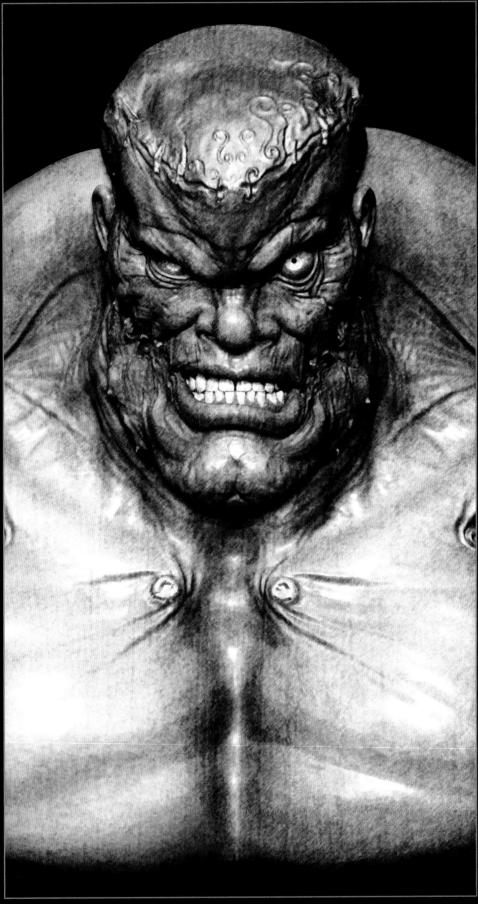

FRANKENSTEIN

BOTH IMAGES

MEDIUM: Z-BRUSH AND PHOTOSHOP

(2009)

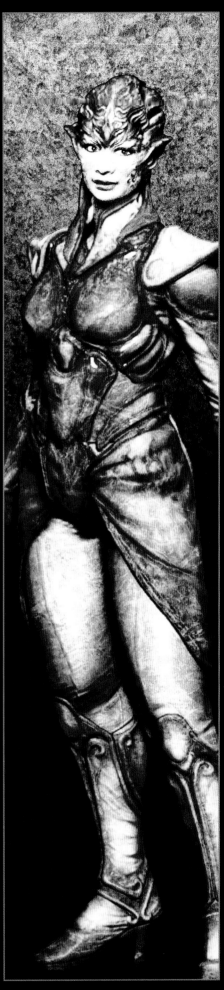

PRINCESS OF DEMONS

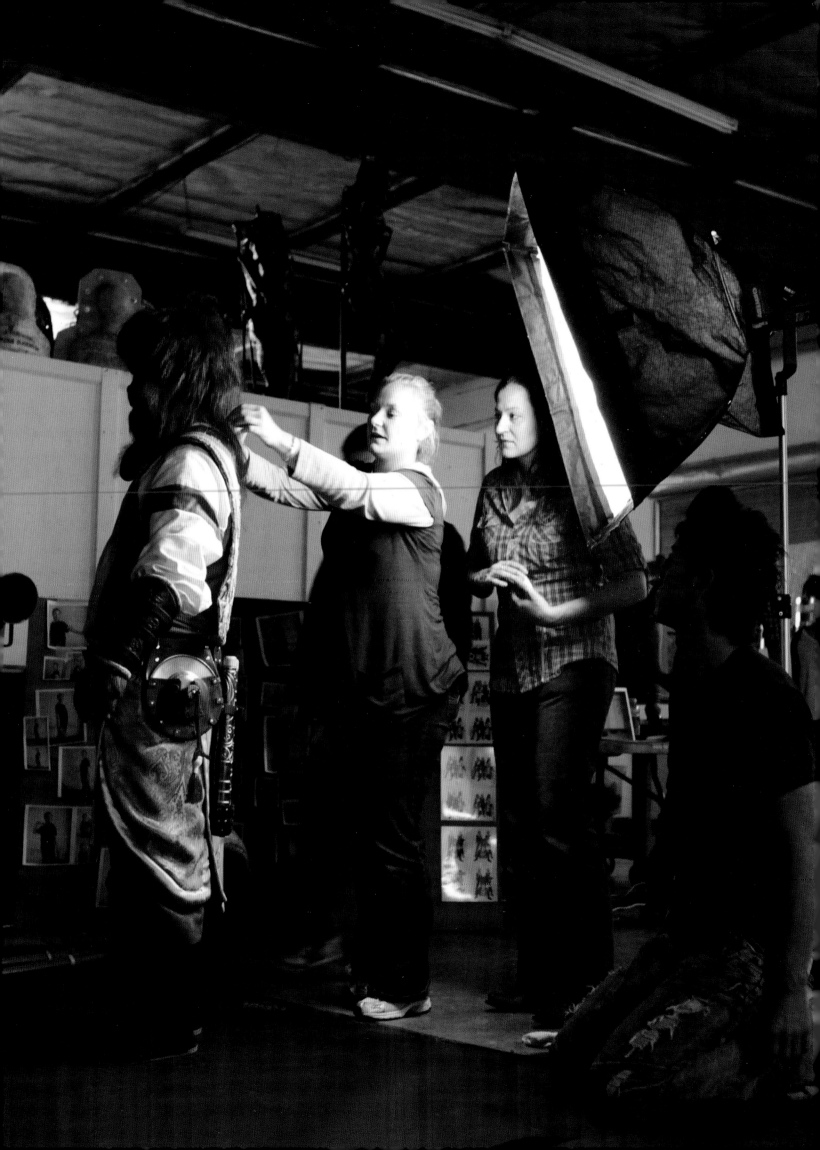

WORKSHOP

In this chapter, I will share some secrets with you and take you through the process as I create some art pieces and special-effects objects. Unfortunately, I can't show every step of the process and all of my techniques. Some of the things I do are innate and second nature. You can see a few aspects of my process, though. I am sure you can appreciate all the effort my crew put into preparing these projects with me. They worked hard on long projects, laboring to make the perfect pieces. The pictures do not do their hard work justice.

BEHIND THE SCENES

OF THE REGENERATED MAN

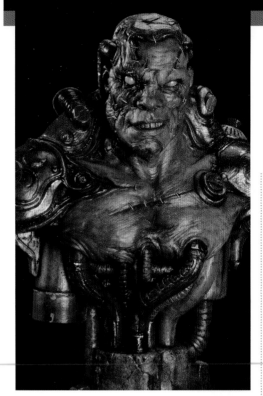

Can you imagine how wonderful it is to sculpt something when you feel completely confident with your sculpting skills and excited about an amazing design? The world is open to you and you can create anything that you can dream of. But the reality is that it is difficult to sculpt and it takes a long time to get to a level where you're content with your skills. These days, we have fast new tools like ZBrush and other 3-D programs that help us realize our visions. But the truth is, even those amazing tools still need to be employed by skilled and trained hands. Any sculpting, whether practical or digital, needs fundamental knowledge as a base. I will share with you some secrets and take you through the process of creating the Regenerated Man.

ZBursh Design

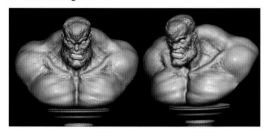

Sculpting Materials

WED clay, sculpting tools, rubber gloves, spray bottle filled with water, baby powder, aluminum wire, mid-size and small brushes.

SCULPTING

Start sculpting using WED clay on the sculpting stand and armature. This was created for the Son of the MonsterPalooza convention that was held in October 2012. The size is H 20 inches (52cm) x W 16 inches (40cm) x D 10 inches (26cm). The concept came from a ZBrush design from a few years prior. I took only 6 days to finish sculpting.

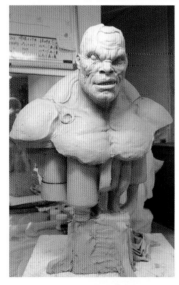
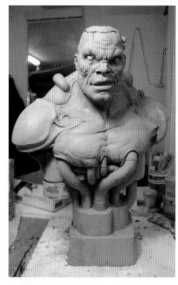
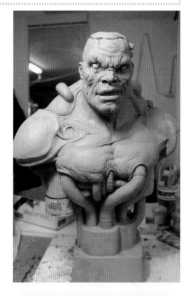
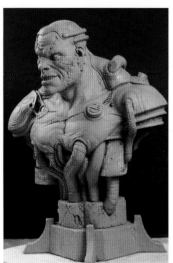
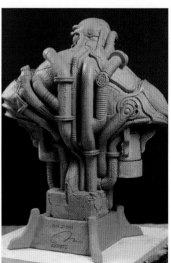
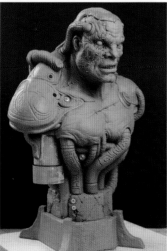

MOLD MAKING (BRUSH-UP-STYLE MATRIX MOLD)

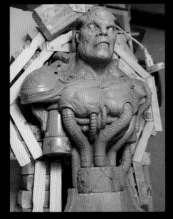 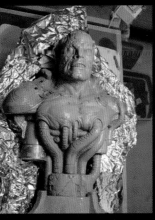 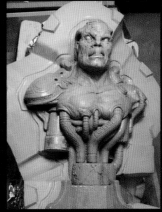

A two-piece mold is separated at a point called the parting line. Lay the finished sculpture down carefully. Using a glue gun, build up the base of the parting line by gluing paint sticks together.

Cover the wood with aluminum foil in order to protect the white water-based clay from drying out quickly. Brushing waterproof paint or latex works as well.

Place the white water-based clay on the base for the mold wall and make it as clean and smooth as possible. This step is very important. The result of a good mold parting wall is a beautiful casting with little or no seaming.

Using sculpting tools, go in and refine the edges and the mold's white water-based clay parting wall. Use a foam latex make-up sponge soaked in water and squeezed out to rub the surface of the wall smooth.

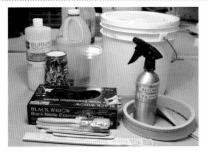 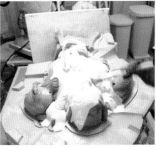

Molding Materials

1065 molding silicone set, ultrafast catalyst, gloves, chip brushes, painting sticks, paper cups, silicone keys, 99% alcohol spray

Mix silicone and catalyst, and then brush up silicone on the sculpture carefully. Use compressed air carefully to blow bubbles out of the silicone.

Brush up silicone mixed with Cab-O-Sil to make a second layer after the first layer has been completely set. Mixing Cab-O-Sil in the silicone makes the silicone thicker. Take care to fill out undercuts and cavities. You will not be able to de-mold the sculpture if you do not fill the undercuts with flexible rubber. Use 99% alcohol to smooth the silicone as you work. It will aid you as the silicone gets sticky.

Place silicone keys on the center and edges of the sculpture being molded. This is to fit the mold's jacket cover over the silicone. You should have prepared the silicone keys before making the silicone mold. Using a sharp blade, carefully cut out the silicone that lies past the edges before making the mold's jacket.

Mold Jacket Materials

Laminated resin and catalyst, paper cups, gloves, chip brushes, Vaseline, painting sticks, Cab-O-Sil, acetone, fiberglass mat

Silicone needs a supporting jacket because it is soft and cannot keep its own shape. The photo shows adding and tapping a fiberglass mat saturated with laminated resin.

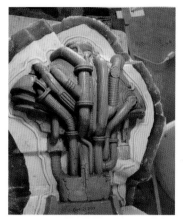

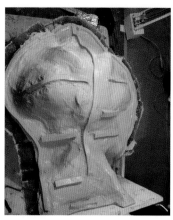

CLEAN UP MOLD

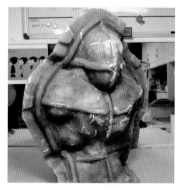

have to make sure to sand the surface and the edge of the fiberglass mold for handling. Oftentimes, the fiberglass strands will produce uncomfortable slivers.

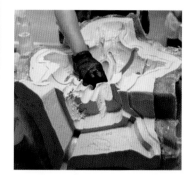

Once the fiberglass is completely set, you will need to cautiously flip the sculpture and its completed mold side. At that point, you can start to clean up everything, including all the clay stuck on the opposite side and the painting-stick foundation. After releasing the fiberglass with Vaseline, repeat the steps to make the other half mold. Once you have completed the second side's fiberglass jacket, the molding process is finished.

Secure the mold with many bolt holes. Place them on the wall equally spaced to keep the 2 parts of the mold tightly closed. In this instance, I didn't opt for bolts, since I was going to be using mold straps. Mold straps are quicker, since you do not have to secure many bolts. You

Open the mold, take the WED clay out, and clean up the inside of mold. Every piece of debris left in the mold is an imperfection in your cast piece.

CASTING

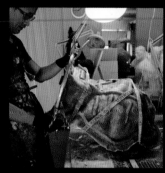

Cover the bottom of the mold with a released flat surface. This will help to create a smooth face when it comes time to finish and trim your casting. The cap has a small hole in it that makes rotating easier.

I used white cast urethane resin that sets up in 180 seconds to pour into the mold. I mixed batches, poured it in quickly, and rotated the mold around. Make sure that resin covers the entire surface of the silicone. Repeat the steps in order to get the desired thickness.

CLEAN UP CAST

Remove the casting carefully from the silicone mold after the urethane has set.

Using an X-Acto blade, small knife, and Dremel tool, clean up the seam carefully. Fill in small bubbles and holes.

PAINTING

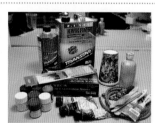

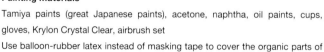

Painting Materials

Tamiya paints (great Japanese paints), acetone, naphtha, oil paints, cups, gloves, Krylon Crystal Clear, airbrush set

Use balloon-rubber latex instead of masking tape to cover the organic parts of the body. Balloon latex is more convenient for masking organic parts and curves. It's easier to mask small parts this way too. The area you mask off depends on your design. Start painting mechanical parts after the latex dries.

How to make paint look like steel:

1. Paint mechanical parts flat black.
2. Next, use two coats of Crystal Clear.
3. Last, use fine silver paint (I used Alsa chrome paint).

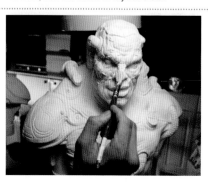

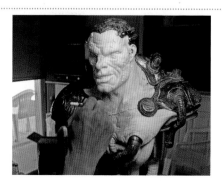

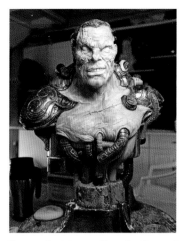
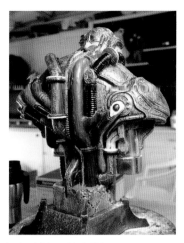
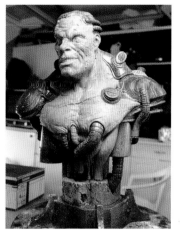
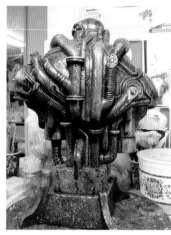

Remove the latex masking after the mechanical paint has dried. Using green, orange, and black acrylic paints, apply washes as shown in the images.

Create spots and stippling by using alcohol-based paints. In this case, red, blue, brown, flesh, and yellow were used to take the bright colors down and make his skin tone more realistic. This same technique was used to age the steel. You need to thin the alcohol paints down considerably.

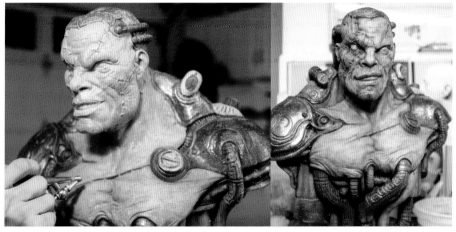

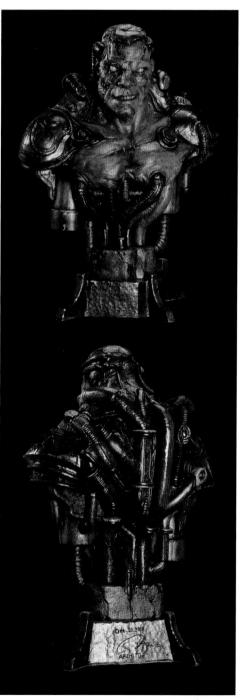

Using an airbrush, lay in shadow areas with brown and black. Shadow adds depth and dimension. Take a fine dry brush and, using a flesh color, lightly brush in some highlights. This will pop out fine sculpting details. Do not be afraid to use multiple passes. Apply spots and stipple again after you dry-brush, and then airbrush shadows again too. Once you are satisfied, spray clear lacquer to seal everything in. Use a thin wash of black, brown, and light brown oil paint for spotting. The spots and stippling create character and make mechanical parts look more realistic and heavy. This also helps make the skin tone more realistic and fresh.

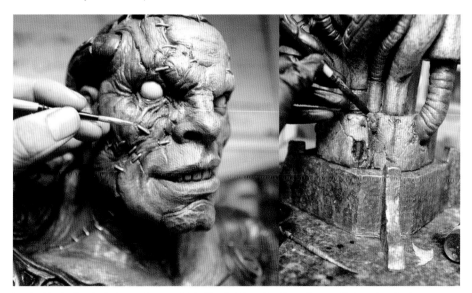

Lastly, black oil paint helps seal parts with leaking fluids and adds realism and interesting shadows.

Wipe away any excess paint before it dries. Use Lusty Lacquer for sealing. Lusty is only a coating; it is matte, not shiny. Using Modern Masters aluminum-colored paint, paint the staples on the face and chest. You are finished!

BEHIND THE SCENES
OF THE KILLER CLOWNS

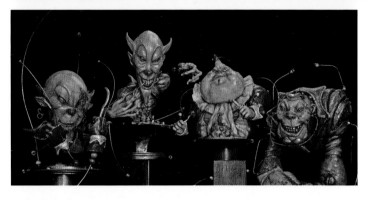

These were created for the annual sculpting show Master Blaster of Sculpting at the Hive Gallery in Downtown Los Angeles in November 2012. I gave each character a unique personality and a short story. I created the clowns' characters based on American culture. People in the U.S. have different feelings about clowns than Japanese people. In the United States, some see clowns as scary and creepy. In Japan, they are just cute and friendly. I think it would be wonderful to see these clowns in a movie someday.

In creating the clown killers, I used WED clay to speed up the sculpting process. I spent 1.5 days sculpting each character, making matrix molds (silicone and plaster jacket), and casting resin. I costumed them like old-style wooden toys. See page 90-93, The Regenerated Man, for fine detail of a very similar process.

ZBRUSH DESIGN

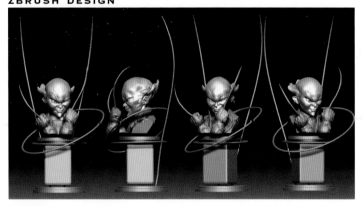

Ichi Killer

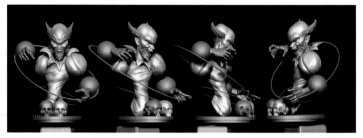

Dr. Sue

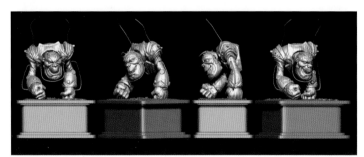

Iron Head

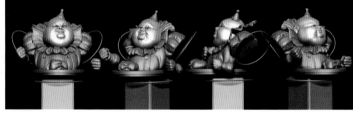

De-Butcher

Sculpting Materials

WED clay, sculpting tools, rubber gloves, spray bottle full of water, baby powder, aluminum wire, mid-size and small brushes

SCULPTING: DE-BUTCHER

I quickly sculpted the characters using WED clay. They ranged in size from 19 inches (48cm) to 24 inches (61cm), including the base. They were made from a brushed-up matrix mold and cast in urethane casting resin.

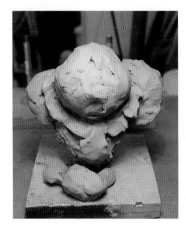
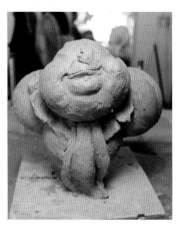
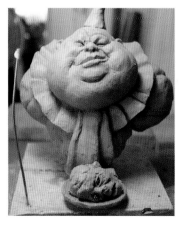
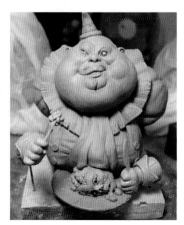

SCULPTING: ICHI KILLER

 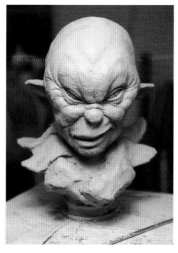 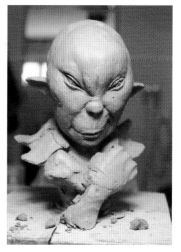 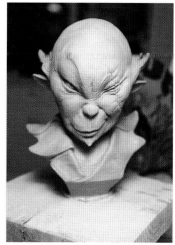

SCULPTING: DR. SUE

 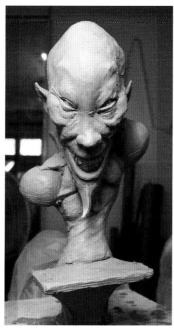 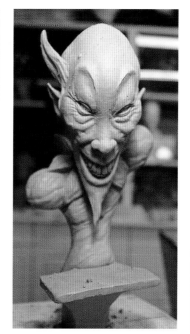 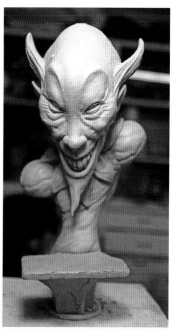

SCULPTING: IRON HEAD

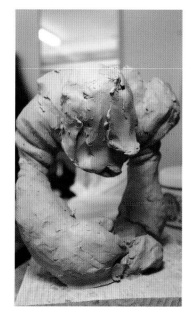 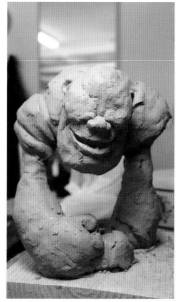 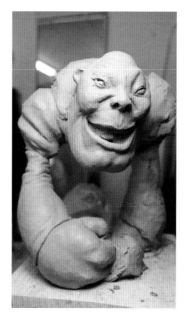 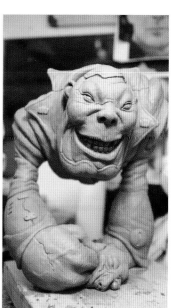

MOLDING

Molding Materials
1065 molding silicone kit, ultrafast catalyst, gloves, chip brushes, painting sticks, paper cups, silicone keys, 99% alcohol spray

I used white water-based clay to make the mold wall and brush up the silicone on the sculpture. I carefully made the matrix mold. (Silicone negative skin with plaster jacket).

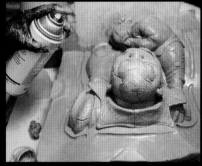

We sprayed Krylon Crystal Clear to seal the water-based clay.

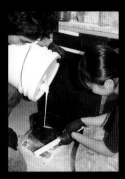

I used V-1065 silicon for the mold.

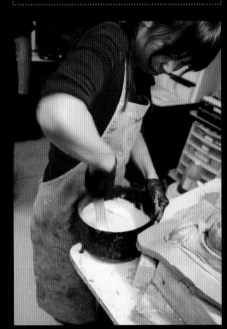

We then brushed up the silicone carefully using a chip brush.

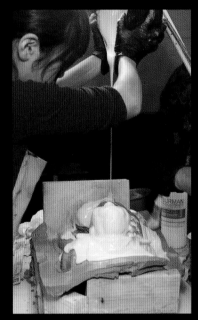

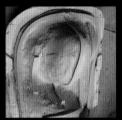

We used compressed air to blow bubbles from the silicone before it set.

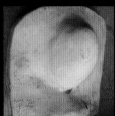

We placed silicone keys on the cured silicone after we made sure that it was thick enough.

After the silicone had fully cured, we made a plaster jacket to support it. The molding process is complete at that step.

CASTING

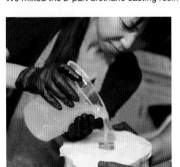

We mixed the 2-part urethane casting resin and then poured it into the closed mold.

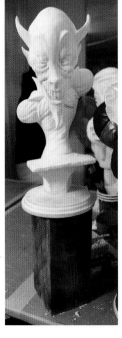

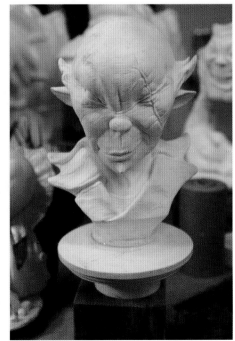

PAINTING

Painting Materials

Tamiya paints (great Japanese paints), acetone, naphtha, oil paints, cups, gloves, Krylon Crystal Clear, airbrush set

I used the same paint as I used for the Regenerated Man (see page 90-93): acrylic paints, alcohol-based paints, oil paints, and a 2-part finish coat.

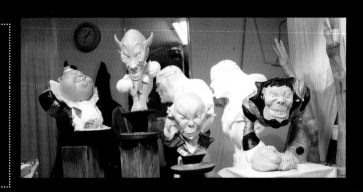

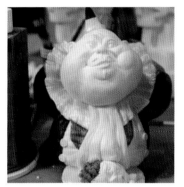 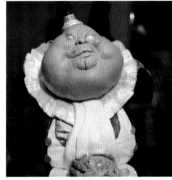 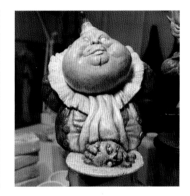 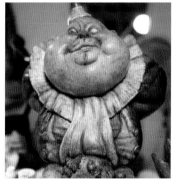

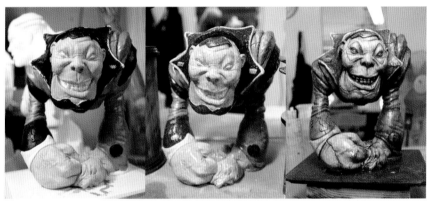

I always ensure that I wash the casting so that the paint adheres properly. I brush different colors as I follow the designs in the photos. I add spots and stipple by using alcohol-paint spatter after I finish the finer brush painting. Using an airbrush, I lay in shadow areas using browns and blacks. This adds more depth.

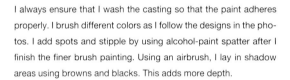

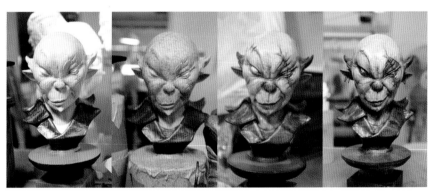

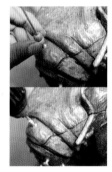 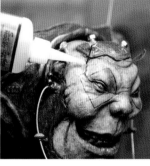

I added brass, small wood balls, bolts, and wires after the painting was finished. I placed the hands on at this stage because I made them separately.

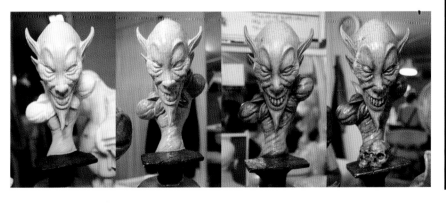

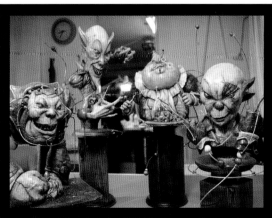

BEHIND THE SCENES
OF HIMIKO

LIFE CASTING

Selecting the appropriate model is very important. Select the closest model to your design as possible. For Himiko, we selected the model and actress Tara Platt. Tara has numerous credits, including the voices of many popular anime characters.

Before starting the life cast, we took Tara's measurements and matched her skin color with makeup. Lastly, we took Tara's picture, including her profile.

The process of life casting can potentially cover everything in the vicinity with the materials you are using. So it is a good idea to cover everything with plastic. Sometimes that includes parts of the model. Once everything was protected, I applied the bald cap with Pros-Aide medical adhesive. This protected Tara's hair, and also simplified the cast and sped up the removal. We also covered Tara's eyelashes, eyebrows, and any other facial hair with Vaseline. If you are using Alginate, gather the rest of the model's long hair into a ponytail and support it with aluminum foil and plastic wrap. This will stick out of the plaster bandages when complete.

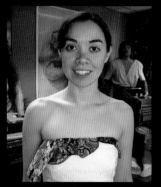
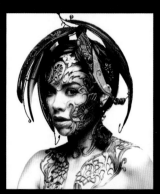

We mixed a small amount of Alginate in order to fill the space behind the ear. This thickens the plaster ear and makes it easier to remove when complete.

Lino Stavole assisted me with the life cast. We added plaster bandages to the back of the head and let them set first. The idea was to allow more time for the model to be free and at ease with the process. Our main intention for the plaster brace was to hold the model in the position that Lino and I placed her in.

We applied a light coating of Vaseline on Tara's skin before applying both the plaster bandages and the Alginate. If you forget this step, the plaster will stick to tiny hairs that everyone has on their face and neck. This causes great pain to the model. With 2 workers, the life cast took an hour. That included 30 minutes of prep time when we applied the bald cap and released the model's hair. You want to expedite this process as much as possible. The quicker it goes, the more comfortable the model is. It is also a good idea to talk to the model through the process. This reassures and relaxes your subject. You should optimally have 3 to 4 people working to make a full head cast.

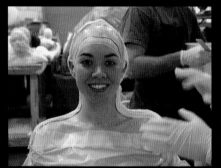

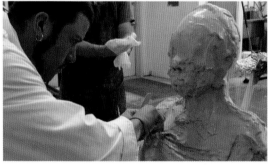
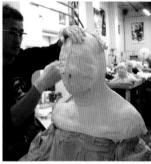

Once the plaster on the back set, Lino and I quickly applied Alginate to the front part of the face. We took great care to make sure the model's nostrils were kept clear, the entire surface was covered well, and we trapped no voids.

We liberally applied Vaseline on the cured plaster bandages supporting Tara's back. This allowed the 2 halves to separate. Once the Alginate set, we placed plaster bandages behind it to reinforce and support the material. Using a watercolor pencil, we marked the separation line and placed registration marks to help us realign the 2 pieces later.

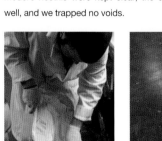

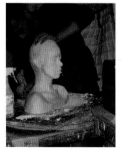
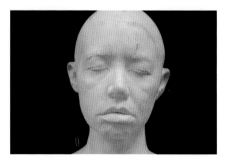

Lino Stavole and Bruce Mitchell poured plaster in the finished Alginate mold after it was removed from Tara.

Once the plaster had set and cooled down, we removed the bandages and Alginate carefully. I made some adjustments, and Tara's life cast was finished.

SCULPTING

I paint my life casts the same color as the clay because it helps to visualize the target design. It also helps when you use Al-Cote, a liquid that dissolves in water and makes separation easier.

When I finished sculpting, I carefully placed the plaster cast with the sculpture in a large tub of water. The sculpture must be completely submerged for a full day for the Al-Cote to properly separate. I sculpted the pieces on the life cast and

then "floated" them off because I wanted to check the overall balance and flow of the complete piece.

We used Pros-Aide transfers, and they need to be molded flat. Once they were on flat boards, I continued to refine them and sculpt fine details. The umbrella in the following photos was inspired by a traditional Japanese tray. The items and design have a simple beauty that I enjoy very much.

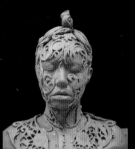 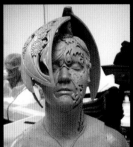 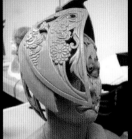 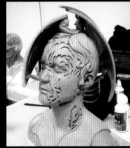 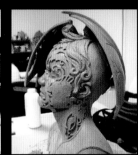

Lino made box silicon molds for the Umbrella sculpture elements of the head. He then made copies of it in white casting resin.

Then, I painted it to look like a Japanese lacquered tray.

The photos here show the sculpted pieces taken from Tara's life cast. They were transferred to 4 separate boards to be cast individually.

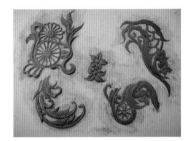

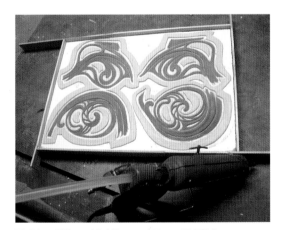

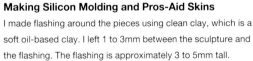

Making Silicon Molding and Pros-Aid Skins

I made flashing around the pieces using clean clay, which is a soft oil-based clay. I left 1 to 3mm between the sculpture and the flashing. The flashing is approximately 3 to 5mm tall.

Lino made the silicone molds for the Pros-Aide transfers. He used painting sticks to make walls, and mixed silicone, evacuated it, and poured it carefully. The ideal thickness is slightly larger than your highest feature. The silicone takes 6 to 8 hours to set, depending on the ambient room temperature. Once the silicone was set, Lino carefully removed the silicone from the sculpture and cleaned the molds.

I spatulated thickened Pros-Aide into the negative molds. You can either thicken the Pros-Aide with Cab-O-Sil or let it age naturally. I wanted the consistency of the Pros-Aide to be similar to that of toothpaste. I placed a plastic film over the open mold,

squeezed the excess out, and placed it into the freezer for 2 hours. The freezing time is dependent on your mold thickness and the appliance thickness. Once frozen, the pieces were placed into a dehydrator to be dried.

PAINTING

The first step in painting these sorts of appliances is to apply a sealer to the Pros-Aide skin to encourage better adhesion. You can stipple Pros-Aide on the appliances if you do not have access to makeup sealer. Brush gold powder on the skin. I started painting light colors with alcohol paints using an airbrush.

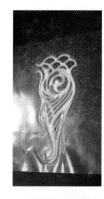

COSTUME AND UMBRELLA

The costume was designed by Kathy Sully. She is a costume fabricator at KNB Effects Group Inc. I worked with her on many projects. She made both Ara-Han and Himiko's costumes. We made the umbrella removable in order to give the model breaks. Those pieces were heavy and would cause stress if worn for long periods. I was very pleased with the costumes that Kathy Sully made for the project, based on my designs.

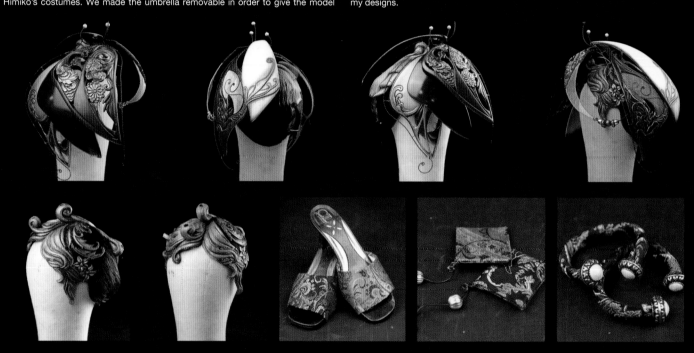

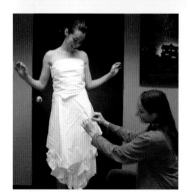

TEST MAKE-UP

I tested the makeup 3 times before the photo shoot. I wanted to familiarize myself with the use of Pros-Aide transfers. It helped me discover certain issues. For example, the skin is extremely thin, which causes unexpected wrinkles. I solved this by adding a softener to the Pros-Aide. In the first test, the skin color was too harsh. I believe it was a result of rushing the application. I had no clear vision for the color palette the day before the test. The test was very helpful because it gave me a lot of information that I was able to digest and correct. The second test was similar but allowed me to adjust the hues in Photoshop. I adjusted my makeup colors accordingly.

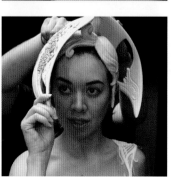 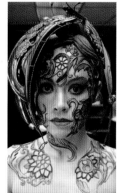 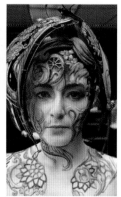 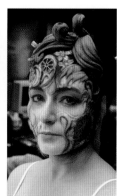

AKIHITO SPECIAL EFFECTS PROGRAM IN LOS ANGELES, CA

I held a week-long special-effects-makeup program in LA in the summer of 2012. This was planned by the Timeless Language Center in Los Angeles. During the program, I performed makeup demonstrations including a zombie, a Japanese demon, and original characters like Himiko. We also showed how to apply scars and toured a makeup studio. I focused on applying the Himiko makeup in a 2-day presentation. During this application, we were able to take more detailed photos of the process.

Akihito Special Effects Program in Hollywood

Timeless Language Center, Inc. tlc@tlcusa.jp

818-757-7657

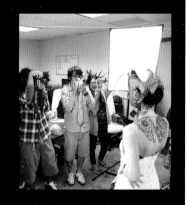

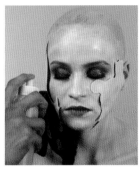
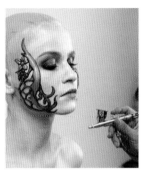
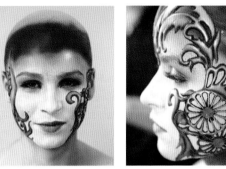
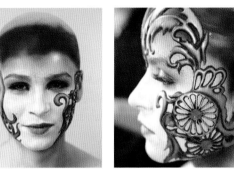

I placed a bald cap to protect her hair and airbrushed white and pearl-white Skin Illustrator.

Then, I airbrushed gold and black around the head and neck, as shown in the photos.

I applied Pros-Aide in this order: cheeks, forehead, neck, and shoulders. Then I sprayed water with the airbrush to remove tattoo paper.

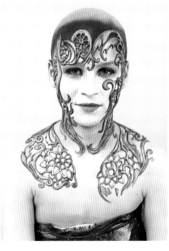
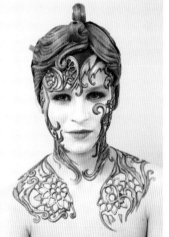
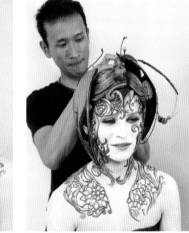
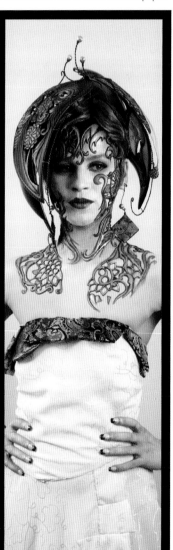

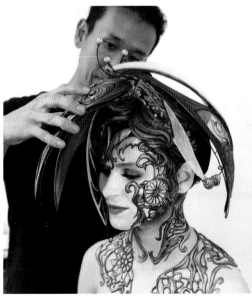
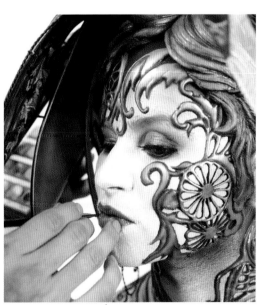

I placed the umbrellas after applying the wig.

I painted her lips and touched up her eye shadow and cheek color.

BEHIND THE SCENES
OF BIO-VERONICA

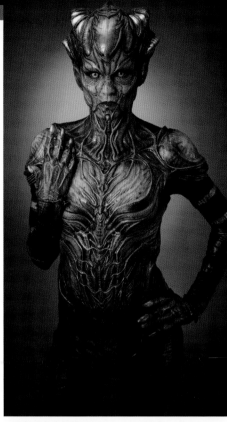

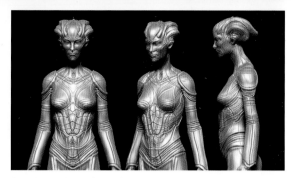

It took me almost 6 months to finish the Bio-Veronica project. It took considerably longer than I anticipated. I was determined to make the process faster for the next project. Luckily, I had a lot of help. Unfortunately, the original model injured her face right before the shooting day. I had to replace her with another model. We also had to replace the photo location because the studio fell through at the last moment.

You can see this piece in the book *A Complete Guide to Special-Effects Makeup 2: Zombie and Dark Fantasy*. This photo has the original model whose life cast we took. I am very happy that she made arrangements to have the photos retaken. I want to thank Jul and my entire crew. Even though we faced many obstacles, I am very satisfied with the results of this makeup.

LIFE CASTING

After taking the model's life cast, the plaster cast was painted brown to match the medium NSP oil-based clay we used. A painted life cast helps unify the sculpture with our model and aids in the design process.

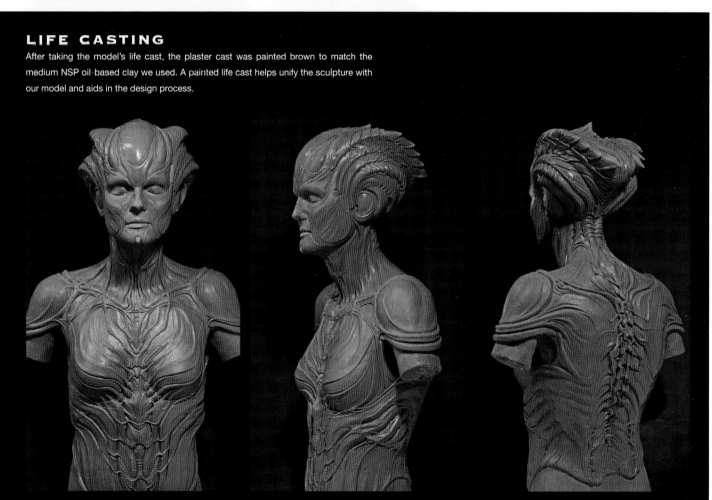

CHEST AND HEAD

I laid out the original design of Bio-Veronica in ZBrush. I followed that design as I laid in the designs in clay on the life cast of the model. I sculpted the head in 2 parts, which included the intricately sculpted skullcap and the helmet that nests over it. I also sculpted the body corset and 2 hands. I decided to sculpt 2 different parts of the head in order to vacuum-form the outer helmet in a clear material. This was to allow the skullcap's details to show through. Unfortunately, this did not work as planned, as you will find out later.

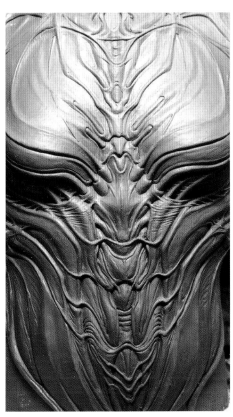
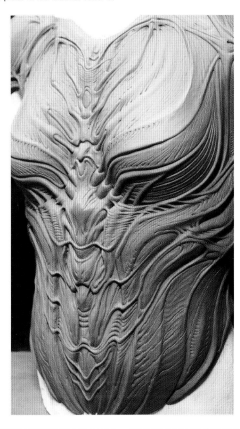
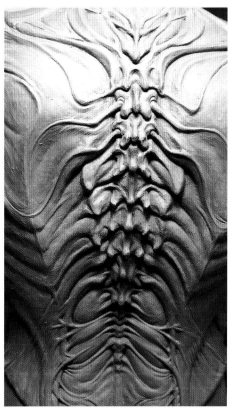

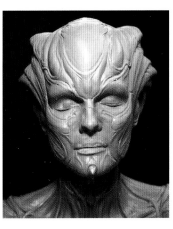
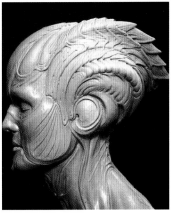
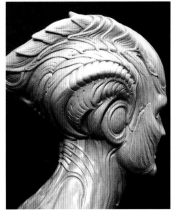
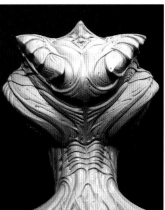

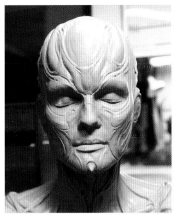
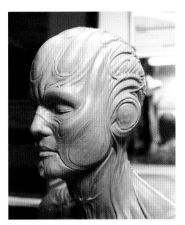
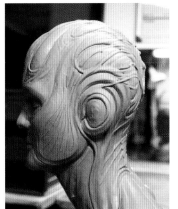
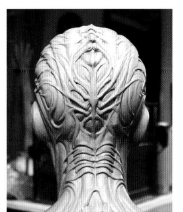

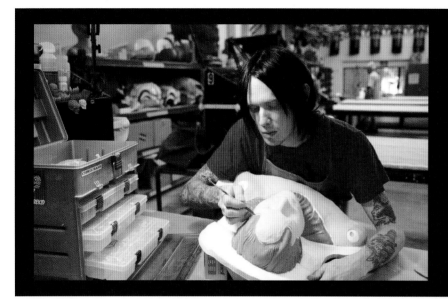

MOLD MAKING

Mold maker Chris Baer from Amalgamated Dynamics Incorporated made the molds for this project. The head and body molds were made from epoxy syntactic dough with an epoxy surface coat. We chose to make 6 separate pieces for the head and neck appliances. We also made 3 pieces for the body and separate molds for the gloves.

I spent 6 months finishing this project at night after working on my regular film responsibilities. The bulk of the molds were made from epoxy-based syntactic dough and a rapid-curing polyurethane called BJB-1630. The images on the accompanying pages will help you visualize some of the process; however, the method is nuanced and was difficult to capture in a few pictures.

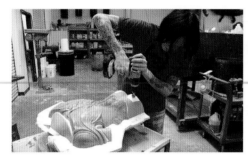

Chris Baer made mold keys on the body. These are used to align mold halves.

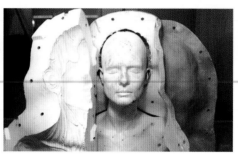

The mold was 3 pieces and was made from epoxy syntactic dough with an epoxy surface coat for the head.

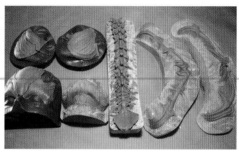

We floated the finished sculptures onto the 1630 bases (4 pieces for face, 1 backbone, 2 shoulders), and I cleaned up the sculpture on them.

Here is a more detailed view of the cheek sculptures.

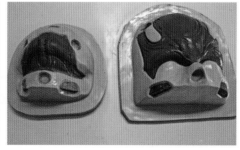

We placed clean clay on the base, edges, and flashing. It should be roughly 1 to 3mm in height. We sprayed Krylon Crystal Clear on it, and it was ready to mold.

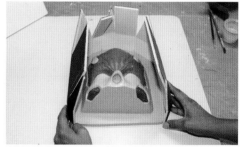

We used foam-core boards to make walls. This is for pouring 1630 into.

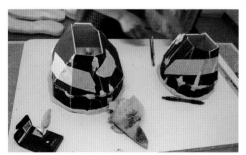

We used a glue gun and masking tape to reinforce the temporary walls.

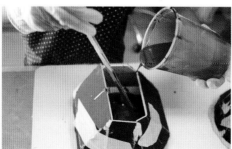

We poured 1630 into all of the molds. It takes about 1 hour to set up.

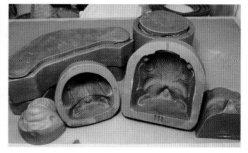

After we opened the molds, we sanded and cleaned up the inside of every mold. We made 12 molds for this.

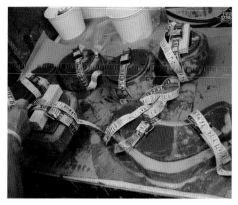
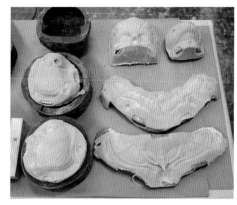
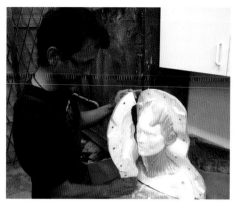

We poured silicone into the molds to make the skins. I used silicone Gel-10 for the face, head piece, and shoulders. The body and hands were made from foam latex.

COSTUME DESIGN

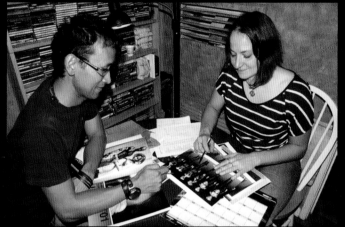
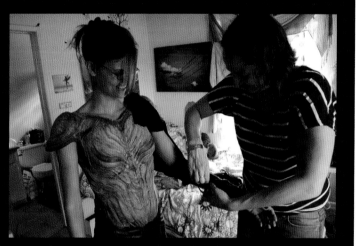

I have worked exclusively with costume designer Kathy Sully for all of my projects in the United States. We met at KNB Effects Group Inc. on the film *The Chronicles of Narnia: The Lion, the Witch and the Wardrobe*. Kathy made and designed the costumes for Himiko and Ara-Han in the book *A Complete Guide to Special-Effects*

Makeup: Conceptual Creations by Japanese Makeup Artists and the 3 costumes for the taiko performance characters. She is a very talented and hard-working costume designer. No matter what crazy design or insane budget she is given, she happily gives her best.

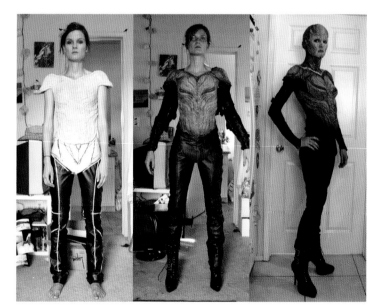
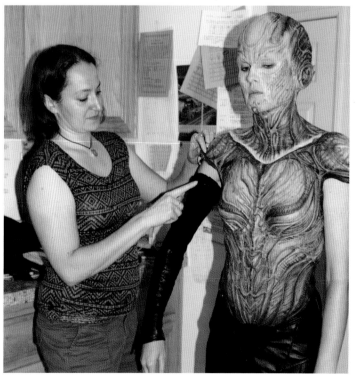

We performed 3 costume fittings before our shoot date. Kathy advised me to buy black leather pants and then convert them for new makeup by painting them and incorporating them into the design. She felt that was the only way for us to create a costume within our budget and our time constraints. We used acrylic paint to match the foam latex body suit.

PAINTING

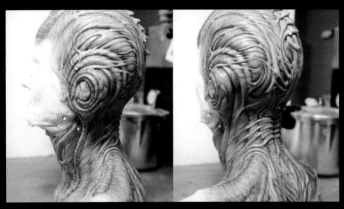
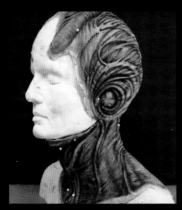
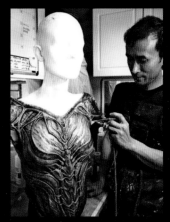

I used Skin Illustrator and other alcohol-activated paints on the silicone skin and on the model. My final coating of paint utilized Baldiez bald-cap material as a paint medium. I also used Tamiya paints and Pros-Aide as a clear coat to form a more translucent feel on the foam rubber suit. I always sandwich colors between layers of Pros-Aide. It gives the piece more depth.

1. I used PAX paint, which is a 1:1 mix of Pros-Aide medical adhesive to acrylic paint, as a base for the rubber bodysuit.

2. I then laid in spots using thinned-down alcohol paints. In this case I used red, blue, brown, flesh, and yellow to make the skin more realistic.

3. Using an airbrush, I laid in shadow areas with brown. At this time, I also painted reptile patterns. I then laid in supplemental shadows using black in order to add both depth and dimension.

4. I took a fine-bristled dry brush and, using flesh color, lightly brushed in some highlights. This popped out the fine details of the sculpture.

5. I repeated steps 2 and 3 as needed.

6. I mixed E6000 with naphtha to a thin consistency. I then added pearl and brushed a finish coat over the foam rubber suit to make it shiny and slightly iridescent.

Body Painting (From Rubber Suit)

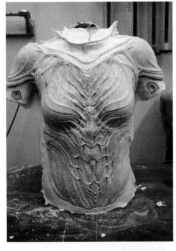
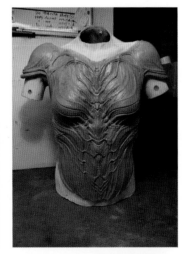
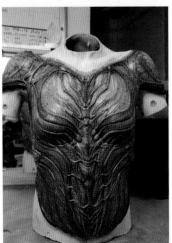
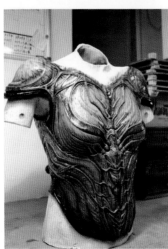
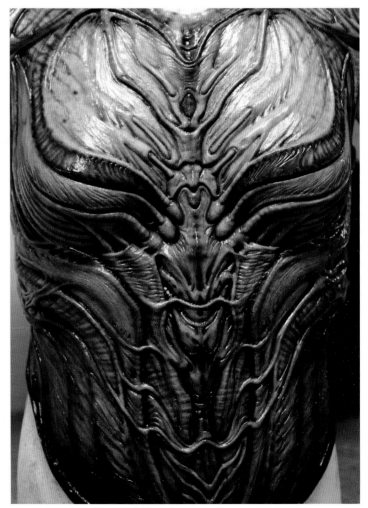

CREATE TRANSLUCENT HELMET

I always try to push myself as an artist and try something new. I wanted to try to make the outer helmet of this character as transparent as possible. My plan was to use vacuum-formed plastic and spray a light coating of BJB 8750, which has been discontinued. BJB 8750 was a 2-part flexible and semiclear urethane. Unfortunately, this BJB 8750 was too old, and that caused it to brown considerably. Ideally, it should have a very light yellow, milky color.

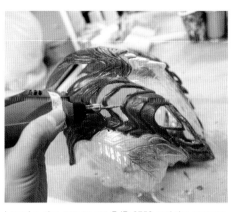

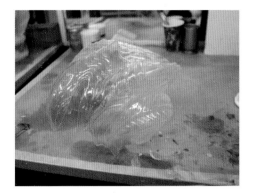

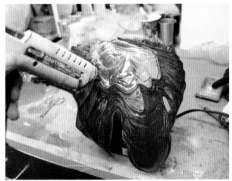

I used a glue gun to put BJB 8750 and the vacuum-formed shell together. I used Bondo (a mix of Pros-Aide and fumed silica) to clean up the gaps between BJB 8750 and the vacuum form.

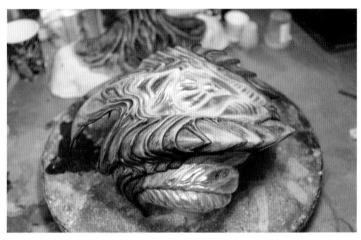

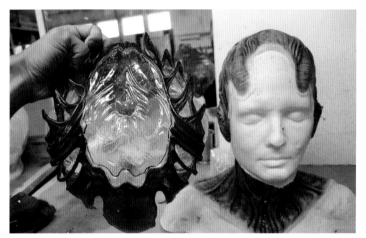

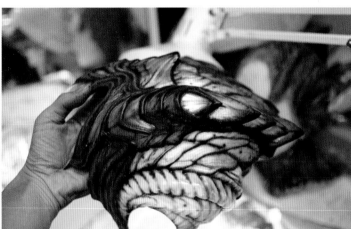

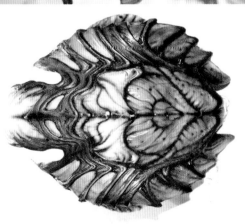

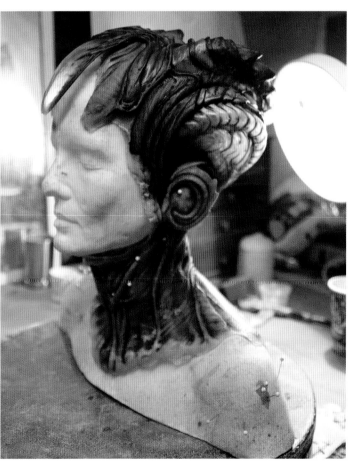

TEST MAKE-UP

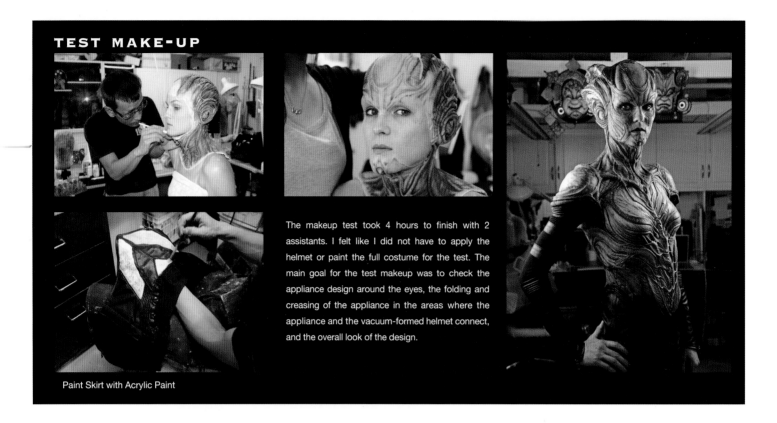

The makeup test took 4 hours to finish with 2 assistants. I felt like I did not have to apply the helmet or paint the full costume for the test. The main goal for the test makeup was to check the appliance design around the eyes, the folding and creasing of the appliance in the areas where the appliance and the vacuum-formed helmet connect, and the overall look of the design.

Paint Skirt with Acrylic Paint

ACTUAL SHOOTING OF BIO-VERONICA

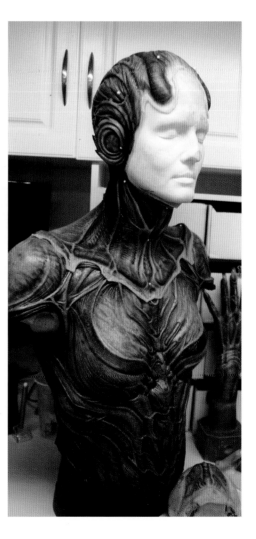

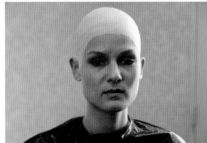

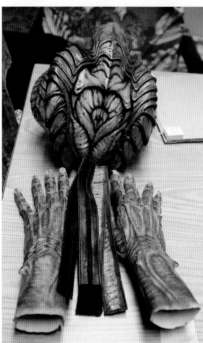

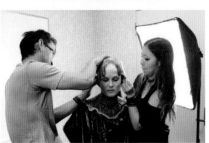

We protected the model's hair by applying a bald cap. The model is Julia Senecal. Assistant is Miyo Nakamura

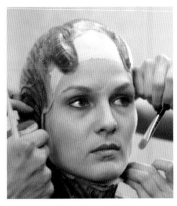

We carefully placed a silicone cowl on Julia's head. We made sure it was applied in the correct position.

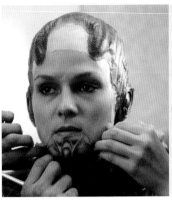

We placed the cowl, chin, cheeks, forehead, nose, body suit, and gloves, in that order. I used Telesis 5 for the adhesive, and Skin Illustrator for the face, rubber mask, and around the eyes

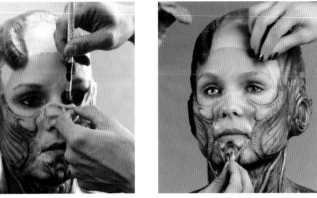

I placed predator contact lenses in her eyes.

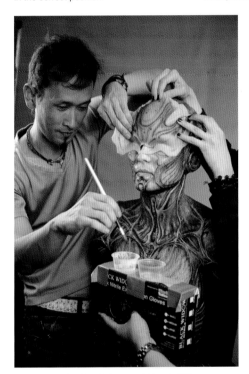

I applied the forehead piece and blended it in.

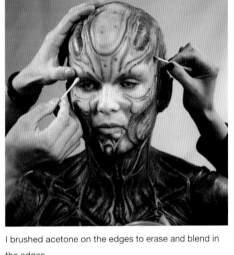

I brushed acetone on the edges to erase and blend in the edges.

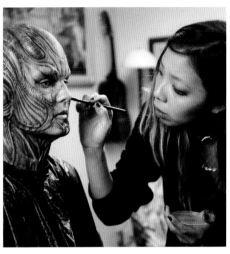

I applied a small piece of 3-D transfer on her nose and upper lip.

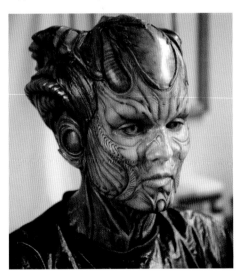

I applied the translucent helmet.

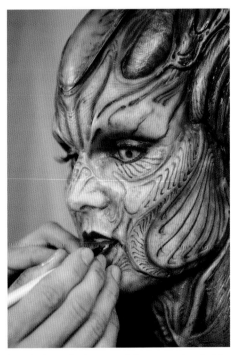

I brushed eye shadow around the eyes and applied lipstick to make the character more feminine and beautiful.

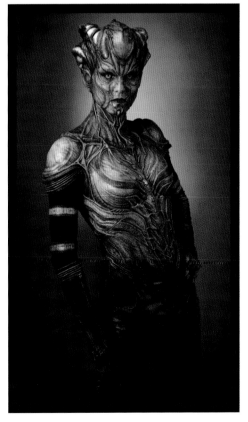

BEHIND THE SCENES
OF THE TAIKO PROJECT

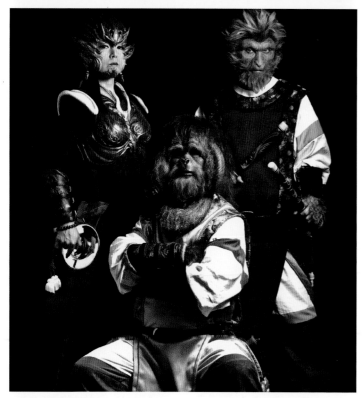

SCULPTING

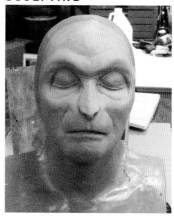
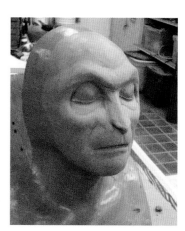

Japanese Macaque

We decided to forgo the use of dentures because the performers felt it would hinder their routine. Taiko is arduous and requires careful breathing and concentration. Dentures in simian makeup have the added benefit of "plumping" out the mouth. Without them, I had to take extra care to achieve realistic ape-like anatomy.

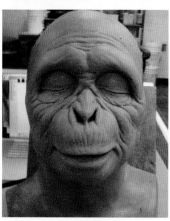
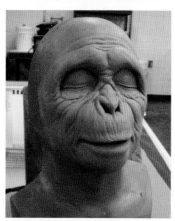

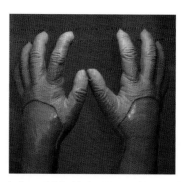
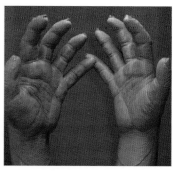

In the end, I decided not to use these monkey hands because they interfered with playing the Japanese drums (taiko). It was also very warm, causing her to sweat a lot.

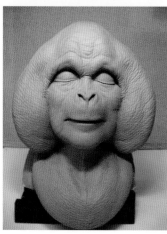
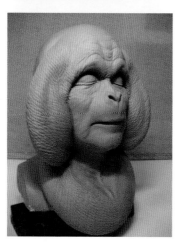
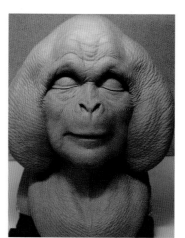
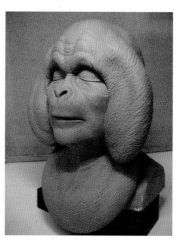

Bornean Orangutan

I documented the original design of the orangutan. I changed the design after I was about 70 percent finished with the sculpture to add the cheek pads. I believe that this makes the character more visually interesting.

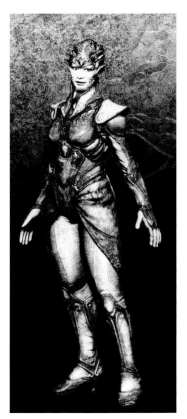

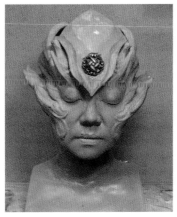 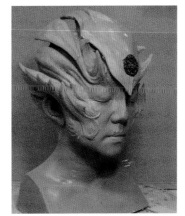

PRINCESS OF DEMONS

We had to change our model because the project went on longer than the original model anticipated. I had to sculpt the head twice. My intent was to have this character be very feminine and beautiful but at the same time express a feeling of strength and power.

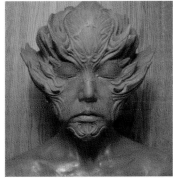 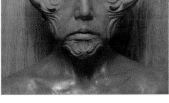

I've included an image of the original model and design.

These sculptures are without wings on the top of the head.

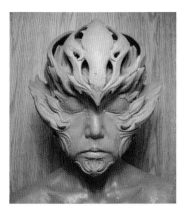 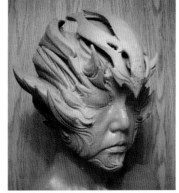 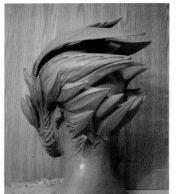 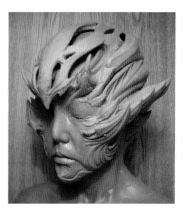

CHEST ARMOR
I wanted to design the chest armor to closely emulate Japanese samurai armor with softer, more feminine lines.

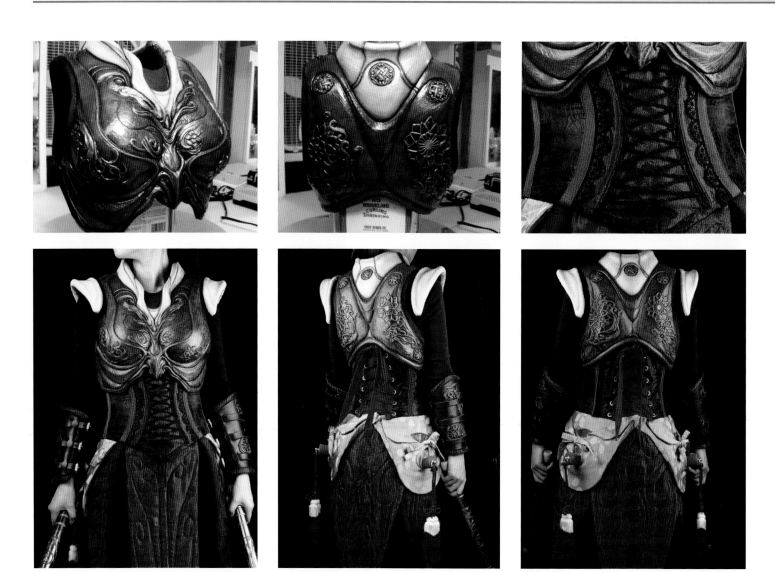

Please take a look at the amazing detail on the costume.

I designed her waist to look like she is wearing a corset. The team name, Kogenkai Taiko, is embroidered on the back of her skirt.

COSTUME AND PAINTING

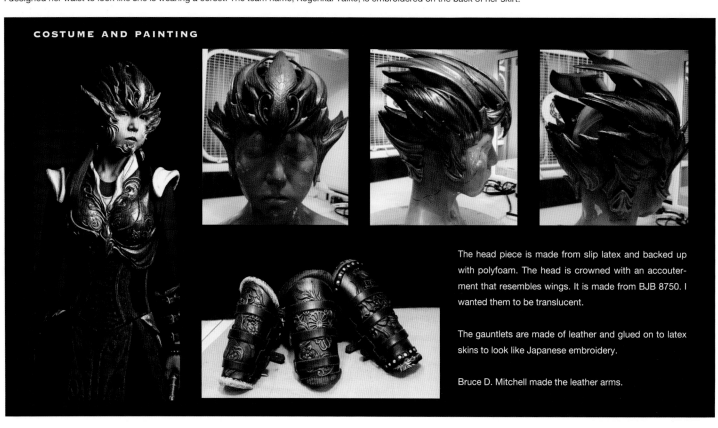

The head piece is made from slip latex and backed up with polyfoam. The head is crowned with an accouterment that resembles wings. It is made from BJB 8750. I wanted them to be translucent.

The gauntlets are made of leather and glued on to latex skins to look like Japanese embroidery.

Bruce D. Mitchell made the leather arms.

MAKEUP: PRINCESS OF DEMONS

The application time on this character was 2.5 hours. I was the main makeup artist on this piece, with Mari Hanazono assisting me. This character is supposed to be the leader of the 2 monkeys, at least in concept. This makeup has 4 pieces for the face and head.

This make-up has 4 pieces on face and head piece.

I placed red contact lenses in her eyes and pulled her hair back.

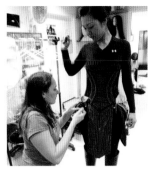

Kathy Sully doing a costume fitting.

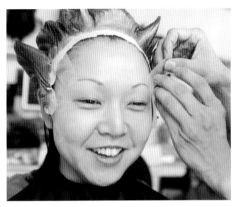

I placed medical tape near her eyebrows and pulled the outer corners of her eyes back and up to reinforce the Asian shape and form of her eyes.

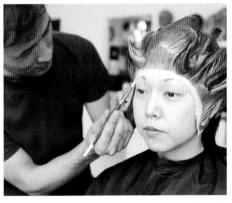

I arranged the head piece on her head and made sure it was in the correct position.

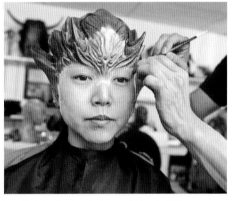

I applied the forehead piece and blended it in.

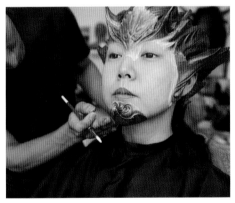

I applied the chin.

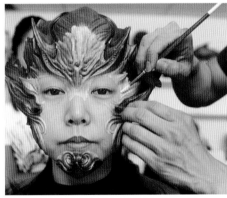
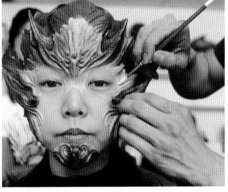

I applied the cheeks appliances, being sure to apply pieces symmetrically, and stippled flesh-colored PAX on the edges in order to erase the edges and blend them in.

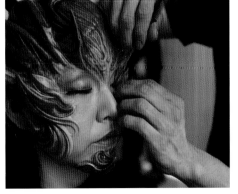

I applied false eyelashes.

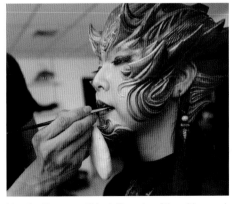

I brushed brown and black (the color of the rubber mask greasepaint) on the eyelids That made her eyes stand out. I also put a nice color on her lips.

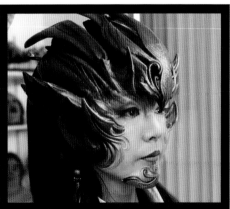

Lastly, I put wing armor pieces on top of the head.

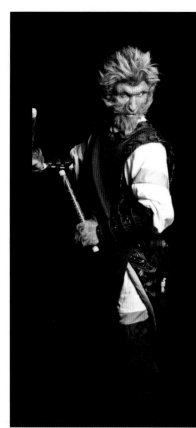

COSTUME

I made the drumsticks look like steel. I also sculpted patterns that look like Japanese embroidery on the sticks. I didn't paint the ends of the sticks because I didn't want to harm the skin of the drums.

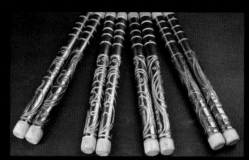

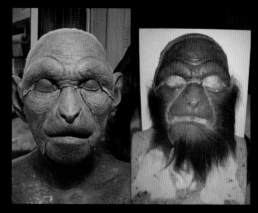

Mari Hanazono ventilated the hairpieces for the cheeks. Kazuyuki Okada styled the wig to make it look like the Monkey King.

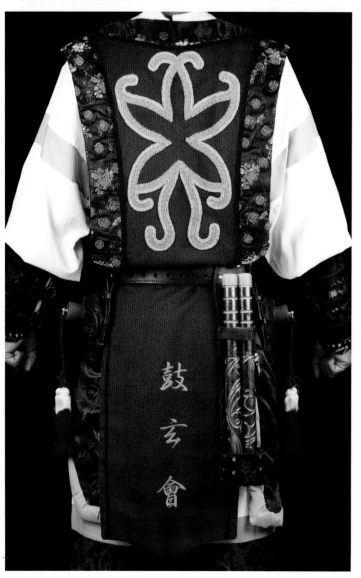

The Kokura Gion Taiko Drum Festival is one of the most well-known events in Fukuoka, Japan. The Monkey King plays the Kokura Gion Taiko (Japanese Drum). That's why I made the symbol on his back using the image from a mark of Fukuoka Prefecture,. I asked Kathy Sully to make the symbol look like Japanese embroidery.

Bruce D. Mitchell made leather pouches for the small Japanese cymbals and drumstick.

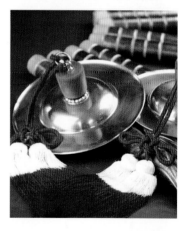

MAKE-UP
JAPANESE MACAQUE

The application time for this makeup was 2.5 hours. Kevin Wasner was the main makeup artist. Kevin is one of the key makeup artists at KNB Effects Group Inc. His assistant was Kayo Nagasaki. Kayo was the first graduate of my private school in 2009. The model is a gentleman named Ken Matono. He is the deputy department head of the Kogenkai Taiko Club. I tried to match the quality of the orangutan.

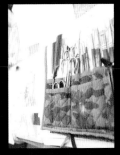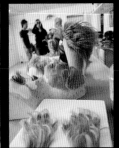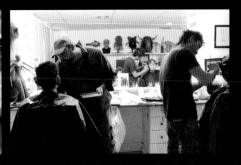

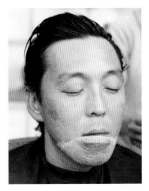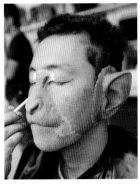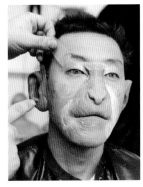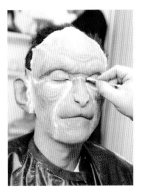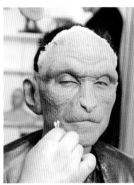

First, Kevin Wasner and Kayo Nagasaki carefully applied the chin and ears. The nose was applied second, and the cheeks last. All pieces have to be applied carefully.

Kevin and Kayo used flesh-colored PAX paint to blend in the edges. They then finished with Skin Illustrator to add color to make the skin look realistic.

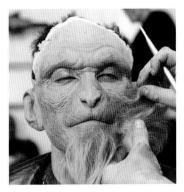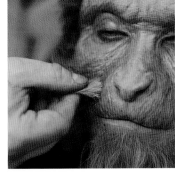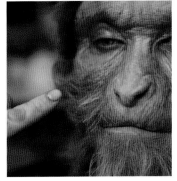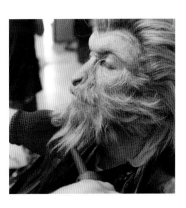

The hair was applied to the cheeks, and the wig was placed on the head.

Kevin used a small hair iron to make the hair curl and look more natural.

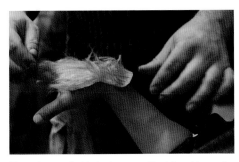

They also applied hair pieces on the latex skin on the back of the actor's hand.

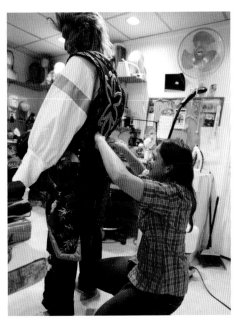

Kathy puts every costume on nicely.

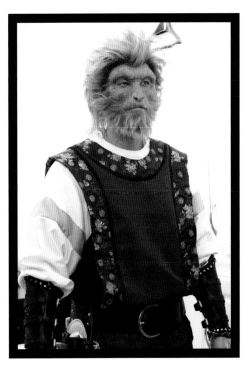

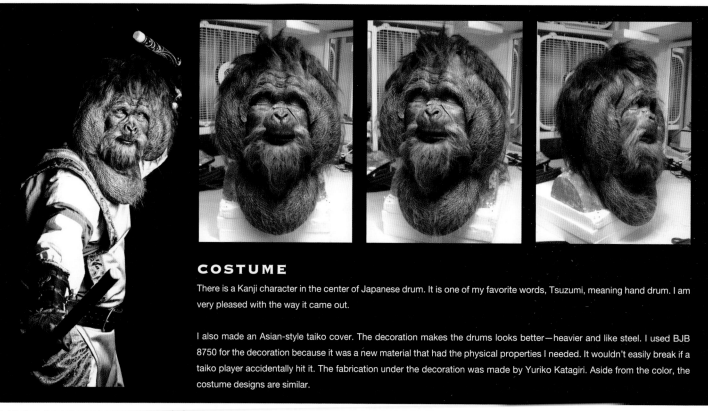

COSTUME

There is a Kanji character in the center of Japanese drum. It is one of my favorite words, Tsuzumi, meaning hand drum. I am very pleased with the way it came out.

I also made an Asian-style taiko cover. The decoration makes the drums looks better—heavier and like steel. I used BJB 8750 for the decoration because it was a new material that had the physical properties I needed. It wouldn't easily break if a taiko player accidentally hit it. The fabrication under the decoration was made by Yuriko Katagiri. Aside from the color, the costume designs are similar.

Aside from the color, both of the costume designs are similar.

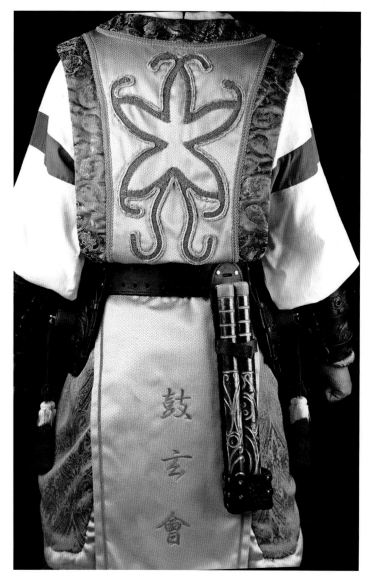

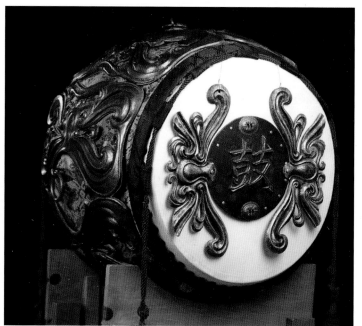

MAKE-UP

The orangutan's makeup was the most popular of this project. It was very rewarding to hear people's reactions to it. I feel that it was the largest departure of the 3 makeup designs. Kerrin Jackson was the main makeup artist for this character, and Yusuke Mori was her assistant. The model was the team leader of the Koestler taiko club, Mr. Mr. Eiji Shishido. We took 4 hours to apply this makeup. Initially, I wanted to make the makeup silicone, but I decided to use foam latex instead because of weight considerations. Silicone also traps perspiration and that was a concern, especially under the neck and cheek pads. Sweat will cause the makeup adhesive to dissolve and the prosthetic to delaminate. That is bad. Carefully considering such things is important before you start a project. That foresight will save you money, working time, and stress. Enjoy the pictures!

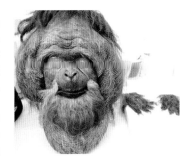
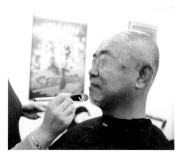

I pre-painted every foam latex piece for the Bornean orangutan. Mark Boley made beard lace pieces.

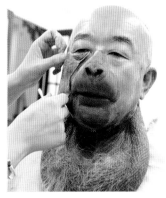
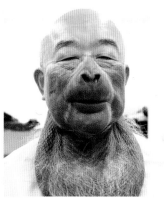

Yusuke Mori did hair punching on the orangutan's sacs and forehead.

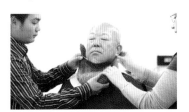

Kerrin applied the lower sacs, chin, cheeks, head sac, and forehead in order. Kerrin Jackson used Telesis 5. She applied it carefully, as to not to glue the hair. She used Skin Illustrator and rubber-mask greasepaint to add shadows and highlights.

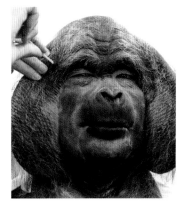
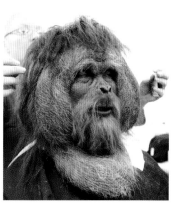

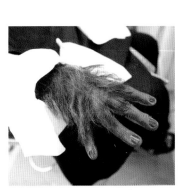

We put hair on the latex thin skin on his palms, and we painted his fingers black like an orangutan's with Skin Illustrator. She glued the beard and wig on.

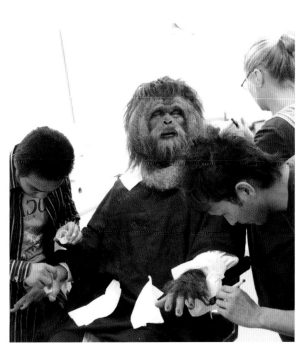
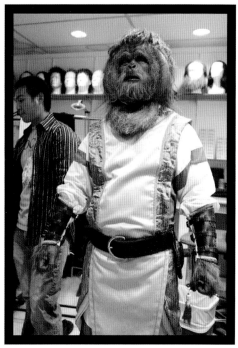

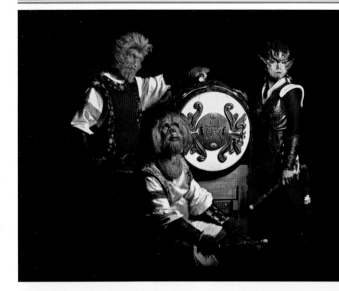

SHOOTING DAY

The day was very busy. We started makeup at 7 a.m. in KNB's studio and shot until 9 p.m. I had to direct the performance of the 3 characters in the photo shoot. I also shot the video of the 2 monkeys playing taiko as the demon princess played the cymbals. I've included some behind-the-scenes photos.

Photo shooting by Tomoko

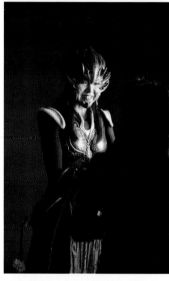

Directing the characters while shooting.

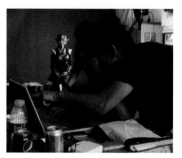

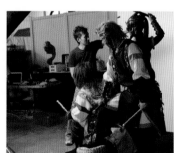

Tomoko and I check lighting with some preliminary photos before shooting.

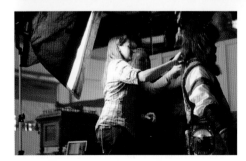

Kathy and Kerrin discuss costume and hair choices.

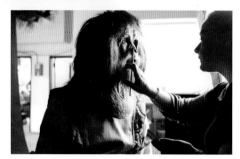

Kerrin retouches orangutan makeup.

Kevin and I take a break and enjoy some girl talk.

Directing the 3 characters that play taiko.

I used 3 professional photographers for video shooting.

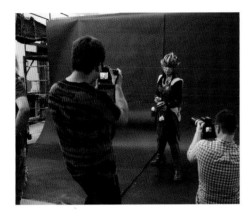

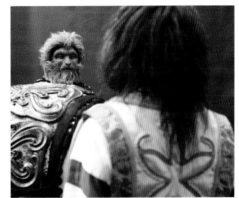

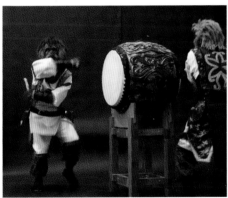

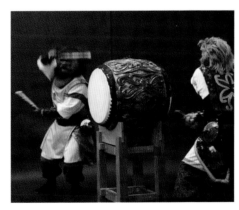

The orangutan and macaque play drums. The rhythm pulses like a heartbeat and can often be felt through the ground. One player makes the bass heartbeat. This is the foundation of taiko performance. The other player makes different sounds. The players have to match pitch and rhythm to make great sounds.

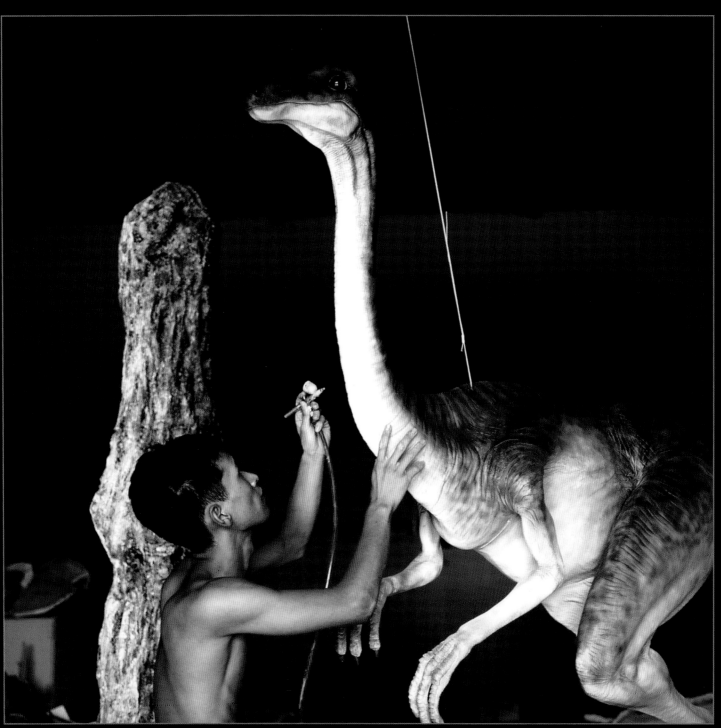

GALLIMIMUS MEDIUM: MIXED (1994)

The first personal work of AKIHITO undertaken in 1994;

A sculpture of a life-sized Gallimimus dinosaur.

MY HISTORY

My hometown is Fukuoka Prefecture. Believe it or not, I was born at Ikeda Hospital in Shimabara City in Nagasaki Prefecture. We were not rich, and the hospital wasn't named after my family. It was strictly a funny coincidence. My grandmother did happen to work there, though.

My full name is Akihito Ikeda (池田朗人). The Kanji for my name means "cheerful person." I believe my parents longed for a cheerful son during a time of turbulence. Riots had broken out among college students in Japan around 1972. Tensions were high. My father wanted to name me after the prime minister. His name was Hayato, but my father thought it would be too similar since Hayato's last name was also Ikeda. He did not want me compared to the prime minister. Unfortunately, the emperor's name was Akihito. My father should have realized that it was much more difficult to live up to an emperor than a prime minister.

We moved when I was 3 months old to my father's hometown of Hokkaido Prefecture. It is the northernmost island. It is also the 2nd-largest of the 4 Japanese islands. We moved because of my father's work and stayed in Hokkaido until I was 3 years old. We then moved to the Fukuoka Prefecture on Kyushu Island. I spent the rest of my extremely happy childhood there until I graduated from high school.

I am still friends with my kindergarten teacher, Mrs. Momoyo. She remembers that I was good at drawing when I was young. She said I was noticeably better than the other children. I remember drawing animals and characters in order to get girls' attention. As I grew older, I always doodled on my papers while I was in class. For some reason, I stopped drawing in high school.

The turning point was when I was 15. I was a special-effects makeup artist on TV and it changed my life. I decided at that point that that is what I wanted to be. The show was called Chikyu ZiguZaga, and it introduced a Hollywood makeup-effects artist to a Japanese audience. There was really no way for me to learn about special effects at that time. We couldn't afford a makeup-effects course at the professional film institute. We were saving up to move again because of my father's work. I decided to take a design course at the junior college in Okayama because it cost less and I could focus on design. I decided to save money for the special-effects course. I really enjoyed studying design. Sculpting a car with industrial clay was a lot of fun. It gave me a unique experience and valuable skills that I used in sculpting later. I soon received bad news, though.

I was planning on staying with a relative as I attended the special-effects school. He called to tell me that the school burned down. A fire grew out of control and soon took over. The choice was made for me. I don't remember how I felt at the time. I did, however, go. I am not sure why. There was not much the school could do. The teachers did not show up. There were no materials and there was nothing to learn. I wasted my time for a few months. The school did pull something together for 3 days, but it was too little, too late. People still ask me why I didn't leave the school. It is one of the great mysteries of my life. I made the decision to take that bad experience and renew my drive to propel myself into the film business as a special-effects artist in Japan.

It was at that point that I started to create a life-sized Gallimimus dinosaur by myself. I was frustrated by my situation and angry at the school because I had nothing to do. I had no crew and, at the time, did not even know how to use plaster. I just did it. I worked at the school and asked every adult every question I could think of. In 2.5 months, I finished it.

The Gallimimus was huge. It was H 137.8 inches (3.5m) x W 137.8 inches (3.5m). I was 5'9" tall and weighed 138.8 pounds (63kg). I lost 17.6 pounds (8kg). I spent all my money on the creation of the dinosaur and only ate once a day. I ended up looking like a Filipino boxer. The teachers at the school were impressed with my skill and my dinosaur. That was my first step into the SFX industry.

In 2002, I was lucky to get a scholarship through the Agency of Cultural Affairs in Japan. This scholarship allowed me to move to the United States. I felt that I had reached a plateau in Japan, and if I wanted to proceed as an artist, I had to make the move. I felt there was a huge gap between what I wanted from my career and what the reality was at that time.

At the time, I had won 3 consecutive seasons of a TV competition called Special-Effects Makeup King Competition on a major network, TV Tokyo. I was also the main designer for the television series Ultraman Cosmos, but I couldn't garner the big budgets that would take me to the next level. I had to change my environment.

Imagine, I was in the United States with no connections and I couldn't speak English. Looking back, I am still amazed at my actions.

I took a great leap of faith and completely started over. I started sending résumés and making cold calls to studios. I was terrified of calling them because I couldn't understand what they were saying. Once day, though, my life changed. Howard Berger, one of the owners of KNB Effects Group Inc., called me and gave me a job. Howard changed my life. He gave me the chance I needed: the opportunity to work in the United States. I owe him a great deal.

I worked as a sculptor for him at KNB Effects Group Inc. for 6 years as he supported my visa. Since then, I've worked with shops such as Amalgamated Dynamics Incorporated and Legacy Effects. I want to thank those studios as well as the many friends I've made, and the American community who adopted me.

I am sure you see my journey as hard, but I try to stay positive and optimistic. I've worked on many great films, including *Ginger Snaps*, *Transformers*, the *Alien vs. Predator* franchise, the *Narnia* franchise, *Alice in Wonderland*, *Terminator 4*, *Predators*, *Pacific Rim*, and *World War Z*. My favorite was my work on *Alien vs. Predator* because I designed and sculpted the Queen Alien, which was my dream. It is a great memory that I will treasure forever.

What would I be doing if I was still in Japan? It has been 11 years since I came to the United States. The film industry has changed dramatically since I started. I want to be a famous fine artist. I would like to solidify my brand of independent art throughout the world. I would like to emulate artists like H. R. Giger and Syd Mead. My dream is to see my art in museums and have it be recognized everywhere. One thing is certain: I will enjoy my future.

LINO STAVOLE

www.behold3d.com

Lino Stavole was born in Cleveland, Ohio, in 1972. He served in the Army in heavy demolitions and explosives. He took his knowledge into independent-film pyrotechnics and started performing special effects for films throughout the Midwest. He studied theater and film design at the University of Toledo in Toledo, Ohio. There, he decided to focus more on art and the mechanical and soon started working for illusionist Owen Redwine, building illusions and magic tricks at Redwine Magic. His unique interests led him to renowned sculptor Thomas Kuebler, and he worked as his assistant. He then became production coordinator at a unique animatronics company called LifeFormations. In 2001, he moved to Los Angeles and formed The Creature Company. In 2004, he worked at KNB Effects Group Inc. on numerous projects and was extensively influenced by special-effects-makeup gurus Greg Nicotero and Howard Berger. Around that time, his interest in art and technology developed even more, and he started working with 3-D scanning, rapid manufacturing technologies, and digital modeling for the physical makeup-effects industry. Stavole is considered one of the innovators of new technologies in this area and speaks frequently for the Society of Manufacturing Engineers on new 3-D imaging and rapid manufacturing technology in the entertainment industry. Stavole currently works with the industry's best artisans and craftsmen at Behold 3D, providing digital manufacturing for an ever-changing film industry.

KAZUHIRO TSUJI

http://kazufx.com

Email : kazutfx@gmail.com

Kazuhiro Tsuji was born in Kyoto, Japan. During high school, he focused his career aspirations on special-effects makeup and started a correspondence with Dick Smith (*Amadeus, The Exorcist, The Godfather*). Smith invited him to work on the Japanese film Sweet Home. In a few years, Tsuji started his own business and worked on numerous Japanese movies, including *Rhapsody in August*, directed by Akira Kurosawa. Tsuji also taught special-effects makeup at the Yoyogi Animation Institute. In 1996, he was sponsored by Rick Baker to work on *Men In Black*. This started a collaboration between Baker and Tsuji (as project supervisor and makeup artist) that has lasted over 10 years. Baker received Oscar nominations for *Life* and *Mighty Joe Young*, and won Oscars for *Men In Black* and *How the Grinch Stole Christmas*. Tsuji was the key artist for these films. Tsuji also won a BAFTA Award for *How the Grinch Stole Christmas*, and was nominated for *Planet of the Apes*. He won the Hollywood Makeup Artist and Hair Stylist Guild Awards for *Planet of the Apes* and *How the Grinch Stole Christmas*. He received Oscar nominations for Click and Norbit. Tsuji started his own company, KTS Effects, Inc., in 2007. In addition to working in the film industry, he does makeup design for Las Vegas shows, creates his own fine art, and collaborates with other fine artists.

AKITA YASUNARI

akita.yasunari@facebook.com

Born in Tokyo, Akita Yasunari has been a photographer in the Los Angeles area for over a decade. He has also worked as a writer for several magazines in Japan. Akita is a graduate of the University of California, Los Angeles, with a television and film major. He is expanding his career in the field of video shooting.

KATHY SULLY

Custom Boot Maker, Costumer and Fabricator

klsully@yahoo.com

Kathy has spent 11 years working in the special effects business for various films, tv shows and commercials. Recently she spent a year and a half working for fashion designer, Greg Lauren, as one of his leads on his design team. Currently she is developing her own custom boot business.

TOMOKO

photographer

www.tphotography.com

Tomoko was born in 1971 in Osaka, Japan. At 17, she convinced her father to let her study English in London for a year. Prior to her departure, her father bought her a camera so that she might document her journey, as well as learn the principles of photography. Experiencing her trip from behind the lens became the embryo of a dream to become a professional photographer. In 1994, she enrolled in the Academy of Art University in San Francisco. She headed south to Los Angeles to specialize in portrait, fashion, and music photography. This move gave her the opportunity to work with major Hollywood celebrities and music icons, including Snoop Dogg, which was her dream come true. Tomoko is currently living in Los Angeles and enjoying the life of a freelance photographer.

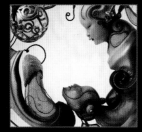

HEART OF ART

PHOTOGRAPHER / KAZUHIRO TSUJI

ASSISTANTS / MIYO NAKAMURA, SHUHEI SEKIGUCHI, KODAI YOSHIZAWA

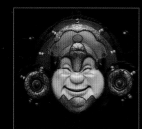

RELIEFS

SPECIAL THANKS / AMALGAMATED DYNAMICS INC.

PHOTOGRAPHER / KEVIN MCTURK, KAZUHIRO TSUJI

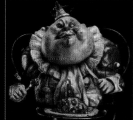

KILLER CLOWNS

PHOTOGRAPHER / AKITA YASUNARI

ASSISTANTS / MAIKO CHIBA, YUSUKE MORI, YUKO KAMADA, MAYUMI OKAMOTO, HIROSHI FURUSHO

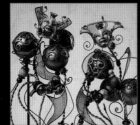

THE BEE FAMILY

SPECIAL THANKS / KNB EFFECTS GROUP INC.

PHOTOGRAPHER / KAZUHIRO TSUJI

ASSISTANT / AKI FUJIWARA, AYUMI SAITO, DAIKI SUZUKAWA

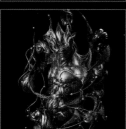

RAIJIN

PHOTOGRAPHER / AKITA YASUNARI

ASSISTANT / SHUHEI SEKIGUCHI

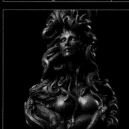

ELEGANT MEDUSA

SPECIAL THANKS / SHINSUKE KENJYO, NANA MITAMURA, AMALGAMATED DYNAMICS INC

PHOTOGRAPHER / KAZUHIRO TSUJI

MOLD MAKER / TIMOTHY REED MARTIN

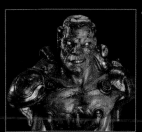

THE REGENERATED MAN

PHOTOGRAPHER / AKITA YASUNARI

ASSISTANTS / YUKO KAMADA, YUSUKE MORI

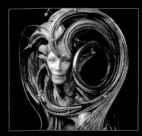

WIND MESSENGER

PHOTOGRAPHER / AKITA YASUNARI, TOMOKO

MOLD MAKER / KOJI OOMURA, SHUHEI SEKIGUCHI

ASSISTANTS / KOJI OOMURA, SHUHEI SEKIGUCHI, CHICACO KITABATA NARCISSE

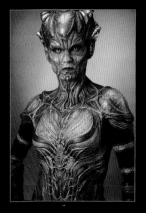

BIO-VERONICA

SPECIAL THANKS / AMALGAMATED DYMANICS INC., BJ GUYER

ART DIRECTOR / AKIHITO

PHOTOGRAPHER / AKITA YASUNARI

MODELS / VALENTINA IVANCIONCE, JULIA SENECAL

COSTUME DESIGNER / KATHY SULLY

MOLD MAKER / CHRIS BAER

PROSTHETIC TECHNICIAN / MATTHEW GERAND MASTRELLA

ASSISTANTS / JON K. MILLER, AYUMI SAITO, YUKO, KAMADA, MIYO NAKAMURA, DAIKI, SUZUKAWA

2ND ASSISTANTS / HIROSHI FURUSHO, MAYUMI, OKAMOTO

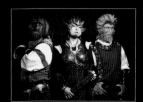

TAIKO

SPECIAL THANKS / KNB EFFECTS GROUP INC., KOGENKAI TAIKO GROUP

ART DIRECTOR / AKIHITO

PHOTOGRAPHERS / TOMOKO, JASON SHOOK

IN-PROCESS PHOTOS / AKITA YASUNARI, 217... (NINA)

MODELS / EIJI SHISIDO, KEN MATONO, YUKO UEDA

MAKEUP / AKIHITO, KERRIN JACKSON, KEVIN WASNER

COSTUME DESIGNERS / KATHY SULLY, BRUCE MITCHELL, YURIKO KATAGIRI, BETH HATHAWAY

PROSTHETIC TECHNICIANS / DEREK KROUT, MIKE LACHIMIA

HAIR / MARI, HANAZONO, MARK BOLEY

ASSISTANTS / YUSUKE MORI, KAZUYUKI OKADA, KAYO NAGASAKI, MIYUKI YOSHIHARA, CHICACO KITABATA NARCISSE, LINO P. STAVOLE

FU-BI

SPECIAL THANKS / KNB EFFECTS GROUP INC.

ART DIRECTOR / AKIHITO

PHOTOGRAPHER / KAZUHIRO TSUJI

MODELS / TARA PLATT, RALPH J. HOOPER

TEST MODELS / PATRICIA URIAS, JOSEPH GILES

MAKEUP / AKIHITO, KAZUYUKI OKADA, LINO P. STAVOLE

COSTUME DESIGNER / KATHY SULLY

ASSISTANTS / STEVEN MUNSON, BRUCE MITCHELL, MARI OKUMURA, LINO P. NICOLETTA, DEREK B. KROUT, ATSUKO IKEDA

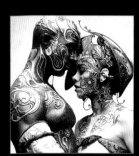

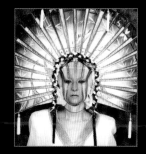

RUNWAY SHOW

ART DIRECTOR / AKIHITO

PHOTOGRAPHERS / KEIJI KUBOUCHI, KAKUSEI FUJIWARA

COSTUME DESIGNER / BABY GRAND

MODELS / SPRING: NAMI RU, **SUMMER:** AYA TSUCHIYA, **AUTUMN:** MAYUMI OOMORI, **WINTER:** MAIKO SHIMOMURA

CLOWN / AI SATO

SOLDIERS / TOMOAKI AOYAMA, MASAKI KAMINAGA

ASSISTANTS / TOSHIYUKI MAKIUCHI, FUMIE YOSHINO, MOTOHITO KIRIHARA, RINA IMAI, KAORI FUNAYA, JUNYA NAGATOMO, YUMIKO FUCHIGAMI

VIDEO EDITING / TOMOE OOTSU

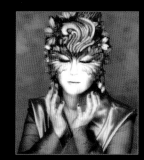

CHERRY BLOSSOM

SPECIAL THANKS / TOKYO FILM INSTITUTE

ART DIRECTOR / AKIHITO

PHOTOGRAPHER / KEIJI KUBOUCHI

COSTUME DESIGNER / EKO

MODEL / NOBUKO OKADA

ASSISTANTS / KANA NISHIHARA, RINA IMAI, KAORI FUNAYA

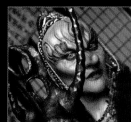

TENGU

SPECIAL THANKS / TOKYO FILM INSTITUTE

ART DIRECTOR / AKIHITO

PENMANSHIP / KATSUNOBU IKEDA

PHOTOGRAPHER / KEIJI KUBOUCHI

IRON WEAPON / TETSUPEI TSUTSUI

ASSISTANTS / KANA NISHIHARA, RINA IMAI

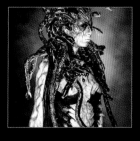

TV CHAMPION NO. 2 SFX CHAMPIONSHIP

1ST COMPETITION, SUPERMODEL MEDUSA

MAKEUP / AKIHITO

MODELS / TETSUKI NAGATA

PHOTOGRAPHER / AKIHITO

COSTUME DESIGNER / NORIKO HIRATSUKA

ASSISTANTS / MOTOHITO KIRIHARA, TETSUKI NAGATA

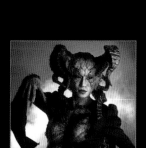

TV CHAMPION NO. 3 SFX CHAMPIONSHIP

1ST COMPETITION, A BRIDE OF THE DEVIL

MAKEUP / AKIHITO

MODEL / KAZUHIRO KIMURA

PHOTOGRAPHER / KEIJI KUBOUCHI

ASSISTANT / KAKUYUKI YAMAZAKI

ACCESSORIES / SAITO

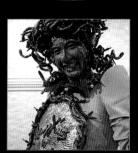

TV CHAMPION NO. 3 SFX CHAMPIONSHIP

1ST COMPETITION, BREATHING WREATH

MAKEUP / AKIHITO

MODEL / SHIGEMASA YOSHIDA

PHOTOGRAPHER / AKIHITO

COSTUME DESIGNER / NAOTO NISHIWAKI

ASSISTANT / TOSHIYUKI MAKIUCHI

BIO-VERONICA, FU-BI, TAIKO PROJECT, AND IMPERATOR WERE FIRST PLANNED AND PUBLISHED BY GRAPHIC-SHA PUBLISHING CO., LTD.

1-14-17 KUDAN-KITA, CHIYODA-KU, TOKYO, 102-0073, JAPAN

TV CHAMPIONSHIPS PLANNED AND SHOWN BY TV TOKYO.

THE AKIHITO SPECIAL-EFFECTS MAKEUP RUNWAY SHOW WAS IN COOPERATION WITH THE INDIES MOVIE FESTIVAL IN TOKYO IN 2001.

SPECIAL THANKS: KNB EFFECTS GROUP INCORPORATED, AMALGAMATED DYNAMICS INCORPORATED

MORE TITLES FROM DESIGN STUDIO PRESS

isbn 978-193349258-2

isbn 978-193349292-6

isbn 978-193349269-8

isbn 978-097266764-7

isbn 978-193349295-7

Hardcover
isbn 978-193349273-5
Paperback
isbn 978-193349259-9

To order additional copies of this book
and to view other books we offer,
please visit: **www.designstudiopress.com**

For volume purchases and resale inquiries,
please email: **info@designstudiopress.com**

Or you can write to:
Design Studio Press
8577 Higuera Street
Culver City, CA 90232

Telephone: **310.836.3116**
Fax: **310.836.1136**

To be notified of new releases, special discounts
and events, please sign up for the mailing list
on our website, join our Facebook fan page,
or follow us on Twitter:

 facebook.com/designstudiopress

 twitter.com/DStudioPress

AKIHITO OFFICIAL WEBSITE
Special effects make-up and fine studio
www.shiniceya.co.jp

CONTACT
Akihito / panther3black@yahoo.co.jp

AKIHITO JAPAN OFFICE
Cordinator
Naoko Sumitomo / mama-sumitomo@tcct.zaq.ne.jp

SPECIAL EFFECTS MAKE-UP AND FINE ART STUDIO
Timeless Language Center, Inc.
tlc@tlcusa.jp
Telephone: **818-757-7657**